BERNARD SHAW

ON

PHOTOGRAPHY

BERNARD SHAW
ON
PHOTOGRAPHY

───

Edited and with an Introduction by
BILL JAY
and
MARGARET MOORE

Foreword by
MICHAEL HOLROYD

PEREGRINE SMITH BOOKS
SALT LAKE CITY

First edition

93 92 91 90 89 5 4 3 2 1

Text and photographs copyright © 1989,
The Trustees of the British Museum, The
Governors and Guardians of the National
Gallery of Ireland and Royal Academy
of Dramatic Art

Introductory material, appendices, glos-
sary, bibliography, and index copyright
© Gibbs Smith, Publisher

This is a Peregrine Smith Book, published
by Gibbs Smith, Publisher, P.O. Box 667,
Layton, Utah 84041

Design by J. Scott Knudsen

Jacket photographs:
 front: Portrait of Bernard Shaw, by
 G. C. Beresford
 back: Unidentified, by Bernard Shaw
Manufactured in the United States of
America

**Library of Congress Cataloging-in-
Publication Data**

Shaw, Bernard, 1856–1950
 Bernard Shaw on photography / [com-
piled by] Bill Jay and Margaret Moore :
Foreword by Michael Holroyd.
 p. cm.
 Bibliography: p.
 Includes index.
 ISBN 0-87905-338-0
 1. Photography, Artistic. I. Jay,
Bill. II. Moore. Margaret.
1958- . III. Title.
TR183.S42 1989
770 — dc19 88–39595
 CIP

CONTENTS

Appendices:

FOREWORD

Shaw's writings and speeches on photography are an extension of the electioneering art criticism he wrote in his early thirties. As an art critic who saw his job as carrying on Ruskin's business, he had championed the reforms of the New English Art Club against the conventions of the Royal Academy. Going round the photographic galleries he was on the campaign trail again and supporting the group of art photographers called the Linked Ring, which had broken free from the "infuriating academicism" of the Royal Photographic Society of Great Britain.

Photography in its early days had begun with men who were tradesmen, and as a trade process it commanded very low wages. By the late nineteenth and early twentieth centuries it had been partitioned off in Britain by a snobbish cultural barrier. The established view was that, as the very junior colleagues of painters, photographers should strive to make their work simulate drawings and even engravings or dissemble a painterly effect in order to liberate themsevles from their journeyman status, qualify as artists, and attract a more reasonable income. The result was that some of "the most sensitive photographers," Shaw wrote, "have allowed themselves to be bulldozed into threatening painting, not as an obsolete makeshift which they have surpassed and superseded, but as a glorious ideal to which they have to live up."

Shaw used all his formidable powers of invective, paradox, and dialectical ingenuity to give contemporary photographers a sense of collective self-esteem. He believed that the camera, "with the right lens and the right distance, could draw with absolute correctness." There was no need to import into the photographic dark room such tricks as cooking and stipling sitters' faces, manipulating the pig-

ment process and underexposing negatives to achieve a pseudo-impressionistic effect. Such fashionable aberrations and impostures, he argued, compromised the truthfulness of photography. "I say that a photographer imitating the work of a draughtman is like a man imitating the noises of a barnyard: he may do it very cleverly, but it is an unpardonable condescension all the same."

"On art I am prepared to dogmatize," Shaw conceded. When on the offensive he would cite the scandal expressed and the terror felt by outraged British painters at the claims and performances of American photographers, and go on resoundingly to announce that "the old game is up" and "the day of the daubs is over." In moods of apparent conciliation he varied his strategy and enjoyed reversing the truisms of the time, declaring that painting was in no danger of being superseded by photography after all because the latter was so much more difficult as an artistic discipline and, being less mechanical, it took much longer.

The bitterness Shaw felt at the rejection of his novels fueled his case against the "idle fancies" of painting as compared to the non-fictional reality of the camera. He threw himself into this battle—almost literally so when recounting the story of "when I was a younger and probably a better-looking man, I was walking down the hall of a house in Ashley Gardens, when I saw a man who made an extremely disagreeable impression upon me. He appeared so sinister that I instinctively turned aside; as I did so, he did the same, and then I realized that the image was myself in a mirror."

This story, which ostensibly illustrates a limitation in photography, is really the clue Shaw gives us to the hostility it aroused as well as what he believes to be its supreme virtue when practiced by skilled tradesmen. "The portrait photograph has only come into popularity by the destruction of its essentially truthful qualities," he wrote. "Photography comes up against a real antipathy in human nature to the truth. One may attribute the hatred of photography which is felt by many artists to the fact that photography is a little too uncompromising."

As a campaigning critic Shaw was almost always on the side of change and in the thick of controversy. He liked to claim that he had learnt all he knew about photography from the simple method of buying a camera and using it. He learnt from his mistakes not how to correct those mistakes but how to advise others to do so. He con-

tinued taking photographs like one who never had the benefit of reading his own advice. All his life he had a schoolboy's love of gadgets such as the bicycle, motorbike, automobile, and wireless, as well as the camera. He was as good a photographer as he was motorist, and considerably less dangerous. But the discrepancy between his expertise and assurance as a commentator and what the local chemist at Ayot St. Lawrence admiringly called "his quite outstanding deficiency in mechanical sense" never lessened.

Shaw's trial-and-error tactics produced some endearlingly eccentric results, as well as a number of successes such as the image of himself and his wife in a mirror and the delayed action shot of himself as a crippled begger — a characteristic exercise in self-subversion. "My photographs ought to be rather valuable," he told a correspondent, "as they are extremely rare, owing to my genius for wrecking them in the course of development." But even when he took them to the chemist for development the results were not much better.

The generous-hearted editors of this volume, Bill Jay and Margaret Moore, have felt incensed that "Bernard Shaw has been inexplicably and shamefully ignored as a photographer and photographic critic." They have gathered his few reviews, letters, and miscellaneous pages on the subject into this convenient volume, added a selection from his own camera, and had the wit to use as an epigraph Shaw's own recipe for the partiality of good criticism. With the reckless bias that Shaw advocated they have washed away the shame of his neglect and triumphantly put wrong to right.

MICHAEL HOLROYD

PREFACE

George Bernard Shaw* was born in Dublin, Ireland, in 1856, the last year of the Crimean War, and died three months after his ninety-fourth birthday at his home in Ayot St. Lawrence, Hertfordshire, in 1950, five years after atomic bombs had been dropped on Japan. During his career, he wrote fifty-five plays, five novels, hundreds of political pamphlets, and volumes of art, theater, and music criticism; his collected works occupy thirty-three volumes. In addition, he penned an average of ten letters a day for seventy-five years. At the time of his death he was, without question, the most famous man on earth. And he remains the second most-produced playwright (after William Shakespeare) in the English language. Shaw received the Nobel Prize for literature for 1925, but he refused to accept a proffered Order of Merit and a seat in the House of Lords. "Order of Merit?" he said. "I bestowed that upon myself years ago."

Shaw's fame and popularity rest on his plays, but, as John Mason Brown observed, "This astonishing Mr. Shaw has been greater than anything even he has written." Variously described as egotistical, vain, garrulous, contrary, credulous, idealistic, prudish, eccentric, iconoclastic, feisty and shy, G.B.S., in a real sense, invented himself, as he claimed. He needed no urging to pronounce his opinions on every conceivable topic, and they were always delivered in an entertaining and thought-provoking style. G.B.S. was the created spokesman for social, moral, political and literary theories, with a particular passion for political and economic socialism, a new reli-

*Shaw never used his first name, preferring that it be reduced to an initial or dropped entirely. In deference to his wishes, "George" has not been used in the rest of this text, except where it occurs in the original titles of articles or in quotations.

gion of creative evolution, vegetarianism, capital punishment, antivivisection, spelling reform, women's rights and a host of other controversial causes, all argued with barbed humor and devastating wit in his own inimitable manner. The adjective *Shavian* was even coined to describe this iconoclastic style.

The "Sage of the Western World" was constantly besieged by reporters for his views on all aspects of life, yet Shaw said that he would never write his autobiography because his life story was not at all interesting: "I have never killed anybody. I have had no heroic adventures. Nothing unusual has ever happened to me. On the contrary, it is I who have happened to the world . . . "

In spite of this declaration, over three hundred books have been written about Bernard Shaw and his works, exploring such topics as: Shaw and prize-fighting; Shaw and actresses; Shaw's wife; Shaw as seen by his housekeeper, doctor, gardener, neighbors; Shaw's lectures, speeches and debates; Shaw by his secretary; Shaw by G. K. Chesterton; in effect, Shaw in relationship to every conceivable connection — except photography. This seems a curious omission in that one of Shaw's earliest published writings, in 1883, reveals him to be an astute, knowledgeable and enthusiastic supporter of photography. In the last year of his life, he was frequently seen walking the country lanes around his home village with a camera slung round his neck. It was common knowledge to all who knew him that Shaw's most absorbing hobby was taking photographs (second only to his love of being photographed).

Bernard Shaw was a devoted and prolific camera user from 1898 until the day he died. His essays about photography, published between 1901 and 1909, were not only Shavian in spirit, but were also major contributions to discussions on contemporaneous issues; Shaw held his own in these debates with some of the most respected photographers in the world. His articles were printed and reprinted, discussed and analyzed, until no photographer of the period, even remotely aware of the issues, could have been ignorant of Shaw's deep involvement in and knowledge of photography.

Yet few of Shaw's own photographs have ever been published or exhibited, and his essays have never been compiled into an anthology. This gap in Shaw scholarship is finally rectified by this volume devoted to Shaw's photographs and photographic essays.

Perhaps one of the reasons why Bernard Shaw's photographs have received scant attention is that the primary collection of prints is not located anyplace frequented by photographic historians in their pursuit of original images. They are instead housed at the London School of Economics, a choice understandable only in light of Shaw's interests and career as a whole.

Bernard Shaw was a lifelong committed socialist and wrote many essays, leaflets and speeches on politics and economics, including one longer work, *The Intelligent Woman's Guide to Socialism and Capitalism* (1928). Shaw was also one of the select group of middle-class intellectuals who, in 1883, founded the Fabian Society, the aim of which was to promote socialist values. His wife, Charlotte, was also a Fabian. Their home logically became the meeting place for some of the most prominent socialists of the age. Inevitably G.B.S. would photograph these friends and visitors, as well as Fabian house parties in other locations.

Charlotte died in 1943. The following year, Shaw bequeathed Shaw's Corner, as his house was called, and all its contents to the National Trust. The house was opened to the public a few months after his own death, six years later. An exception to the bequest was that all of Shaw's documents, manuscripts, correspondence and business papers were to go to the British Library of Political and Economic Science at the London School of Economics and Political Science.

When the National Trust took possession of the house, they discovered thousands of photographs and packets of negatives stuffed into the drawers and cupboards which no visitor to the home would ever see. They suggested that the prints and negatives accompany the documents to the LSE. This made some sort of sense, in that the photographs would receive curatorial care, which would not be possible if they were left in situ. A further justification was that many photographs depicted leaders of socialism in Britain and might be of use to political historians. The result is that all Shaw's photographs are owned by the National Trust, but are on permanent loan to the London School of Economics.

Another complication arises from the fact that the administration of Shaw's estate is in the hands of the Society of Authors, which negotiates contracts, provides copyright releases, arranges fees and is generally responsible for managing the income which accrues from

Shaw's work. To date, however, the photographs have hardly been a financial asset; their existence has been known only by a handful of individuals who have their own interests in Shaw's work, and these have not included "Shaw the photographer."

For all these reasons, it is understandable that Shaw's photographs have been shunted aside, seldom seen and even more rarely appearing in publications. It is also true that no photographic historian has ever made diligent efforts to find this collection. The photographs have not been deliberately withdrawn; they have always been accessible to bonafide scholars, but until now, no one has expressed any interest in examining the collection and its ramifications in terms of Bernard Shaw: photographer and photographic critic.

After researching and rereading Shaw's essays on photography, we were convinced that they should be brought before a new, wider audience, together with a selection of his own photographs. This decision inevitably led to conversations with the Society of Authors and with Dan Laurence, an eminent Shaw scholar and literary adviser to the society.

Correspondence proliferated, our publisher was enthusiastic, Dan Laurence opened channels of access, permissions were granted, and we arrived at the tiny reading room of the London School of Economics, anxious to view the anticipated hundred-or-so prints made by G.B.S. It came as something of a shock to see a trolley wheeled in, laden with a dozen-or-more albums and a score of large brown cardboard storage boxes, all stuffed with photographs and negatives. Although no inventory has ever been made of the Shaw photographs, it is estimated that they comprise at least ten thousand images. G.B.S. was nothing if not prolific, and unselective.

But what, on first encounter, seemed a daunting problem emerged as a major advantage. Sheer quantity enabled a more confident appraisal of Shaw the photographer; it yielded impressions as well as facts, the large number of prints delineating a human "face" rather than merely a photographic persona. In this sense, the technical failures, the aborted directions, the overshooting of a particular scene, the repetitions and the constant return to similar subjects and viewpoints were far more indicative of the photographer's approach to the medium than a more rigidly selected group of final prints would have been.

Viewing every single photograph over many days effected a trans-
formation on our critical attitudes. The initial impression was that
Shaw was an insignificant amateur snapshooter, no better than mil-
lions of new acolytes who swarmed around photography after the
introduction of hand cameras and dry-plates in the 1880s. This opinion
gave way to a grudging respect for Shaw's enthusiasm and tenac-
ity—his enduring love affair with the camera, which few other ama-
teurs of the period were able to sustain with such precocity. This, in
turn, led to an acknowledgment that if Shaw was not a master image
maker, at least he had left us with a store of useful documents depict-
ing the people and places with which he was associated. Then came
a delight in specific images which are among the most charming and
vibrant photographs of the period—by any photographer, irrespec-
tive of merit. Mild initial disappointment was thus converted into
enthusiastic appreciation through an absorption into the photographer's
thinking/seeing process, an achievement made possible only by a
large quantity of images.

If the quantity of images was a major advantage in assessing the
photographer's intent, it was a major disadvantage in selecting spe-
cific images for reproduction in this volume. There are scant clues
in the collection to Shaw's own preferences. Each print seemingly
carries equal weight—no prints were singled out by Shaw for special
process, enlargement or presentation.

In the absence of any direction from Shaw, the authors have
made their own choice as to which images should represent him,
recognizing that editing is a creative act. The history of photog-
raphy is rife with examples of reputations which have been created,
or distorted, by editors and critics. For this reason it is important to
clarify the selection guidelines.

There is no doubt that, by judicious editing, the authors could
have created any number of Shaws—the dreamy romanticist, the at-
home portraitist, the casual snapshooter, the epic pictorialist, the
modest landscapist, the complacent recordist, the social historian
and so on. Shaw was all of these, and none of them. He was an
enthusiastic amateur photographer who aimed his camera at whom-
ever, or whatever, touched his heart or his head. Like the work of
most amateurs, his photographs defy neat categorizations, and his
work should not be judged according to the standards of specialists.
Would these photographs receive such attention if they had been

taken by an anonymous nobody instead of the "Sage of the Western World"? Probably not. But the question is irrelevant. They *were* taken by G.B.S., and they do have value because of that fact. They not only shed fascinating light on the attitudes of one of the most remarkable men of the twentieth century, but also provide unique images of the people and places of his age. They also reflect a particular approach to the medium of photography prevalent in the early decades of the dry-plate which has been neglected by subsequent historians.

Suffice it to say that the photographs of G.B.S. offer us a unique opportunity to *see*, with greater clarity, and through charming images, the mind of a man, his age and the photographic medium at a particular stage in its history. The reproductions in this book have been chosen to illustrate these elements, not to invent a category of photographer in which to place Shaw. In the future, other researchers will discover aspects of Shaw's photography to emphasize in particular studies, and these, too, will have their validity. In this volume, the aim has been to assess Shaw's approach to photography by using a catholic selection of images, taken during his active life as an enthusiastic amateur.

The question will inevitably arise: was Shaw a great photographer? Ignoring the temptation to dismiss the question as simplistic, meaningless and irrelevant, we would answer: no. But Shaw undoubtedly was a significant, interesting and talented photographer.

His photographs also provided the practical experience and enthusiasm which informed his essays on photography. In this sense, Shaw was also an extremely influential photographer. His articles were in great demand and were avidly read, discussed and debated by a whole generation of photographers. They would not have resounded with such authority and assurance had they not been written from the personal conviction which comes from firsthand experience. Bernard Shaw was, indeed, a power in photography, especially during the first decade of this century, the period when he was most active in his own photography and in his criticism of the medium.

THE PHOTOGRAPHS

All the photographs in this volume, unless otherwise noted, are from the Shaw collection in the British Library of Political and Economic Science, housed at the London School of Economics, 10 Portugal Street, London, WC2 AHD, England. The collection comprises four-

teen commercially produced (usually Kodak) albums with standard-size, slip-in mounts, usually four prints to a page. Some albums are dated and titled. For example, inside the front cover of one album Shaw wrote "Pitfold 1898," the year when he began to make photographs. In this album, all the prints are on Printing Out Paper (P.O.P.) and depict typical beginning subject matter: the house and grounds, friends and family on the lawn, the family pets and attempts at more formal portraits, many of which are badly faded. Another typical album dates from the following year and is titled "S. S. Lusitania. 1899." These images are also P.O.P.s of poor snapshot quality and portray various aspects of the voyage, including groups of shipboard passengers, their deck games, and sundry views of the sea, ships and ports. Altogether at least four of the fourteen albums are, or can be, dated from 1898 to 1899.

By 1902–1903, the P.O.P.s were giving way to platinum prints which, due to the permanency of this process, have retained their original pristine quality. In addition, the aesthetic quality of the images was rapidly improving along with the technical quality, and the subject matter was becoming much broader and more ambitious in scope, including pictorial views. Most of the prints in the remaining albums are platinum; most of the albums are untitled and undated, and contain a miscellany of subjects. One exception is dated 1907 and is captioned inside the front cover: "Llanbedr, North Wales. The Fabian Summer School. August–September 1907." But such specificity is rare.

An assumption is that most of the albums date from the first decade of Shaw's involvement in photography, and that he later merely stored his prints in packets and boxes. There are three exceptions. One is an album containing mainly bromide prints, one of which is dated 1930. Because the other images are similar in subject matter, style and process, it seems reasonable to assume they were all taken at the same time. Another album of later bromide prints contains mainly views of Shaw's Corner and individuals on the grounds. The third exception is a postcard album of stage scenes from various Shaw theatrical productions and studio portraits of actors and actresses in costume. It seems doubtful that Shaw made these photographs. The platinum prints made between 1902 and 1909 are the most accomplished technically and the most interesting aesthetically.

In addition to the albums, the collection includes ten large cardboard boxes, containing thousands of small (contact) unmounted prints, either loosely stacked or separated into envelopes. By far, the majority of these prints are platinotypes, although there are also albumens, P.O.P.s, carbons, chlorides and bromides, usually uncaptioned and undated. There are many duplicates. Some prints have penciled, handwritten captions on the reverse side of the image, and labels on some packets identify the enclosed prints: "Mevagissey Shipping"; "Madame Vandervelde's river party at Bray. Aug. 1919"; "Venice"; "Taken on bicycle rides from Holkham, 1902"; "Tintern"; "Irish Tour"; "Algeria 1909"; "Leica prints: New York harbour in dirty weather"; and so on.

One box contains hundreds of loose prints which are mainly portraits *of* G.B.S. by various photographers, including Yevonde, Studio Lisa, Coster, Barraud, Karsh, Arbuthnot, Beresford and many others, both known and unknown, identified and unidentified. Another box contains primarily self-portraits. Yet another contains prints depicting various Shaw theatrical productions (probably not by G.B.S.). In addition, there is a box of negatives in various paper packets and envelopes, only some of which are categorized by subject matter.

In spite of their neglected state, the bulk of Shaw's images have fortunately been preserved in a single group and therefore constitute a major collection of photographs by a seminal figure of the twentieth century. It awaits additional research.

THE ESSAYS

In contrast to his photographs, Shaw's writings on photography have been widely accessible, if rarely studied, since their first publication in popular periodicals. A few essays have been reprinted in recent years, creating a slightly larger audience among students. For example, "The Exhibitions," first published in 1901, was excerpted in *Photography in Print: Writings from 1816 to the Present* (1981), edited by Vicki Goldberg. "The Unmechanicalness of Photography," from 1902, was also reprinted in *Camera Work: A Critical Anthology* (1973), edited by Jonathan Green. A facsimile reprint of "Evans—An Appreciation," from 1903, was published in *The Print* (1970), a volume from the *Life* Library of Photography.

But apart from these and a few other rare and infrequent reprintings of Shaw's essays, the majority have remained obscure. Cer-

tainly there has never been a collected anthology of all Bernard Shaw's writings about photography prior to this present volume. This anthology contains all Shaw's major essays on photography, written, with few exceptions, for *The Amateur Photographer* magazine between 1901 and 1909. But it also includes three pieces which relate to photography and which were written prior to Shaw's personal use of the camera. His earliest discussion of photography occurs in the 1883 novel, *An Unsocial Socialist,* originally printed in serial form in the periodical *To-Day* at the beginning of the snapshot era in 1884. The other two pieces are short reviews of photographic exhibitions, published in *The World* (for which Shaw was art critic) in 1887 and 1888. These reviews are unsigned, and it is through the scholarship of Dan Laurence that they can now, for the first time, be positively assigned to the pen of G.B.S.

Each essay in this volume is introduced by contextual information and details of first and subsequent publications. Only two additional notes are necessary here. Shaw not only wrote articles on photography, but also delivered lectures and took part in discussions on the subject. His remarks were usually reported in the photographic press. Because these reports are paraphrases of Shaw's words, they have not been included in this anthology, with one exception, "Photography in its Relation to Modern Art," which seems to have reproduced Shaw's style to an unusual degree.

Throughout his essays, Shaw makes frequent references to photographic personalities, processes and terms and to artists, as well as literary references, which may be unfamiliar to contemporary readers. In order to avoid excessive footnoting, these references are defined or explained in a separate glossary section.

This volume is the first study of Bernard Shaw as both photographer and critic; it will not be the last. The inimitable, inimical G.B.S. is a much more fascinating photographic figure than can be captured in a single work. This book marks a beginning.

BILL JAY
MARGARET MOORE
1988

ACKNOWLEDGMENTS

The authors would like to place on record their special gratitude to the following individuals, without whom this appreciation of Bernard Shaw, photographer and critic, could not have been completed:

Dan H. Laurence, senior Shaw scholar and literary and dramatic advisor to the Estate of Bernard Shaw, who brought the Shaw collection of photographs to our attention. He also expedited our access to the collection and provided many helpful suggestions and criticisms of the manuscript. Without his assistance and support, this book could not have been contemplated, let alone finished.

Roma Woodnutt, head of literary estates at the Society of Authors, who answered all our questions with charm, patience and encouraging goodwill. She was also responsible for untangling the knotty problems of ownership, copyright and rights to reproduction.

Dr. A. Raspin, archivist for the British Library of Political and Economic Science at the London School of Economics and Political Science, in whose care Shaw's photographs have been placed. In spite of the busy and inconvenient time of our arrival at the LSE, we were given full access to all the Shaw photographs for many days.

G. Fraser Gallie, former custodian for the National Trust of Shaw's home at Ayot St. Lawrence, who treated every visitor as an honored guest and was the most enthusiastic of hosts.

Roy K. Flukinger, curator of photographs at the Humanities Research Center at the University of Texas and a brilliant photographic historian, who gave us full cooperation and access to the photographs and G.B.S. correspondence in his collection. And Barbara McCandless of HRC, who facilitated all our requests with professionalism and efficiency.

In addition, the authors wish to acknowledge the research grant awarded by Arizona State University, which allowed us to conduct research in England.

THE DEVIL'S ADVOCATE

BERNARD SHAW
AND
PHOTOGRAPHY

. . . the way to get at the merits of a case is not to listen to the fool who imagines himself impartial, but to get it argued with reckless bias for and against. To understand a saint, you must hear the devil's advocate; and the same is true of the artist.

BERNARD SHAW
The Sanity of Art, 1908

BERNARD SHAW AND PHOTOGRAPHY

<big>B</big>ERNARD SHAW WROTE thirteen articles about photography, delivered many lectures on the subject, debated issues in the medium at photographic societies, numbered many of the greatest photographers of the age among his closest friends, included astute and provocative comments about photography in much of his correspondence, and made thousands of personal photographs, both as records of faces and places and as personal efforts at fine art. Photography was Shaw's primary hobby, one which he pursued with the prolific devotion of an acolyte. What he lacked in professionalism he made up for in passion.

In spite of all this, the subject of photography is rarely mentioned in the more than three hundred studies published about Shaw. In most of them, the only reference to photography is the observation that Shaw enjoyed being photographed. A notable exception is Archibald Henderson's biography, published in 1911, which states that "Shaw's most signal art criticism of the last decade beyond question has had to do with photography." Otherwise Shaw's enthusiasm for *making* photographs does not constitute a theme in a single book purporting to describe the man, his life and his work; there exist only passing notes, usually disparaging in tone, that Shaw made snapshots.

This is an extraordinary omission. It was no secret that Shaw was a prolific and passionate photographer; his friends and acquaintances often remarked that the camera seemed to accompany him everywhere. Indeed Shaw's photographs have often been used to illustrate his own biographies, even though the authors have not

thought it relevant or interesting enough to include information about his involvement with the camera in their studies.

Understanding some factors which have played a role in the neglect of Shaw as a photographer does not excuse this omission. One reason is that photography's social status had plummeted to an all-time low by the time Shaw took up the camera. At the turn of the century, photography was considered by the public at large to be a demeaning hobby or tradesman's occupation; it was not regarded as either an elevating art or a socially rewarding profession. In his advocacy of both these ideas, Shaw was swimming upstream, as he did with so many issues. Only recently has photography regained some of the prestige of its earlier years. It seems understandable, then, that his biographers would not wish to associate their hero with a hobby so antithetical to a brilliant mind.

Another reason for ignoring Shaw the photographer is that photographic issues at the time were so esoteric that only an active participant, such as Shaw, could comprehend them. Shaw's articles on photography resounded with the jargon of initiates, and took passionate sides in the battles of the Salon vs. the Royal Photographic Society, gum-splodgers vs. purists, ortho. vs. pan. film; they expounded on platinotypes, fuzzygraphs, and other arcane topics. Biographers without an interest in or knowledge of fin-de-siècle photography would, understandably, tend to ignore such specialized discussions and consider them irrelevant to Shaw's other, more public, activities.

Yet it is still rather puzzling that these authors have never even mentioned Shaw's assertion that photography has a greater claim to art than painting. It is such provocative and feisty remarks which have made Shaw "good copy" for journalists and biographers, who have certainly made much of his controversial attitudes towards birth control, vivisection, capital punishment, boxing, vegetarianism, votes for women, spelling reform, eccentric dress, Ibsenism, socialism, and a host of other causes, for which he was "denounced on all hands as a reckless mischiefmaker, but forgiven as a privileged Irish lunatic." At any rate, there is no doubt that Bernard Shaw has been inexplicably and shamefully ignored as a photographer and photographic critic.

This oversight needs to be corrected. First of all, any activity which was pursued with as much time, expertise and enthusiasm as

Shaw devoted to photography belongs in a comprehensive biography; what was important to him should be important to faithful biographers. More important, a photographer is someone who points, saying, "Look at that! I find *this* significant, beautiful, interesting." Looking at Shaw's photographs, therefore, will give us a greater knowledge of what he considered worth recording; through them we will see with Shaw's eyes.

In order to fully appreciate both Shaw's photographic intentions and the value of his photographs as unique personal documents, his photography must be examined in relation to his career, as well as the history of the medium. First, the state of Bernard Shaw's career at the onset of his enthusiasm for photography.

G.B.S.: EARLY CAREER

Bernard Shaw was born at 31 Upper Synge Street (later renumbered 33 Synge Street), Dublin, Ireland, on 26 July 1856 at the beginning of the wet-plate era in photography, when the medium was suddenly blossoming with potential. His mother was a kindly though unemotional woman who had received a genteel education ("as carefully brought up as Queen Victoria"), as befitted the daughter of a "country gentleman." She had married George Carr Shaw, some twenty years older than herself, who had a squint, a corn mill which was in steady decline, and a love of drinking to excess.

Shaw's parents were totally incompatible. George was not a brute; he was merely irresponsible. He did have one saving grace which he passed on to his son: a mockery of solemnity. When, for example, his firm went bankrupt, he burst into raucous laughter at the ludicrous nature of the disaster. In spite of the fact that Shaw often remembered and quoted examples of his father's sense of anticlimax, in all other respects, Shaw did not cherish memories of his father. In fact, Shaw insisted that his first name, George, never be used. He signed his letters "G. Bernard Shaw" or "G.B.S."

In spite of his mother's lack of maternal emotion and her aspirations to a social status beyond the family's means, she imprinted on Shaw a lasting love of music, which was to become one of the most important influences in his life and career. Mrs. Shaw's one absorbing passion was singing. She studied under George Vandeleur Lee, a Dublin conductor and voice trainer. Eventually Lee came to live with the Shaws and share their financial burdens, as well as fill

the house with music. Shaw was surrounded during his childhood by the sounds of Mozart, Verdi, Beethoven and Gounod. His schooling was less influential. He later wrote: "I hated school, and learnt there nothing of what it professed to teach . . . The method of teaching was barbarous: I was ordered to learn the declensions and conjugations and instalments of the vocabulary by rote on pain of being caned or 'kept in' after school hours . . . "[1]

It was at one particular school in Dublin that Shaw was first confronted with a grave social problem, a source of deep shame as well as personal discomfort. At the time of Shaw's adolescence, Ireland was still recovering from the famine of the forties, a decade of such hunger that more than one and a half million people had either starved to death or fled the country. Most of the victims were Roman Catholics, who were predominantly poor and agricultural. Shaw belonged to the ascendant Protestants, proud of their English past, who were in the minority yet controlled practically all the wealth. Shaw was therefore deeply aware of the social chasm which divided him from the majority of the people, an unbridgeable gap created not only by national origin and religion, but also by haunting memories of recent deprivation and the sense of land robbery.[2] Ireland was (and is) a bitterly class-conscious society of such severity that the two groups remain not only strangers but savage enemies.

Yet G.B.S., a Protestant, was sent to a Catholic school. He could not associate with the "lower classes" at school, and boys of his own class would not associate with him outside school. This experience was so humiliating that for eighty years he did not mention it to anyone, not even his wife.

At fifteen Shaw left school and began work for an estate agent in Dublin. According to all reports, he was an accurate, efficient and industrious employee who was so valued that he was quickly promoted to head cashier in spite of his youth.

Unfortunately his home life was going from bad to worse. His father was incapable of providing a steady income or of curbing his drunkenness, and, in despair, his mother decided to make a new start in London as a singing teacher. She abruptly sold the house and, with the proceeds, moved to England.

For five years Shaw lived with his father in a lodging house, while earning a living as a clerk. During this time he was becoming self-educated in an unsystematic and fragmentary way. Some of his

fellow employees were university graduates with whom he engaged in heated discussions on art, music and literature; he frequented the theatre, the concert hall, and the National Gallery of Ireland; he taught himself to play the piano; he was impressed by a fellow lodger, Chichester Bell, who was an inventor of the phonetic script, and who introduced Shaw to Wagner's music-drama. Shaw would later champion spelling reform and advocate an appreciation of Wagner.[3]

Shaw was also becoming publicly vocal about social issues. His first published work was a long, hotly atheistic letter in *Public Opinion,* in 1875, condemning the revivalist meetings of Moody and Sankey.[4]

One year later, at the age of twenty, Shaw resigned from his job, left Dublin and traveled to London, where he stayed with his mother. Shaw was determined to be a novelist. He wrote five novels — and received some sixty rejection slips. For the next ten years, he earned virtually nothing and contributed nothing to household expenses, living entirely on his mother's income as a singing teacher. Shaw confessed: "At that age most young men throw themselves into the battle of life. I threw in my mother."

This period in Shaw's life, from 1876 to 1886, coincided with the most momentous shock wave of change yet experienced in the medium of photography: the introduction of hand cameras and snapshots for the masses. The implications of this revolution in attitudes about picture making were not lost on the young Shaw. Although it is not known how, or when, he first became aware of photography and the upheavals going on, it is evident that he was more than a casual observer of the revolution. His fifth novel, *An Unsocial Socialist,* written in 1883, contains a dialogue which reflects an insider's knowledge.

Meanwhile the Shaw of these years was undergoing his own type of revolution. He deliberately refused to earn a living, became steadily seedier in appearance, courted eccentricities, embraced a host of fringe attitudes, and seemed to work hard only at making himself as obnoxious as possible. In retrospect, it is evident that he was sculpting and forging his most original and creative work of art: G.B.S. Bernard Shaw was a painfully shy, socially awkward and withdrawn young man; his created persona, G.B.S., was a feisty intellectual with a pugnacious and hectoring manner, shot through with devastating wit.

During his transformation, all the elements of the later "Sage of the Western World" were fused into place. Shelley's prose and poetry disgusted him with the "savagery of a carnivorous diet," and he became a lifelong vegetarian in 1881. He refused to wear anything but an all-wool garment, invented by Dr. Jaeger, worn over a head-to-foot undergarment and no shirt, because "I want my body to breathe." Most found the effect quite hideous. He began growing his ginger beard, which did nothing to offset his strange appearance, and he refused to sleep between sheets.

Eschewing society, Shaw lived on pictures and music, opera and fiction. When not writing at home, or visiting an art gallery, he spent his days in the Reading Room of the British Museum studying Karl Marx's *Das Kapital* or the score of *Tristan und Isolde*. He had no time, or the necessary self-assurance, to meet young ladies. Shabby and diffident, he escaped seduction until he was twenty-nine, "when an enterprising widow, one of my mother's pupils, appealed successfully to my curiosity."

Willfully Shaw transformed his diffidence into G.B.S. the orator. In 1879 he endeavored to make a speech at the Zetetical Society, a group concerned with social reform. He so disgraced himself, he felt, through his nervousness and lack of skill that he took every opportunity thereafter to speak in public until he had acquired brilliant skills as an orator.

Through his readings, especially of Marx, G.B.S. became convinced that socialism was the answer to the problems of society. He shared this conviction with Sidney Webb, whom he had met at the Zetetical Society. Sidney and his later wife, Beatrice, became lifelong friends of Shaw. They joined the newly formed Fabian Society in 1884, and quickly became its most tireless and dedicated workers, endlessly publishing fact-filled tracts and promoting socialism as a practical political alternative.

Through the Fabians, G.B.S. became friends with a like-minded group of intellectuals (including, in addition to the Webbs, Annie Besant, a spiritualist and advocate of birth control; Charles Bradlaugh, a dreaded atheist; Edith Nesbit, a writer of still-popular children's books; Hubert Bland, a conventional gentleman who was addicted to having more than one wife at a time, including Edith Nesbit; and, later, H. G. Wells). He lectured throughout the country, debated

direction at the executive meetings, wrote pamphlets and marched through the streets, all for the socialist cause.

When not engaged in fiery political agitation, Shaw could escape the problems of society by visiting a very different group of friends: Henry and Kate Salt, Jim Joynes and Edward Carpenter. They wore sandals, revered Shelley, and led a Spartan country life, consisting of long hikes interspersed with poetry readings and earnest discussions on the role of art. Shaw was always a puritan by nature.

By 1886 Shaw was no longer a shy collection of individual eccentricities; he was now G.B.S., a self-assertive, and widely and deeply read socialist, with fully formed opinions on art, literature, music, drama and politics, which he asserted at every opportunity with persuasive argument and biting sarcasm. But he was still poor, shabby and unemployed.

Shaw had become friendly with William Archer, a working journalist, whom he had met at the British Museum.[5] This was a fortuitous meeting for two reasons. First, Archer was a fanatical admirer of a then little-known Norwegian playwright named Henrik Ibsen, who was at the peak of his creative life.[6] Archer urged Shaw to forget novel writing and to attempt socially relevant plays like Ibsen's. Shaw was convinced. The result was his first play, *Widowers' Houses,* which Shaw called "An Original Didactic Realistic Play," a description hardly likely to attract audiences.[7]

Secondly, through Archer's connections Shaw began to write book reviews and art criticism, and was offered the position of art critic for *The World* in 1886, at five pence a line. It was in this capacity that Shaw wrote his first two pieces of photographic criticism, reviews of annual exhibitions by members of the Photographic Society. Both pieces are remarkable for their firm grasp of the photographic issues of the day. They do not read as if written by an "outsider," although Shaw was not to become a photographer for at least ten more years. In the review of 1887, for example, Shaw castigates improbable perspective, retouching of portraits, and the award of a medal to F. E. Evans[8] and not to Andrew Pringle,[9] and concludes that the Photographic Society should "promptly mend its ways."

It is abundantly clear from the spirit, as well as from the substance of these reviews, that Shaw was already a knowledgeable and opinionated follower of photographic trends, processes and person-

alities. He speaks with the assurance of an expert; yet there is no clue to the origins of Shaw's expertise. He seems to have blossomed spontaneously as an astute critic of photography, and this explanation will have to suffice until documentation for the origin of Shaw's photographic knowledge is discovered.

Shaw contributed occasional pieces to *The World* for two years. It was not until the beginning of 1888 that Shaw obtained regular employment. A new evening paper, *The Star,* began publication on 17 January, and on the eighteenth, G.B.S. was hired as a leader writer.[10] He was quickly in trouble. He treated the newspaper as if it were the official voice of the Fabian Society, and his leaders were full of socialist propaganda. Within three weeks, Shaw was forced to resign, but was rehired as music critic, at a slightly lower salary, several months later. As critics were anonymous, G.B.S. invented a pseudonym, Corno di Bassetto.[11] In later years, when Shaw's music criticism was collected and published, musicians and critics were astounded not only by his wit and humor, but also by his deep appreciation and his accurate forecasts of musical reputations. Above all, his critical essays were personal and passionate.[12]

G.B.S. was establishing a reputation for brilliance of wit and style among a narrow circle of intelligent admirers. But he could not be described as successful. He stayed at *The Star* for only two years and then rejoined *The World,* this time as music critic rather than as art critic, at a princely wage of five guineas per week.

In 1892 Shaw was thirty-six years old. He had written five books, which had failed to find publishers; a large number of newspaper articles; a play; two chapters in *Fabian Essays,* which he had edited; and *The Quintessence of Ibsenism,* published in 1891. His play *Widowers' Houses* was finished in 1892 and staged in December of that year; it was performed only twice.

Nevertheless Shaw's fame was gradually on the rise. For the next few years, in spite of seeming failures as playwright and author, his income was increasing and, for the first time, he had adequate cash with which to support himself and his mother.

Eighteen hundred ninety-eight was a propitious year. A trivial injury to his foot led to a bone disease which required two operations. He was on crutches for eighteen months. Two years earlier Shaw had met Charlotte Frances Payne-Townshend, who was his opposite in almost every respect. She had a hatred of publicity and

was as loathe to be photographed as it was difficult to keep him away from the camera. She was a society lady; he was a slovenly eccentric. She was immensely rich; he was barely keeping his head above water. She was idle; he was becoming a physical wreck from overwork. She was also critical of his writing. But they liked and respected each other, and were comfortable in each other's company. Hearing about Shaw's foot, Charlotte rushed to his bedside, only to be appalled by the sordid squalor in which he was living. She insisted he recuperate at her house in the country. Only, insisted Shaw, if they were married first. She also had a condition: only if the marriage was never consummated. On 1 June 1898, G.B.S. married his "green-eyed millionairess." Charlotte was forty-one; Shaw was forty-two.

G.B.S. was now comfortable, with efficient servants to administer to his daily needs, and his fortunes had made a sharp turn, eventually leading towards success and popular acceptance. By the time he was forty-eight years old in 1905, fame and fortune were assured.

It was during the first year of his marriage that Bernard Shaw became an enthusiastic amateur photographer. Undoubtedly his new-found prosperity was an important factor, in that photography has always been an expensive hobby, even more so in 1898 than now. He wrote to a friend: "We have been amusing ourselves during the summer with a Kodak. Charlotte is sending you some of the results. I have had one of them published in *The Academy*[13] (now an illustrated paper) with the inscription, 'The Dying Vegetarian.' "[14]

All of Shaw's serious pieces of photographic criticism were published during this period of growing fame between 1901 and 1909. This was also the period when he was becoming technically proficient in photography, as well as aesthetically assured; and he was developing close personal ties with some of the leading photographers of the period, particularly Frederick Evans and Alvin Langdon Coburn.

PHOTOGRAPHY IN THE *1890s*

Photography was born in 1839. In that year, Queen Victoria had been on the throne for two years; Charles Dickens was gaining a reputation with the *Pickwick Papers;* Eugene Delacroix had just returned from North Africa; and critics were beginning to turn their attention to social evils, such as child labor, highlighted by Chartist agitation.

The earliest photographic processes were the daguerreotype[15] and the calotype.[16] By far the most popular was the daguerreotype, which produced exquisite, jewellike images with clarity and sharpness. Unfortunately it was also an intractable, awkward process with several major disadvantages: its chemicals (bromine and chlorine fumes and hot mercury) were highly toxic; its materials (silver-coated copper plates) were expensive; its images (on a highly polished, mirrorlike surface) were difficult to view; and it only produced one image — each daguerreotype was unique.

The calotype employed cheaper, safer chemicals and produced a negative from which an unlimited number of identical prints could be made. It had only one major disadvantage: its negative was made on paper, and the final prints lacked the tonal delicacy and exquisite sharpness of its rival. This drawback was enough to make the calotype a poor second best in popularity to the daguerreotype. What was needed was a process which could combine the unimpeachable detail and tonal fidelity of the daguerreotype with the negative/positive advantages of the calotype.

In 1851 the collodion process first came into use, and it quickly made the previous processes obsolete.[17] Collodion is a mixture of gun-cotton in alcohol and ether. It is a clear, syrupy liquid which adheres readily to glass and dries to a thin, firm skin. This was the ideal substance to bind active, light-sensitive chemicals to a transparent base, from which sharply detailed prints could be made. However, the process itself was less than ideal.

For one thing, the collodion mixture was both highly flammable and extremely explosive. Many photographers demolished their darkrooms, studios, and neighbor's homes, as well as lost their lives, by carelessly handling their photographic chemicals. A more pervasive, though not dangerous, problem was that the collodion only remained active when wet; as soon as it dried, it became impervious to development. Therefore, the photographer was obliged to hand-coat his glass sheets with the collodion mixture just prior to exposure, then immediately develop the exposed plate before the collodion had a chance to dry. This fact caused a major inconvenience: the landscape photographer was obliged to travel with a fully stocked darkroom, usually a tent.

In addition, the collodion emulsion was not very sensitive — exposure times were commonly ten to twenty seconds. The camera, there-

fore, needed to be anchored securely on a heavy, sturdy tripod, an added drawback for the outdoor photographer.

All in all, the process could never be described as convenient. The practicing photographer was highly visible, and his deliberations occupied a great deal of time and, in the case of portraits, necessitated the full cooperation of the sitter. To a large extent, the chemical manipulations were an arcane mystery to the layman, and the neophyte photographer required a lengthy "apprenticeship" before mastering the process.

A dramatic and revolutionary change occurred around 1880. The introduction of dry-plates rendered obsolete, almost overnight, the cumbersome, slow and complicated wet-plate process.[18] The dry-plate obviated the need for a darkroom tent. The increased emulsion speed eliminated the need for a tripod. The introduction of self-contained systems of picture making dispensed with any specialized knowledge on the part of the photographer. In 1888 the first Kodak was introduced with the promise: "You press the button — we do the rest."

Literally millions of amateur photographers entered the scene, all snapshooting indiscriminately and causing social and photographic chaos, the repercussions of which are still being felt today. Kodak-ing everywhere, these amateurs delighted in the camera's newfound ability to catch people unaware, preferably in awkward or embarrassing situations. The ubiquitous amateurs were feared and loathed, even called "camera fiends" or "snapshot pests." Their inexpert photographs overwhelmed the carefully wrought craft of the professionals and brought photography into such social approbation that the medium has never fully recovered. By the end of the century, the prestige of photography had hit rock-bottom.

Photographers of the so-called Old School, those who had entered the medium at a time when skill, craft and experience still played a part in image making, reacted in several ways in order to separate and distance themselves from the mere snapshooter and his "vile productions." One way was to reassert the skill necessary to make the final print, and so keep the craft of picture making above the casual amateur. Many print making processes could achieve this effect; the two most important were the platinum process and the gum-bichromate process.

The platinum-print process (or platinotype) had been introduced in 1873,[19] and became available to the public in 1880. Platinum is a more stable metal than silver, and the paper was primarily valued for its permanence. Previous papers had had a disturbing tendency to fade over time. But to many photographers, the permanency of the platinum print was secondary to its aesthetic quality. It produced images with a long tonal range and soft, silvery grays. Platinum prints were difficult to make and were favored by the "pure" photographic stylists.

The principles of the gum-bichromate process were known in the early years of the medium, but it was not until the 1890s that the technique was employed for pictorial purposes.[20] It was favored by those photographers with an artistic leaning, because the process allowed a great deal of control over the appearance of the final image. Because the process used watercolor pigments, the image could be made in any color, and pigment could be strengthened or removed at will, using a brush which revealed the individuality of the artist. Gum-bichromates could be made on rough-textured papers used by artists in other media. Indeed, gum prints often resembled watercolors, crayon sketches or wash-drawings, much to the delight of photographers who wished to be associated with artists and to be elevated from mere snapshooters.

In order to further separate themselves from button-pushing amateurs, serious photographic artists banded together in secession groups. The earliest, and most prominent, was the Brotherhood of the Linked Ring, founded in 1892.[21] This elite body called for "the complete emancipation of pictorial photography" and "its development as an independent art." It called its annual exhibition "The Salon," to associate them with exhibitions of French painting. Exhibits of "photographic art" sprang up throughout Europe, while the fame of leading practitioners of pictorialism spread internationally through photographic periodicals and annuals. In 1893 the art magazine *The Studio* declared: "Photography as a medium for artistic expression is now established forever."

The decade from the early 1880s until the early 1890s heralded revolutionary changes in the medium of photography. On the one hand, the millions of new amateurs, ignorant but enthusiastic, were swamping the medium with their inartistic and crude images; on the other hand, the "secessionists" were fighting immense odds in

order to establish an elite of committed artists in photography. It is
against the backdrop of this swirling chaotic confusion about the
future of photography that Bernard Shaw entered the medium.

BERNARD SHAW: A NOVEL AND TWO REVIEWS

From Shaw's first written notice of photography, it is abundantly
clear that he sided with the artist-photographers in their battle for
prestige in the face of the snapshot onslaught. But he went even
further and asserted photography's superiority over the more tradi-
tional arts, specifically etchings and portrait painting. In *An Unsocial
Socialist,* written in 1883 within a couple of years of the introduction
of the hand camera, Trefusis, the main character, defends the artis-
tic nature of photography in no uncertain terms: "The only art that
interests me is photography." He asserts the superiority of "the new,
more complexly organized, and more perfect, yet simple and beau-
tiful method of photography . . . "[22]

Of course, the words of a character in a novel *may* not accurately
reflect the opinions of its author. In this case, Shaw affirmed that
these were indeed his own views. A contributor to an amateur
photography periodical accused Shaw of having an "aversion" to
photography.[23] Not so, said Shaw in response. "I have been from the
first alone among art critics in asserting the claim of photography to
be as much a fine art as painting or sculpture," and he specifically
referred the contributor to his novel, in which the topic was raised in
a "friendly vein." Shaw also stated that he "had publicly defended
the artistic claims of photography in discussions with authorities no
less conspicuous than William Morris and Mr. Walter Crane."[24]
Unfortunately there is no record of these encounters.

But there is no doubt that Shaw was a provocateur in acting as a
champion of photography during the 1880s. He was also unique
among art critics in his insistence on treating exhibitions of photog-
raphy with as much seriousness as exhibitions of painting. Shaw was
art critic of *The World* for only two years, from 1886 to 1888, but
both years he reviewed the annual exhibitions of The Photographic
Society in London.[25] These reviews were noteworthy in the mere
fact of their existence, even though they were not wholly compli-
mentary to the photographs on display. Several attitudes on photog-
raphy, which would become recurrent themes for the remainder of
Shaw's life, are revealed for the first time in these reviews.

His major criticism of the images on display was an intolerance for photographic "imposture," by which he meant depictions of reality which were *untruthful.* Shaw selected for particular castigation an unnamed picture, a "deliberate concoction of a landscape with several different planes of perspective in it, with the shadows falling in various directions, and with a couple of studio-lighted women twelve feet high or thereabouts in the foreground."[26]

Shaw also rejected as "imposture" the commonly accepted practice of retouching a sitter's face "until the texture of the skin is like nothing but that of white kid gloves."[27] In fact, the review of the following year was wholly concerned with this practice. Retouching, said Shaw, ought to be excluded from a photographic exhibition "on the simple grounds that it is not photography."[28] Concerns for the purity of the photographic process, and its ability to faithfully render reality, would be major preoccupations during Shaw's career, not only as a photographic critic but also as a practicing photographer.

It is worth spending a little more time on the review of 1887 because several other issues were raised which will indicate that Shaw's concerns about photography were already formed at this early point, well before he personally began using a camera. For example, Shaw was particularly critical of the photographs which had received medals for excellence. The blame was laid squarely on the shoulders of the judges. "At this rate of judging," said Shaw, "a New Photographic Society will be needed . . . "

Many photographers agreed. The Photographic Society, since 1853 the preeminent association of photographers in the world, was rapidly losing support. It had been formed as a learned society, disseminating information to its members through the publication of scholarly papers which chronicled the advances of photochemistry and technology. During the 1860s and 1870s, the budding medium needed a service which would both record and promote scientific enquiry into new processes, emulsions and all other kinds of technical advances. The new breed of photographic artist, however, was impatient with "the retarding and nanizing bondage of that which was purely scientific and technical with which [photography's] identity had been confused so long."[29] The Linked Ring's foundation, therefore, five years after Shaw's column appeared, was as much a

secession from the technical emphasis of The Photographic Society as it was a secession from the amateur movement of snapshooters.

It is evident from the tone of Shaw's review of the Photographic Society's exhibition that he was in favor of "a New Photographic Society" long before it happened. It is interesting to speculate that this idea may have been planted in Shaw's mind by W. K. Burton, a prominent photographer and writer who had helped form a rival society, the Camera Club of London, in 1885. We do know that Shaw consulted with Burton, a Fabian colleague, before writing his review.[30] Burton did not play any part in the formation of The Linked Ring, however. He emigrated to Japan the same year that Shaw's review appeared in print. Less speculatively, Shaw continued to champion the Linked Ring and its Salon, over the Photographic Society and its annual exhibitions throughout his career as a photographic critic.

Another continuing photographic interest of Shaw's was first mentioned in the 1887 review and must have caused a great deal of confusion for the average reader of *The World*. (Indeed it would probably mean little to even contemporary readers.) Shaw wrote that "the orthochromatic photographs are remarkably successful, though they are not really orthochromatic."

To unravel Shaw's meaning — and his obsession with the topic — we must understand more about orthochromatic photography. All photographic processes from the invention of the medium until the 1870s were sensitive to blue light only. Inevitably this "color blindness" led to the inaccurate tonal rendering of all colored objects in the picture. Blues emerged too light in tone; reds, too dark. This fact had quite important consequences. For example, in landscape photography, blue sky was recorded with the same density on the negative as white clouds. The result was a blank white sky area in the print. Similarly a red flower in a green bush would fail to register adequately on the negative and would appear as dark areas on the print.

In 1873 a German photochemist, Hermann Vogel, discovered that the spectral response of a photographic emulsion could be extended by adding dyes to the emulsion. Plates dyed blue, for example, became sensitive to yellow. Although Vogel's experiments were conducted with collodion plates, his "optical sensitizing" was

applied to the manufacture of dry-plates in the early 1880s. By 1887 photographers were demonstrating the advantages of these color-sensitive emulsions by deliberately choosing subjects which would have been technically disastrous using the old emulsions. In addition, a new creative control became available to photographers through the use of filters on the camera lens. For the first time, photographers could deepen or lighten specific tones at will. Even though the sensitivity of these early plates, which were called *orthochromatic* plates, only extended into the orange areas of the spectrum, this was a major breakthrough.

What, then, was the meaning of Shaw's remark that these photographs "are not really orthochromatic"? The only reasonable explanation seems to be that Shaw was objecting to the word "orthochromatic" (ortho = correct; chromatic = colors). These plates, although a vast improvement over the old emulsions, could not be "correct" until they achieved the same spectral response as the human eye. It was not until the 1920s that red-sensitive plates, called *panchromatic*, became freely available to photographers.

But Shaw was not only objecting to a misnomer; he was also advocating photography which most faithfully represents the subject. This was a theme to which Shaw returned again and again. He was not only a champion of photography-as-art but also, and more specifically, a champion of *pure* photography-as-art.

Shaw's 1887 short review encapsules most of the issues which would inform his thinking and writing about photography for the next few decades. And, it must be emphasized, the review was written a full eleven years before G.B.S. became an active photographer.

G.B.S. Buys a Camera

It is abundantly clear from Shaw's early writings about photography that he was more than casually acquainted with the photographic issues. He was as well aware of the art movement in the medium, and its technical improvements, as any avid reader of the photographic press. But during the 1880s, he was also desperately poor, completely dependent on his mother's income as a singing teacher.

Photography was an expensive hobby. Even the introduction of the Kodak camera, in 1888, which would bring a system of photog-

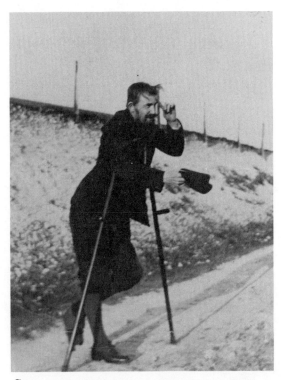

*Self-portrait of Shaw as beggar, 1898. This is one of the
earliest of Shaw's photographs. An injury to his foot led both
to his marriage and to the purchase of his first camera.
P.O.P. Collection of London School of Economics.*

raphy within the skills of millions, required a considerable outlay of
cash. The Kodak cost five guineas (twenty-five dollars in America),
which was enough to feed, clothe and house a working-class family
of four for one month. It would have lasted G.B.S. a lot longer, at a
time when Shaw's reviews were earning five pennies per line.

But by 1898 Shaw's fortunes were improving. Not only was he
earning enough to be independent of his mother's income, but also
he was married to a wealthy woman. He was now in a position to
put his theoretical knowledge of photography into practice.

Like any budding amateur, Shaw acquired a Kodak camera
and joined the ranks of the "snapshot pests" who photographed friends
and acquaintances at every opportunity.[31] Two albums in the Lon-
don School of Economics collection contain snapshots from these

Typical Kodak print wallet in which Shaw stored many of his prints and negatives. "Prints and negatives. Unidenfied [sic] landscapes abroad." Collection of London School of Economics.

first efforts in 1898, and they are no different technically or aesthetically, either in choice of subject matter or reflection of photographic ability, from thousands of amateur albums being filled at the same time by Shaw's contemporaries. Delightful in their spontaneity and casualness, they comprise mainly portraits of individuals in various "caught" poses, as well as simple shots of pets and places visited.[32]

Once the negatives had been developed and printed, Shaw placed each one in a slip mount in the pages of a Kodak album. This process would have completed the cycle for most Kodakers, but Shaw was more ambitious and enthusiastic. He quickly became a real amateur, reveling in the rituals of camera manipulation and the intricacies of developing and printing.

Most photographers love gadgets; they seem to equate an arcane knowledge of technical matters with a measure of expertise. Shaw was no exception. In future years, he would answer relatively simple questions with a litany of technical jargon. Also, like many amateurs, he was constantly switching cameras in the fond and unrealistic hope that a magic combination of equipment would transform ordinariness into art.

As the simplicity of the Kodak box camera began to frustrate his desire for aesthetic and technical control, Shaw went to the opposite extreme and bought a Sanderson field camera, which had a bellows extension of twenty inches. To this cumbrous piece of equipment Shaw added a spectacle lens ("costing nine pence") with a focal length of eighteen inches. He now had a most unwieldy telephoto camera, fitted with a lens of appalling quality, even though Shaw claimed he could make "the achromatic correction by calculation." He also experimented with pinholes, discarding the lens altogether. All this delightful experimentation, typical of many keen amateurs of the period, produced results which were, boasted Shaw, "extraordinarily natural in vision and artistic in quality."[33] In other words, much of the picture was out of focus!

Such image softness was a small price to pay for the advantage of naturalness, Shaw felt. He insisted that long exposure times were essential to good portraits:

> The best photograph I ever took of myself (by two candles and a reading lamp, with a slow spectacle glass of about 18 inch focus) came just right with an exposure of twelve minutes. Under such circumstances, you MUST make your sitters comfortable. It is the short exposures that make it possible to take people in attitudes that Nature rebels against.[34]

Shaw soon discarded this approach as it "took too much time."

Ever searching for the ideal, Shaw experimented with what he called "rectangulars" (by which he undoubtedly meant "rectilinears"),[35] anastigmats,[36] a Dallmeyer-Bergheim telescopic,[37] the Dallmeyer Adon[38] and various other lenses. Shaw also frequently changed cameras, including several Kodaks and other folding cameras, such as a Uno Cameo[39] and a Dallmeyer,[40] both of which remain in his house at Ayot St. Lawrence.

By 1904 Shaw had more photographic apparatus than he knew what to do with. In addition to his folding roll film cameras, he had an assortment of larger format cameras and lenses. Particularly revealing of Shaw's involvement in the technical side of photography is a letter written to Alvin Langdon Coburn, who planned a portrait sitting at Shaw's home, then at The Old House, Harmer Green, in July 1904:

> If it will save your carrying a lot of traps, I can place at your disposal some odds and ends of apparatus which are in a very incomplete condition, as I have only just moved into this house, and have not attempted to equip it completely for photography. But the bath room can be used as a makeshift dark room to change plates or develop a trial exposure. I have a 10″ × 8″ camera that will stretch to 30″ and a half-plate camera that will stretch nearly to 20″. I have an anastigmat (Dallmeyer's Stigmatic F6) that will cover a half-plate, and a Dallmeyer portrait lens F4, that will cover the side of a house with a telephoto attachment, and a half-plate without it. I have a quarter-plate stand camera, also available for telephoto work. Unluckily my 10″ × 8″ slides have no carriers for smaller plates, though I have ordered some. I have a few 10″ × 8″ Cristoid Orthochromatic films which are fresh, and a box of half-plate extra-rapid Ortho plates which I got 6 months ago, and some quarter and half plate Kodoids of uncertain age. But if you will tell me what you require, I will order them. The rooms here are whitewashed and fairly lighted; but I have not yet found out what exposure they will respond to.[41]

In these early years of his enthusiasm for photography, Shaw was not only obsessed with cameras and lenses, but also with the processing and printing of his negatives. Shaw bragged that he was "a real scientific timing developist," and gave an example:

> If I develop with pyrocatechin, for instance, I develop for ten times the period between the pouring on of the developer and the appearance of the sky on the plate. This period may be half a minute or a minute and a quarter according to circumstances: that is, I may want to leave one plate in for five minutes & the next one for thirteen minutes. A five minute film would get terrific density & con-

trast in 13 minutes; and a 13 minutes one would be hopelessly underdone in 5.[42]

Shaw admitted that such individual treatment of the negatives was all very well for single plates, but was inconvenient for roll films where, he confessed, "I generally develop the whole roll without separating the exposures, and put up with the resultant variations for the sake of the simplicity of the operation."

As well as experimenting with various developers, Shaw also tried out novel photographic emulsions of the day. One of the most intriguing new products for the amateur photographer was Cristoid film. This was an all-gelatin film (as opposed to a thin gelatin coating on a base of glass or other substance) which displayed an interesting characteristic during development — it swelled to a larger size than the original camera format. The final negative, therefore, provided a bigger picture without enlargement.[43]

Shaw also experimented with the new Autochrome color process. Introduced to the public in 1907, Autochrome was the first full color process using a single exposure in an ordinary camera available to the general amateur photographer.[44] Autochromes were quite popular, not only with the amateur but also with more artistically inclined photographers. Many highly respected photographers, including Alfred Stieglitz, Edward Steichen, and Alvin Langdon Coburn,[45] experimented with the new color process which produced transparencies of pointillistic brilliance.

Shaw dabbled with the Autochrome but never pursued color photography with any enthusiasm, even when more convenient color films appeared on the market. Even so, one of his earliest trials with Autochrome was exhibited and published. His view of Ayot's fourteenth-century church ruins appeared in *Color Photography and Other Recent Developments of the Camera,* a special summer number of *The Studio,* in 1908 (plate 93).[46] In his introduction, Dixon Scott describes Shaw's image:

The reader is looking at . . . the grey church tower rising up among the autumn leafage, the slant of cloudless sky ascending sharply behind; and he finds that his sensation is almost precisely that which he gets when he looks at a piece of nature through the wrong end of

a telescope—the effect of a sharpened and acidulated nature, or nature curiously tense and glittering, almost metallic.[47]

In his early years of enthusiasm for photography, Shaw "went through all the bother of development, and tried all the developers." He "printed in platinotype, carbon, and all the bromides as well as in P.O.P.; but gum-bichromate, fashionable in my time, completely baffled me. I consider printing the most difficult of the photo operations and the supreme test of the craftsman."[48] The Shaw prints in the archives of the London Library of Political and Economic Science contain examples of all these processes as well as several others, including albumens. Carbon, bromide and especially gum-bichromate prints are few and far between. The early prints are primarily P.O.P.s, and the vast majority of the images are platinum prints.

It is not surprising that Shaw's first efforts at printing were on P.O.P. — this was the preferred paper for most amateurs who wanted to make their own prints around the turn of the century. P.O.P. is an acronym for Printing Out Paper, indicating that it produces the final image during exposure and without development.[49] Although many types of printing-out papers had been introduced in the previous decades, it was Ilford P.O.P., introduced in 1891, which soon dominated the English market and which, through its advertising campaigns, introduced the initials as a generic title for all such papers.

By 1902 Shaw was discarding P.O.P. in favor of platinum prints, which form the bulk of the extant images. It is interesting to speculate on Shaw's preference for platinum. Around 1898 Shaw met Frederick Evans, a bookseller "who was shoving an obscure book of mine on customers who came in to buy Whitaker's Almanack."[50] They became friends. While visiting Evans in his modest lodgings, Shaw said, "I was struck by the beauty of several photographic portraits he had. I asked who did them; and he said he did them himself . . . "[51]

Shaw was impressed:

At that time the impression produced was much greater than it could be at present; for the question whether photography was a fine art had then hardly been seriously posed; and when Evans

suddenly settled it at one blow for me by simply handing me one of his prints in Platinotype, he achieved a *coup de théâtre* . . . [52]

Shaw's appreciation for the photography of Frederick Evans continued to grow and deepen, and they exchanged correspondence, first editions and platinotypes until Evans's death in 1943 at the age of ninety-one. It is not unreasonable to assume that Shaw's admiration for Evans would lead to an acceptance of his advice. And Evans was committed to the use of platinum paper for all "serious" photography. Its soft silver gray tones and matt appearance are in stark contrast to the brown high-gloss surfaces of P.O.P.s, which were considered inartistic.

In fact Shaw seems to have followed the guidance of Evans in almost every aspect and attitude of photography. Evans, like Shaw, advocated the use of soft-focus lenses, especially the Dallmeyer-Bergheim; decried the "splodgers" of the gum-bichromate process; advocated and practiced "straight" or "pure" photography; championed the Linked Ring's Salons over the exhibitions by the conservative Photographic Society; insisted that the pianola was capable of artistic renditions of musical scores; used Cristoid negatives; and was a feisty, iconoclastic proselytizer for his opinions on photography. In all matters of photography, Evans was the master, and Shaw the student.

The tables were turned, with a vengeance, when Evans sent two plays which he had written for Shaw's comments. Shaw was ruthless in his scathing criticism. "These plays are no good commercially. Molly and John is a most super dreadful example of self indulgent writing without the smallest consideration for the unfortunate audience . . . " Shaw continues his destruction of Evans's plays and provides a reason for their failure: " . . . the inevitable truth of the matter is that you are too old [Evans was sixty] to begin writing for the stage." Shaw drew an analogy with photography:

Playwriting is like photography: you have to spoil a prodigious number of plates, and wear out the interest of quite commonplace snapshots and portraits and views for some years before you cease to care for the pictures merely because you made them. Your Molls and Johns and Charybles are the prints of your first Kodak, more

delightful to you, perhaps, than any later masterpiece will ever be, but pure bores to the public.[53]

In the matter of playwriting Shaw was the undisputed master, and Evans the rank novice.

The year 1909 marks the end of Shaw's initial enthusiasm for photographic processes and of his active involvement in photographic journalism. In that year, his last major lecture was condensed in *The Amateur Photographer,* a commentary on the Salon titled "Photography in its Relation to Modern Art," which asserts that: "all that there is to be said about photography I have said long ago—it makes about two pages— . . . "[54]

Shaw was becoming impatient with photographic art and the stylistic posturings of so many of the photographers whose images were being lauded at the Salon:

> Now, photography really began with men who were tradesmen. They sometimes, indeed, carried the thing to ridiculous extremes, but they were able to get all their tones perfectly upon the silver surface, and people were delighted with it . . .
>
> But this kind of thing, like extreme virtue, began to produce a reaction, and in process of time somebody discovered lampblack at an oil shop, and produced the first gum drawing. The actual photograph was taken a little out of focus, and the lampblack piled on. It looked artistic, and the more it was reminiscent of the oil shop the better.
>
> I think, however, that the time has come to go back to some of the qualities of the older men.[55]

Shaw began to personally practice what he had preached to the photographic community. He abandoned his experiments in processing and printing, became less intense about creating "art," and gave away all his apparatus and chemicals. "Dark rooms," he later said, "are black holes, and metol [a developing agent] is a leprous poison."[56] But he never abandoned the taking of photographs. Throughout the remainder of his life, his camera accompanied him everywhere, at home and abroad.

Until platinum paper disappeared from the market during World War I, all his subsequent prints were platinotypes, made from his negatives by professional printers. One of the printers was W. H.

Hoather (of the Photo Nest in Bushey Heath, Hertfordshire).[57] Because the platinum process only allowed contact printing, the final images were the size of the original negatives, often 2¼ by 3¼ inches. Shaw would then trim the prints, often cropping the images into tiny, odd shapes in order to enhance their compositions. Thousands of these miniature, loose photographs, with duplicates, were stuffed into envelopes or piled into cardboard boxes and abandoned in various drawers and cupboards in Shaw's Corner. There they remained until Shaw's death, when they were transferred to the London Library of Political and Economic Science.

By the 1930s Shaw had discarded the larger negative roll film cameras and had begun using the relatively new 35-mm format, which provided the conveniences of small size, easy use and thirty-six exposures on one roll of film. Shaw's images from the final decades of his life were taken with a Leica and later with a Contax camera. The formats of these cameras produced negatives which were too small for contact printing but, by this time, enlarging was not only practical, but also the rule rather than the exception. Shaw's later prints, enlarged onto bromide papers, lacked the charm of the platinum images and seemed less concerned with picture making. They had become, in the manner of his earliest work, direct documents of faces and places. Shaw was using his camera like a visual notebook.

LATER YEARS: PHOTOGRAPHY

Through his reviews of the London exhibitions, Shaw had become well known to photographers by 1909. It was his words, not his images, which were in demand. Photographers seemed to enjoy his tongue-lashings and verbal whippings. At every possible opportunity, Shaw was invited to attack images and image makers, preferably in the presence of the individuals concerned. And the audiences submitted to the harangues with glee.

Shaw's position on every issue was unequivocal. " . . . the way to get at the merits of a case," he argued, "is not to listen to the fool who imagines himself impartial, but to get it argued with reckless bias for and against. To understand a saint, you must hear the devil's advocate; and the same is true of the artist."[58]

Shaw, the devil's advocate, was in top form at the Salon in 1909. One writer reported:

Mr. Shaw's performance was certainly remarkable. Without a vestige of notes, he poured forth a stream of sentences, coruscating with brilliance, for nearly an hour and a half . . . When he sat down it was not because he was tired, or his wit became feeble, but because he had pity upon his audience, and they, after listening to some discussion from photographers who themselves would draw a crowd on any except a Shaw night, clamoured for more Shaw, and got it, to the extent of half an hour of more coruscating brilliance than ever.[59]

Shaw also held forth on many other topics. A particularly fascinating photographic event was "an evening of wit and music" at the Camera Club in 1911 which featured Shaw with Evans, and combined both with a pianola. The audience was similarly divided, being made up of both photographers and musicians, who "found it difficult to decide which was the more worth hearing—Shaw on Evans or Evans on the pianola."[60] It is evident that both Shaw and Evans considered the camera a mechanical instrument capable of artistic expression; it was also clear that they both regarded the pianola the same way. Both performers delivered remarks to the audience on the artistic capabilities of an instrument, considered purely mechanical, when played with feeling and by an "artist." Shaw was his own inimitable, opinionated self: "Using certain disparaged contrivances, Mr. Evans has shown pictorially the mastery of man over nature, and he has gone on from that to do the same thing in music."[61]

Shaw was far less assured—and, indeed, uncharacteristically equivocal—at a later meeting of the same Camera Club. In February 1917, the Camera Club placed on display an exhibition of eighteen vortographs by Alvin Langdon Coburn. At the time these were extremely controversial images because the subject matter was unrecognizable. They are probably the first deliberately abstract photographs ever made. Coburn was a member of the Vorticist group, which stressed strong rhythmic movement in poetry as well as art. Other members included Wyndham Lewis and Ezra Pound, who wrote an anonymous preface to the exhibition's catalogue.[62] The term *vortograph* is derived from this movement.

Many of Coburn's vortographs were made by photographing small objects, such as bits of glass, through a tube of mirrors, which fragmented the image, much as a kaleidoscope would. Coburn said

that the making of these pictures "was the most thrilling experience he had ever had in all the realms of photography. For over a quarter of a century he had been using a camera in one way or another, but never had he discovered a medium to compare with vortography for producing aesthetic excitement and enjoyment."[63]

For once, Shaw was nonplussed and (almost) speechless. As a reporter remarked: "Mr. George Bernard Shaw got up and proceeded . . . to praise the vortographs with faint damns." Shaw struggled to extract meaning from the abstract shapes, lines and tones — and gave up. "He was content to find a certain amount of pleasure in them, to admit the fact, and, for the rest, to take refuge in silence."[64] It is difficult to escape the impression that Shaw was not only bemused, but also rather disinterested in vortography, and that he only attended the discussion as a favor to a friend. He certainly did not enter the fray surrounding the controversial and nonrepresentational nature of these photographs as he would have done fifteen years earlier. Shaw had long since removed himself from the political and aesthetic debates in the medium which he had once relished. Shaw was now content to be an honored guest at openings of exhibitions.

This fact was best illustrated when he attended another exhibition of the Camera Club in 1930. On display were photographs of Russia. Shaw did not lose the opportunity to play devil's advocate — that would have been completely out of character — but his remarks were directed solely towards political and social issues and ignored the photographs completely. His comments most related to the medium actually concerned Russian films:

> I don't know whether it is possible to make Hollywood blush, but I am quite sure it is not possible to make Hollywood's British imitators blush. But when you see the Russian films and remember that never for a moment have they had to fall back on that last refuge of decaying art sex appeal we wish we could make some arrangements for the Soviet to come here and take charge of our educational affairs.[65]

Bernard Shaw was a social reformer and moral crusader all his life; his devil's advocacy of photography occupied a relatively brief period. But he continued to photograph — and be photographed, which he

enjoyed just as much. And because of his personal involvement and experiences with photography, he could never resist the urge to interfere in portrait sessions. As he became increasingly famous, he became an increasingly favorite subject of other photographers, who later delighted in recounting their experiences with Shaw-the-sitter in magazine articles and biographies.

As already mentioned, Alvin Langdon Coburn was one of the most frequent visitors to Shaw's Corner. In July 1904, Shaw was the first "literary lion" to be photographed by Coburn, who subsequently made hundreds of portraits of him in every conceivable pose, even in the nude. In April 1906, Shaw was in Meudon, France, at the home of Auguste Rodin, for a series of sittings. Shaw invited Coburn to join him. On 21 April, they were present at the unveiling ceremony of Rodin's sculpture *Le Penseur* outside the Parthenon.[66] The next morning, Shaw suggested that Coburn should photograph him nude after his bath in the pose of "The Thinker," his true vocation in life. The photograph was exhibited at the Salon and aroused considerable comment in the press, although it was never published during Shaw's lifetime.[67]

Shaw loved being photographed and would frequently visit the artists' studios or give sittings at his London apartment. The photographers who made the pilgrimage to Shaw's Corner, hoping for a sitting, are legion. Some were and are well known as photographers, including: Karsh of Ottawa, Gisele Freund,[68] Malcolm Arbuthnot, Barraud, Yevonde, Alfred Eisenstaedt, and G. C. Beresford (one of Shaw's favorite photographers). Others were well respected in their own times and have since been largely forgotten, including: Wilfred Newton, Reece Winstone, John Graham, T. J. Lewis, Lena Connell (a recently rediscovered pioneer leader in the suffrage movement), Howard Coster, Miss Toplis, and V. K. Blaiklock. The extant prints in the Shaw collection contain hundreds of photographs of G.B.S. by all these, and many other photographers. In addition, Shaw was "news" and a "celebrity" (and therefore hounded by press photographers and amateurs hoping for a quick shot of a famous face).

Occasionally a fine photographer and a talented writer would provide history with not only a striking image of Shaw, but also a verbal profile of an encounter which would add character, personality and insight to the otherwise cold document of a familiar face. As a single example, there is the case of Shaw vs. Therese Bonney, a

*P*ortrait of Shaw *by* Beresford in the eighties. *G. C.*
Beresford was one of Shaw's favorite photographers. This
portrait was made at least a decade before Shaw himself took
up photography. Collection of London School of Economics.

well-known writer-photographer of the 1930–1940s.[69] In 1942 Bonney
and Shaw were guests of Lady Astor at Cliveden House, a stately
home overlooking the Thames river near Maidenhead. Bonney
reported that Shaw's Contax camera accompanied him everywhere,
and that it "seems to intrigue him. He checks and re-checks it just as
any new photographer does."[70] She was obviously not aware of Shaw's
love of gadgets and his amateur delight in the levers, knobs, rings
and dials of the mechanical instrument.

Shaw and Bonney posed for each other's cameras, sitting on a
bench in the grounds of Cliveden. Shaw got off lightly—Bonney's
exposures were made quickly and professionally. Bonney really *sat*

for Shaw who, she said, approached the portrait "with all the preoc-
cupation of a Daguerrean artist."[71] "He seemed to know," she con-
tinued, "exactly what he wanted."[72] He was preoccupied with the
pose. Her arms and hands had to be just so. He fussily directed her:
the head a little to the right; lean on the arm of the bench; look
here, look there, etcetera. Then he fiddled with the camera, adjust-
ing, setting, twisting. Ironically, the results were failures. Shaw sent
a note to Bonney:

> My photographs of you were so overexposed that the negatives
> were returned to me as unprintable. I managed to get the enclosed
> contact prints after some days of blazing sunshine on P.O.P.; and
> a military searchlight could no doubt produce an enlargement in a
> week or two . . . [73]

A Shaw biographer, Allan Chappelow, confirmed Shaw's fascination
with mechanical things and also his lack of facility with them: "Shaw
loved gadgets. He had most complicated cameras and I always felt
that he didn't understand them. That did not prevent him regarding
himself as a very good photographer. He talked the technical jargon
of photographers, but in my opinion he obtained very poor results
from his films."[74] Notwithstanding Shaw's opinion of his own photo-
graphic prowess, or Chappelow's dissension, Bernard Shaw contin-
ued to take photographs to the end of his life. And, in later years,
his favorite subject was the village of Ayot St. Lawrence and, in
particular, its half-demolished church.

THE LAST PROJECT

Shaw loved his village, and his last published work was *Bernard Shaw's
Rhyming Picture Guide to Ayot St. Lawrence*.[75] The guide comprised
simple rhymes which appeared under photographs, taken by Shaw
during many hours spent wandering round the village with his cam-
era. This was Shaw's final project; it was completed shortly before
the illness which culminated in his death.

Before looking at this project in more detail, it is important to
point out that Shaw's photographs had been published and exhibited
at infrequent intervals throughout his life, from 1898 on. With rare
exceptions, the images were presented as mere illustrations of the

Shaw's Corner, Ayot S. Lawrence, from the garden. Shaw lived here from 1906 until his death, in November 1950. Photo by authors.

text, or as photographic curiosities authored by a controversial celebrity, or as visual descriptions of Shaw's acquaintances or of Shaw himself. Rarely were the photographs treated with respect as *pictures,* in spite of Shaw's assertion that he was a serious photographer.

For example, many of Shaw's photographs were used to illustrate *Bernard Shaw through the Camera* by F. E. Loewenstein, published in 1948. This curious volume traces Shaw's life and acquaintances through a succession of snapshots; its only text consists of the brief captions that accompany the images. Shaw's snapshots are mixed in with press pictures and those taken by unknown photographers. The form, format, and presentation of the book are more reminiscent of a printed family album than a serious attempt at publishing interesting photographs.

Perhaps the only publication to present a portfolio of images representing G.B.S. *as photographer* during his lifetime was *The Countryman,* April 1937, which included "Nine Pages of Photographs by Bernard Shaw."[76] The eight images reproduced were: a portrait of Augustus John at his easel; three views of Derwent Water; a snapshot of Sir John Squire on a rocky hillside; Shaw's kitchen garden

The dining room at Shaw's Corner. On the wall, to the right, is an oil painting of Shaw by Augustus John. The photographs on the chimneypiece portray Gandhi, Djerdjinsky (an early Bolshevik), Lenin, Stalin, Granville Barker, Shaw's birthplace in Dublin, and Ibsen. Photo by authors.

and orchard at Ayot St. Lawrence in the early morning; and a sea-scape between Harlech and Portmadoc.

Several of Shaw's photographs were exhibited, including the early Autochrome view of the Ayot Church already mentioned. But these public documentations of Shaw's use of the camera were extremely few and far between. It must have come as some surprise, therefore, when Shaw's book of village views was published, even though it reached a distinctly limited audience.

It began when Ellen Terry, a famous actress and close friend of the Shaws, passed through Ayot St. Lawrence in 1916. She did not visit the Shaws but did stop into the village post office to buy some picture postcards. Shaw heard of her visit and request, and filled a small book with snapshots of the village, each with an attendant verse. He sent the finished book to Ellen Terry, calling her "barbarous" and "wicked" for not coming to tea.

The original album remained in Ellen Terry's possession until her death, and is still in her home, now the Ellen Terry Memorial Museum at Smallhythe. Shaw's assistant, Dr. F. E. Loewenstein, unearthed the draft manuscript or typescript titled *Ayot Saint Lawrence:*

A revolving hut at the bottom of the garden at Shaw's Corner, in which he could write undisturbed by visitors. Photo by authors.

A strip of doggerel verses as written for Ellen Terry, and asked Shaw to explain its meaning. This prompted Shaw's decision to publish it, with revision. Eventually he supplied an entirely new set of verses, and his own photographs.

The contents did not appear as Shaw had originally planned, however. Harold White, the publisher, left out some pages without Shaw's knowledge, "feeling that they might damage his reputation."[77] In addition, at the last moment Shaw decided to eliminate all verses making reference to Ellen Terry: "She never lived at Ayot and had nothing to do with it. And the present generation knows nothing of her; and her inclusion would only confuse the book and puzzle the readers. It would get worse as the years pass."[78]

As usual, Shaw had trouble with the technical aspects of photography: "I have had bad luck with my photographs, as the shutter went wrong and produced wild overexposure."[79] (White surmised that it was Shaw, not the shutter, which "went wrong.")

The fifty-nine photographs in Bernard Shaw's *Rhyming Picture Guide* . . . are certainly not among his best. Shaw was ninety-three when he was working on the project. But what the images lack in

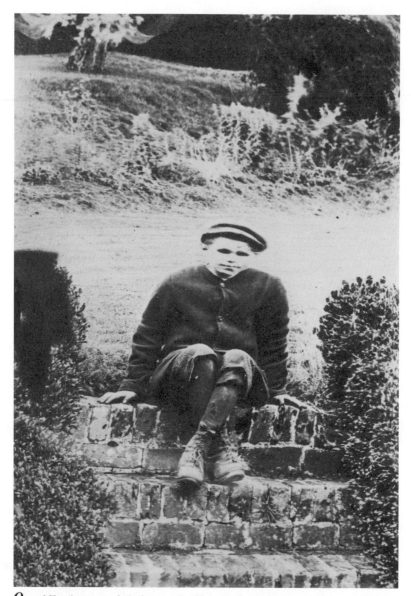

One of Shaw's many technical errors. In this case, the emulsion seems to have melted. Silver chloride print. Collection of London School of Economics.

aesthetic richness they make up for in charm and lack of pretense. A spirit of love for his subject matter suffuses the *Guide* and its contents. Perhaps that is a fitting enough tribute to Shaw's last photographic project.

Notes and References

1. Information about Shaw's early career can be found in scores of studies, many of which are listed in the bibliography. Shaw never wrote his own life story (claiming that he was not interesting biographically), although he did publish *Sixteen Self Sketches,* in 1949, one year before his death. The quotations are from these confessions.

2. Shaw's uncollected writings on Ireland were published a dozen years after his death: *The Matter with Ireland,* edited and with an introduction by Dan H. Laurence and David H. Greene (New York: Hill and Wang, 1962).

3. See Shaw's *The Perfect Wagnerite* (Chicago and New York: H. S. Stone and Company, 1898).

4. Dwight Moody (1837–99) and Ira D. Sankey (1840–1908) were American evangelists who conducted preaching tours of the U.S. and Great Britain.

5. William Archer (1856–1924) was not only a friend of Shaw's and an influential drama critic but also a playwright, producing *The Green Goddess* in 1921.

6. Henrik Ibsen (1828–1906) had written *A Doll's House* in 1879, seven years earlier.

7. *Widowers' Houses* was a collaboration between William Archer and G.B.S.: Archer supplied the plot and Shaw the dialogue. It was left unfinished until 1892, when Shaw added a third act. It was performed in December of that year but only lasted two performances. It was eventually published in 1898, along with other plays, in *Plays, Pleasant and Unpleasant* (London: Grant Richards, 1898). The collection received a scathing review from William Archer.

8. Frederick H. Evans (not E., as in the review) would later become a close personal friend and a favorite photographer of Shaw's. It is interesting that this first mention of his name should be in a critical context.

9. For information on Andrew Pringle, see the glossary.

10. The art critic of *The Star* at this time was Joseph Pennell (1857–1926), American illustrator, etcher, lithographer, who owed his job as critic to G.B.S.

11. This was the name of the instrument better known as the basset horn. G.B.S. liked the name but, at the time, knew nothing else about it. When he did hear its sound, he thought the "watery melancholy" of its tone singularly inappropriate for a column which he wanted to be "sparkling."

12. In one column, G.B.S. asserted that criticism devoid of personal feeling is not worth reading: Bernard Shaw, "September 3, 1890," *Music in London 1890-94,* vol. 1 of 3 (New York: William H. Wise and Co., 1931), 54.

 It is the capacity for making good or bad art a personal matter that makes a man a critic. The artist who accounts for my disparagement by alleging personal animosity on my part is quite right: when people do less than their best, and do that less at once badly and self-complacently, I hate them, loathe them, detest them, long to tear them limb from limb and strew them in gobbets about the stage or platform. (At the Opera, the temptation to go out and ask one of the sentinels for the loan of his Martini, with a round or two of ammunition, that I might rid the earth of an incompetent conductor or a conceited and careless artist, has come upon me so strongly that I have been withheld only by my fear that, being no marksman, I might hit the wrong person and incur the guilt of slaying a meritorious singer.) In the same way, really fine artists inspire me with the warmest personal regard, which I gratify in writing my notices without the smallest reference to such monstrous conceits as justice, impartiality, and the rest of the ideals. When my critical mood is at its height, personal feeling is not the word: it is passion: the passion for artistic perfection — for the noblest beauty of sound, sight, and action — that rages in me. Let all young artists look to it, and pay no heed to the idiots who declare that criticism should be free from personal feeling. The true critic, I repeat, is the man who becomes your personal enemy on the sole provocation of a bad performance, and will only be appeased by a good performance . . .

13. *The Academy* (London) was a weekly review of the arts which ceased publication in 1916.

14. Shaw to Sidney Webb, 18 October 1898, *Bernard Shaw: Collected Letters 1898-1910,* edited by Dan H. Laurence (New York: Dodd, Mead and Company, 1972), 67.

15. The inventor of the daguerreotype process was Louis Jacques Mande Daguerre (1787-1851). Full details of the daguerreotype process were announced to the public in Paris on 19 August 1839.

16. Inventor of the calotype process was William Henry Fox Talbot (1800-1877). He introduced his first photographic process, photogenic

drawings, in London on 20 February 1839. An improved process, the calotype, was introduced on 5 February 1841.

17. The inventor of the collodion process was Frederick Scott Archer (1813–1857), who announced details in *The Chemist* magazine in March 1851.

18. Many individuals contributed to the introduction of gelatin dry-plates, including B. J. Sayce, W. B. Bolton, Richard Leach Maddox, Richard Kennett and Charles Harper Bennett. In 1879 the editor of the *British Journal of Photography* predicted that this year would "be looked back to in the future as one of the most noteworthy epochs in the history of photography." He was right.

19. By William Willis (1841–1923).

20. Although the gum-bichromate process was a simplification of earlier printing techniques in carbon, common during the 1850s, it was not until 1894 that its adaptation to art photography was completed. In that year, Robert Demachy (1859–1938) exhibited prints produced by the gum-bichromate process at the Photographic Salon in Paris.

21. The original founders of the Brotherhood of the Linked Ring included: Alfred Maskell, an early proponent of gum printing for artistic effect; William Willis, inventor of the platinum printing process; H. H. Hay Cameron, son of Julia Margaret Cameron whose "artistic" portraits of the 1860s had inspired, and shocked, her peers; and H. P. Robinson, who had long been a proponent of artistic photography through combination printing.

22. Bernard Shaw, *An Unsocial Socialist* (London: Swan Sonnenschein, Lowrey and Co., 1887), 228, of 1906 edition.

23. Lux, "Personalities," *The Amateur Photographer* (31 August 1900): 162. This periodical, specifically devoted to the increasing ranks of amateur photographers, was the preferred outlet for Shaw's views on photography. It began publication in 1884. An interesting contradiction, concerning Shaw's views on his early novel, was raised by Lucia Moholy in 1939. In a letter to *The Photographic Journal* (4 June 1951): 205, she wrote: "In 1939, while preparing my book on *A Hundred Years of Photography*, I applied to Mr. Shaw for permission to quote from *The [sic] Unsocial Socialist* some of . . . [its] views on Art and Photography." Shaw replied: "I am sorry, but you must not revive this rubbish, which would be as discreditable to you as to me unless you repudiated it. In 1883, when I wrote it, I had never handled a camera. After 1898, when I took hundreds of photographs, I knew what I was talking about. —G. Bernard Shaw. 28.3.39."

24. "Letter to the Editor: Mr. G. Bernard Shaw on the Art Claims of Photography," *The Amateur Photographer* (7 September 1900): 185.

25. "What the World Says," *The World* (12 October 1887 and 17 October 1888): 80, 110. Both columns were unsigned.

26. This is a clear description of a combination print, in which the picture is assembled from several different negatives. However, Shaw later remarked that "There is not a single composite photograph in the exhibition." "Photographic Impostures," "What the World Says" (12 October 1887): 80.

27. Ibid.

28. "What the World Says" (17 October 1888): 110.

29. Joseph T. Keiley, "The Linked Ring," *Camera Notes* 5 (October 1901): 113. The editor of *Camera Notes* was Alfred Stieglitz, who formed the Photo-Secession, the U.S. equivalent to the Linked Ring, in 1902. Stieglitz became the most vocal and influential apostle of artistic photography in America through his journal *Camera Work,* which began publication in 1903, and exhibitions at The Little Galleries of the Photo-Secession at 291 Park Avenue in New York City. Stieglitz and Shaw never met. They almost collided in 1907, when a dinner party was arranged in London during a visit by Stieglitz. He only accepted the invitation on condition that he be permitted to do all the talking. Stieglitz wanted to "put Shaw right on photography." G.B.S. was agreeable. Unfortunately Stieglitz became ill on the day of the dinner and could not attend. The clash of these titans would have been a signal event in photographic history.

30. "Mr. G. Bernard Shaw on the Art Claims of Photography," 185.

31. In 1898 Kodak marketed what is considered to be the ancestor of all modern roll film cameras: the Folding Pocket Kodak Camera. The camera was only 1½ inches thick and 6½ inches long. It produced a negative 2½ by 3¼ inches, and this remained a standard size for decades. The Folding Pocket Kodak Camera was also the first camera with an all-metal case. It is not known if this was the model purchased by G.B.S. in 1898, although it seems most likely.

32. In 1898 Shaw and his new bride visited Pitfold, the home of Lord Beveridge; Freshwater, a town on the Isle of Wight; and Blen Cathra, Hindhead, a rented country house in Surrey.

33. Shaw's answer to a question posed by Helmut Gernsheim in a written interview, "G.B.S. and Photography," originally published in *The Photographic Journal* (4 January 1951): 35. See also Shaw's written answers to questions posed by Kenneth R. Porter, "Bernard Shaw As Photographer," *Illustrated* (31 March 1945): 12–14.

34. Shaw to Agnes F. Jennings, 4 December 1902, *Collected Letters,* 290–291. Miss Jennings was a professional photographer whose portraits had been on national exhibition on several occasions. The complete letter is so indicative of Shaw's approach to portraiture and his self-assurance in giving criticism and advice to a professional that it is worth quoting in full:

Dear Miss Jennings

I have just discovered, to my dismay, that the packet of proofs which you sent me last July, and which I brought down to Norfolk to be dealt with during my holiday, somehow never got unpacked or acknowledged. Quite unpardonable of me, I confess. I hope you have not borne much malice.

The photographs seem to me just diabolical. It is no use: you can do nothing better with that lens and with the sitter staring meaninglessly at the corner of the camera in front of your left shoulder. I knew how it would be when you told me to look at that fatal spot; but you wouldn't have believed me if I had remonstrated; so I let you do your worst. The definition of the large heads is frightful: the skin is seen as under a microscope, whilst the size of the head is reduced greatly from life. There is no suggestion that I am anywhere: I am stuck flat on a background. It is all horrible, studioesque, photographic in the most injurious sense.

Now up to a certain point this is not your fault. The photographs are technically all right; and I suppose that villainous portrait lens cannot have its back cell unscrewed into soft definition. There is nothing wrong with the exposure or the development. But the total result is hideous. No woman will fall in love with any of those portraits: most people will mistrust and loathe the original of so unnatural an image. I am sure you cannot look at them yourself without detestation. You have betrayed this feeling by turning one of the negatives upside down and trying to soften the effect by printing glass-to-film instead of film-to-film. Quite useless: the thing only looks drunk, in spite of the nice lighting.

To shew you what can be done when one is not plagued with a studio and a background, I send you some hasty proofs of plates taken by myself. One of them is almost featureless because the face was denser than I allowed for in the lantern; and all of them are as rough as possible. But I submit to you that they look human, and that they convey an impression that I am somewhere. Also that I am not staring at a camera. I am at my ease for a very good reason—the exposure was three mortal minutes. No matter: il faut souffrir pour etre belle. Lens, a Dallmeyer Stigmatic at full aperture (you *would* put stops into that thing of yours); time, 10 p.m.; light, electric; place, the drawingroom;

size, quarter plate. The negatives are as sharp as can be; but the use of the full aperture, and the enlargement to whole plate, get rid of all harshness. I took no pains, but just slopped the prints into water with a dash of Rodinal in it and fixed them. With an enlarged negative and a careful carbon or gum print, quite nice pictures could be got out of them. Of course you couldn't shew such things as these proofs to regular customers; but with your skill you could easily get the qualities without the faults. The success of Hollyer, who has never used a background, shews that people think a photograph much more "natural" when an ordinary room is taken just as it comes.

I also think that people are too much afraid of long exposures. The best photograph I ever took of myself (by two candles and a reading lamp, with a slow spectacle glass of about 18 inch focus) came just right with an exposure of twelve minutes. Under such circumstances, you MUST make your sitters comfortable. It is the short exposures that make it possible to take people in attitudes that Nature rebels against.

In my opinion the best lens for portraits is the telephoto. Dallmeyer's new sort, the Adon, is much faster than the older ones; but I get decent telephoto portraits in my drawingroom at Woking in this weather in ten or fifteen seconds, with the old sort. You could get a telephoto attachment that would Christianize your portrait lens for Salon work without a very extravagant outlay.

However, I don't know much about the subject; but I maintain that I am more beautiful than those pictures of me which your lens has perpetrated.

yours sincerely — perhaps quite outrageously sincerely

 G. Bernard Shaw

35. Rectilinear lens: a lens which produces correct images of straight lines, without distortion.

36. Anastigmat lens: a lens which produces accurate points in the image corresponding to points in the subject, without distortion.

37. Dallmeyer-Bergheim: a specially constructed soft-focus lens, designed in 1896 by Thomas Ross Dallmeyer at the suggestion of J. S. Bergheim, a painter.

38. Dallmeyer Adon lens: a soft focus lens recommended to Shaw by Frederick Evans.

39. Uno Cameo camera, with 5.5-inch f7.7 Aldis Uno Anastigmat lens, and apertures down to f45. It had three speeds (1/25, 1/50, 1/100 second), plus T and B. A simple folding roll film/plate camera.

40. Shaw's Dallmeyer camera was slightly more sophisticated than the Uno in that it featured speeds from 1 second to 1/250 second. It was fitted with a Dallmeyer Stigmatic Series II Lens, with apertures from f6 to f45. In all other respects, it was a similar folding roll film camera. Both the Uno and Dallmeyer cameras remain in Shaw's study at the Ayot St. Lawrence home.

41. Shaw to Alvin Langdon Coburn, 26 July 1904, *Collected Letters*, 435–436.

42. Shaw to Frederick H. Evans, 28 November 1902, ibid., 289.

43. Shaw referred to his use of Cristoid film in a letter to Frederick Evans on 25 July 1907, ibid., 702. "I am supposed to be holidaying here. Anyhow I bathe and take snaps on Cristoid films through a X3 screen on your recommendation." Shaw was in Merionethshire, Wales, from 15 July to 13 October, during which time he delivered lectures on socialism to the Fabian Summer School, held at Llanbedr. These Cristoid negatives are in the London School of Economics collection, along with Cristoid negatives taken in Parknasilla and during a trip to Algeria, both in 1909. Alvin Langdon Coburn also used Cristoid film, specifically for his portrait of Gilbert Chesterton which Shaw described as "swelling off the plate." After processing, Coburn's 8 by 10 inch negative expanded to 10 by 12 inches in size.

44. The Autochrome process was invented by Auguste and Louis Lumiere. The brothers refined their process during the 1890s and patented it in 1904 at Lyons, France. It reached the market in 1907.

45. A portrait of Bernard Shaw taken by Alvin Langdon Coburn with the Autochrome process is in the Permanent Collection of The Royal Photographic Society of Great Britain. This collection also contains two Shaw Autochromes, one a typical self-portrait, and the other, a close-up study of Beatrice Webb.

46. The Shaws moved into The New Rectory (built in 1902) at Ayot St. Lawrence in 1906. They renamed the house "Shaw's Corner." The old Gothic church, photographed by Shaw, was partly demolished by Sir Lyonel Lyde to improve the view from his house, but the Bishop of Lincoln stopped the church's total destruction. It remains a ruin. Shaw took many photographs of it over the years.

47. The reference to autumn foliage suggests that Shaw took the Autochrome picture in 1907, the first year that the process was available to the public. Scott's reference to the "glittering" nature of the image refers to the fact that the color image was made up of millions of tiny grains of primary dyes, producing a sparkling, pointillistic effect.

48. Porter, "Bernard Shaw as Photographer," 12.

49. It has also been suggested that the letters P.O.P. form the first syllable of the word "popularity," and that this is the derivation of the initials. P.O.P.s are often confused with so-called Gaslight Papers. The latter were more sensitive (so they could be exposed to a gas mantle) and required development.

50. J. Dudley Johnston, "In Praise of Frederick H. Evans, Hon. Fellow: A Symposium," *The Photographic Journal* (February 1945): 31.

51. G. Bernard Shaw, "Evans — An Appreciation," *Camera Work* 2 (October 1903): 15.

52. Ibid.

53. Shaw to Fredrick Evans, 19 February 1913, Collection of the Humanities Research Center, the University of Texas, Austin. The HRC possesses thirty-three pieces of Shaw correspondence to Evans (1895–1922).

54. "Topics of the Week," *The Amateur Photographer* (26 October 1909): 416.

55. Ibid., 416–417.

56. Porter, "Bernard Shaw As Photographer," 12.

57. An Invoice from W. H. Hoather reveals that he charged Shaw ten shillings for thirty platinotype prints, size 5 by 4 inches.

58. Bernard Shaw, *The Sanity of Art* (London: New Age Press, 1908), 7.

59. "Topics of the Week" (26 October 1909), 422. During this lecture Shaw advocated the formation of an historical exhibition of photography, from the daguerreotype to the photogravure. This was an idea ahead of its time.

60. "Shaw-Evans. An Evening of Wit and Music at the Camera Club," *The Amateur Photographer* (March 6, 1911): 220.

61. Ibid. It is worthy of note that Shaw's other photographer-friend, Alvin Langdon Coburn, was also an advocate of the pianola. He wrote: "I have a theory that there is a certain relationship between the Pianola and the camera, for in each case the mechanical rendering frees the artist from certain technical difficulties so that he is able to concentrate on interpretation." Helmut and Alison Gernsheim, eds., *Alvin Langdon Coburn: Photographer* (Faber and Faber: London, 1966), 104.

62. Pound later acknowledged authorship by including a modified version of this essay in his book of essays, *Pavannes and Divisions* (New York: Alfred A. Knopf, 1918).

63. "The Camera Club," *The British Journal of Photography* (16 February 1917): 87.

64. Ibid.

65. "An Exhibition of Photographs," *The Manchester Guardian* (6 December 1930): 15.

66. The bronze statue has since been moved to the grounds of the Musée Rodin, 77 Rue de Varenne, St. Germain, Paris.

67. G.B.S. had no objection to the photograph being published or sold "if they are willing to pay for it."

68. Both Gisele Freund and Karsh of Ottawa described their portrait sessions with G.B.S. in their autobiographies. See the bibliography.

69. Mabel Therésè Bonney was the author of *Europe's Children, 1939–1943* (New York: Plantin Press, 1943), which *Popular Photography* described as "one of the great photographic books of our time." It has since been forgotten.

70. Arthur Busch, "George Bernard Shaw — Photographer," *Popular Photography* XVI (February 1945): 20. Shaw's ineptness with technique was legendary and of long standing. In 1907 he wrote a letter to a teenager whom he had photographed, explaining that "all our best photographs — 12 of them — were blanks, as I forgot to draw the slide before we exposed them." In a letter to the American photographer Mathilde Weil, Shaw enclosed a self-portrait and wrote: "My photographs ought to be rather valuable, as they are extremely rare, owing to my genius for wrecking them in the course of development." This letter is in the collection of the Humanities Research Center and is dated 29 December 1901.

71. Ibid.

72. Ibid.

73. Ibid.

74. Allan Chappelow in *Shaw the Villager and Human Being* (London: Charles Skilton Ltd., 1961), 269–283. Chappelow took several portraits of Shaw, who took a particular pleasure in one of them. It showed Shaw on the porch of his home, leaning on his stick and looking pugnacious. Shaw exclaimed: "This is *alive* — this *ought* to be published. Call it — 'The Chucker-out!' " It became one of the most famous portraits of Shaw. A 16 by 20 inch enlargement was framed and hung on the wall directly opposite Shaw's bed. He told his friends: "That is my favorite photograph." The print still hangs in Shaw's Corner.

75. (Luton, England: Harold White, The Leagrave Press Ltd., 1950).

76. Shaw wrote on the proofs: "I must not be described as a photographer. An amateur photographer if you like . . . 18 January 1937."

77. Harold White, *Shaw the Villager*, 278.

78. Ibid., 278–279. Some of the deleted Terry verses are included in White's chapter.

79. Ibid.

BERNARD SHAW

WRITINGS
ABOUT
PHOTOGRAPHY

AN UNSOCIAL SOCIALIST,
AN EXCERPT, 1883

The following passage is an excerpt from An Unsocial Social-
ist, *Shaw's fifth and last completed novel, written in 1883. It
was first printed in serial form in the English periodical* To-
Day *throughout the year of 1884, and was finally published in
its entirety in 1887.*

*This excerpt marks Shaw's first pronouncements on photog-
raphy, preceding the period of his official criticism and his own
photographic activity by more than ten years. It reveals that he
was interested and informed about the medium long before he
actually became personally active.*

*The story centers around the socialist activities of Trefusis.
In the following excerpt, Trefusis is at a dinner party hosted by
a nobleman, and launches into a lecture on art and photography
in disdainful response to his host's display of etchings.*

*Later in the novel, Shaw makes another reference to photog-
raphy which we have not included, but which is illuminating.
Trefusis put together an album of photographs which show the
contrasting living and labor conditions of the upper and work-
ing classes; he uses these photographs to persuade men to join
the socialist cause. Shaw manifests an early awareness of the
potential of photography for social documentation.*

WHEN THE LADIES came downstairs they found their host and
Erskine in the picture gallery, famous in the neighborhood for the
sum it had cost Sir Charles. There was a new etching to be admired,

and they were called on to observe what the baronet called its tones, and what Agatha would have called its degrees of smudginess. Sir Charles's attention often wandered from this work of art. He looked at his watch twice, and said to his wife:

"I have ordered them to be punctual with the luncheon."

"Oh, yes; it's all right," said Lady Brandon, who had given orders that luncheon was not to be served until the arrival of another gentleman. "Show Agatha the picture of the man in the—"

"Mr. Trefusis," said a servant.

Mr. Trefusis, still in snuff color, entered; coat unbuttoned and attention unconstrained; exasperatingly unconscious of any occasion for ceremony.

"Here you are at last," said Lady Brandon. "You know everybody, don't you?"

"How do you do?" said Sir Charles, offering his hand as a severe expression of his duty to his wife's guest, who took it cordially, nodded to Erskine, looked without recognition at Gertrude, whose frosty stillness repudiated Lady Brandon's implication that the stranger was acquainted with her, and turned to Agatha, to whom he bowed. She made no sign; she was paralyzed. Lady Brandon reddened with anger. Sir Charles noted his guest's reception with secret satisfaction, but shared the embarrassment which oppressed all present except Trefusis, who seemed quite indifferent and assured, and unconsciously produced an impression that the others had not been equal to the occasion, as indeed they had not.

"We were looking at some etchings when you came in," said Sir Charles, hastening to break the silence. "Do you care for such things?" And he handed him a proof.

Trefusis looked at it as if he had never seen such a thing before and did not quite know what to make of it. "All these scratches seem to me to have no meaning," he said dubiously.

Sir Charles stole a contemptuous smile and significant glance at Erskine. He, seized already with an instinctive antipathy to Trefusis, said emphatically:

"There is not one of those scratches that has not a meaning."

"That one, for instance, like the limb of a daddy-long-legs. What does that mean?"

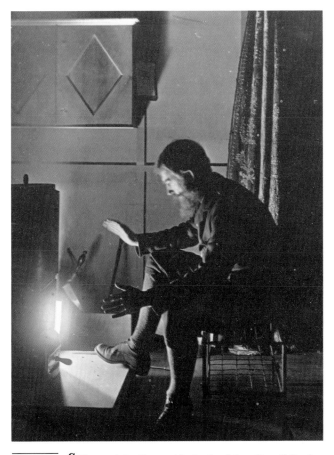

Self-portrait by Shaw, with simulated fire effect. Collection of London School of Economics.

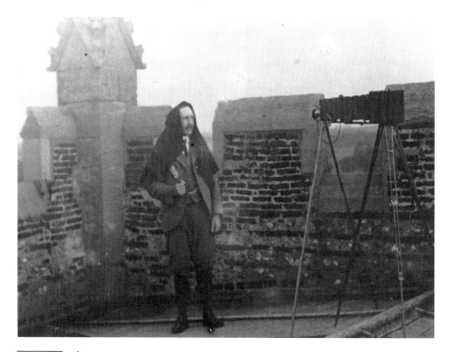

An unidentified photographer at Holkham, 1902. *Albumen print. Collection of London School of Economics.*

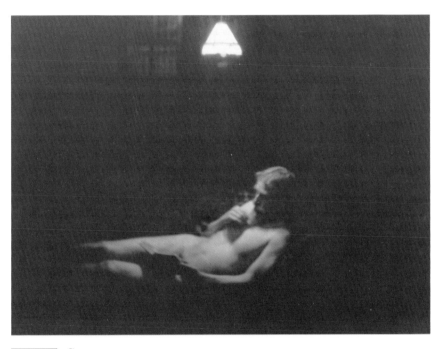

Self-portrait of Shaw in the nude, 24 January 1904. This was made two years prior to Alvin Langdon Coburn's photograph of the nude Shaw in the pose of Le Penseur. *Collection of London School of Economics.*

In Shaw's handwriting: "How is this for composition? Charming, and I'd have liked to go a step or two backward and got a trifle more of the right hand tree in; it seems cut off now." Platinum print. Collection of London School of Economics.

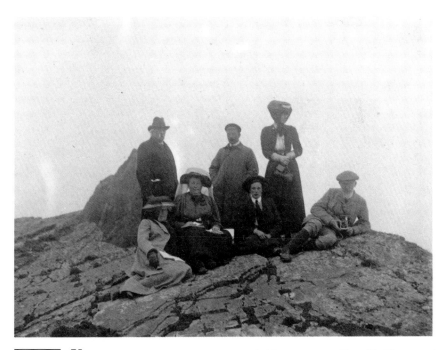

Unidentified group. Shaw is on the right, holding a camera. Silver chloride print. Collection of London School of Economics.

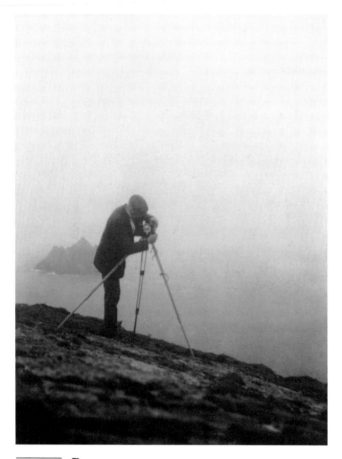

Photographer, taken by Shaw, probably during the shooting of the group on the preceding page. The Skelligs. 1913. *Platinum print. Collection of London School of Economics.*

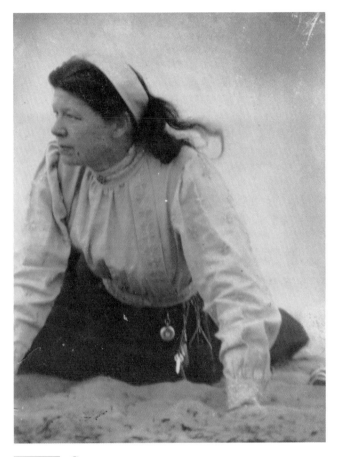

———— *Charlotte Shaw* on the sands at Holkham, by **GBS.**
P.O.P. Collection of London School of Economics.

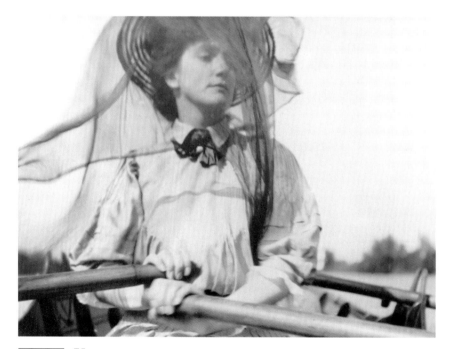

Unidentified. Platinum print. Collection of London School of Economics.

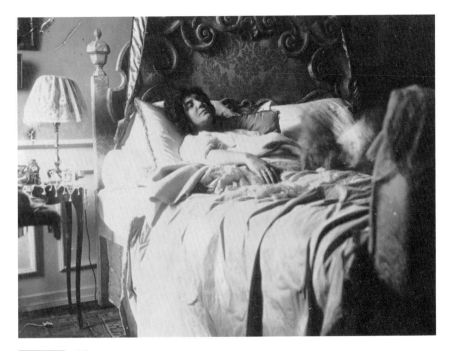

Mrs. Patrick Campbell. P.O.P. Collection of London School of Economics.

Unidentified. Platinum print. Collection of London School of Economics.

Rodin and CFS [Shaw's wife, Charlotte] at Meudon, *1906. Platinum print. Collection of London School of Economics.*

1909. Grey snowy day in Ayot St. Lawrence. The Ames girls photographing. *Platinum print. Collection of London School of Economics.*

Bridge over the Seine, Paris, 1906. Platinum print.
Collection of London School of Economics.

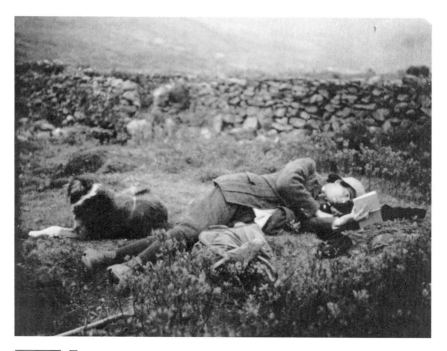

Frederick Keeling and Artro [Shaw's dog]. North Wales. During The Fabian Summer School. August–September 1907. *Platinum print. Collection of London School of Economics.*

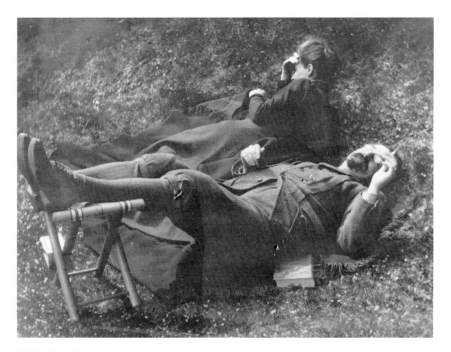

Sydney and Beatrice Webb. *Platinum print. Collection of London School of Economics.*

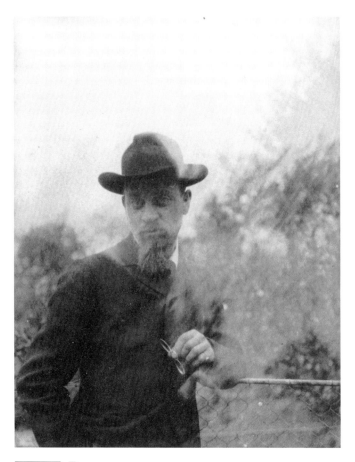

Rainer Maria Rilke, the Austrian poet. At Rodin's villa at Meudon. 1906. *Platinum print. Collection of London School of Economics.*

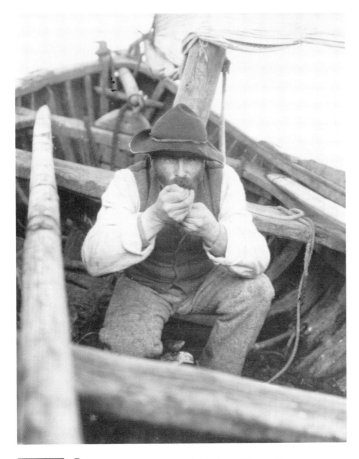

Irish fisherman, c. 1908. Collection of Harry Ransom Humanities Research Center, the University of Texas at Austin.

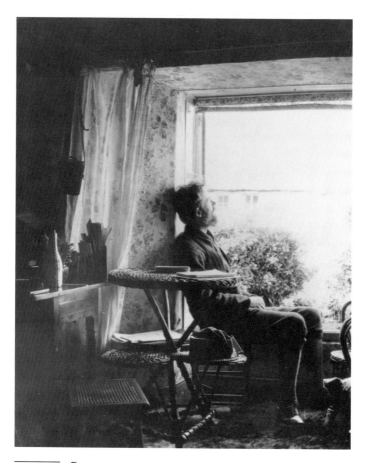

Self-portrait with Charlotte. Collection of London School of Economics.

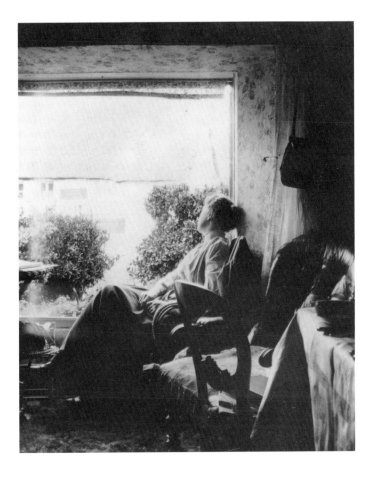

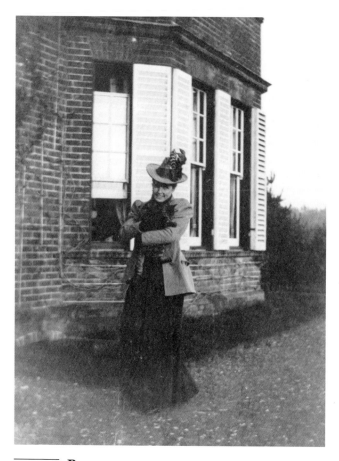

Beatrice Webb at Blencathra, now St. Edmund's Cot-Cottage, Hindhead, circa 1899. *Collection of London School of Economics.*

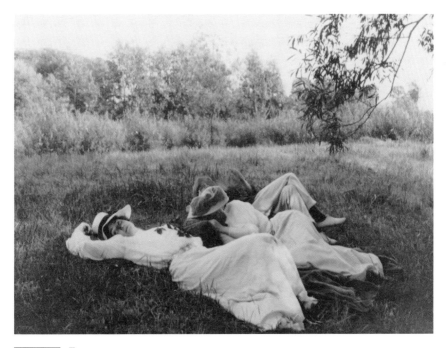

Lillah McCarthy, C. F. S. [Shaw's wife, Charlotte] and Granville Barker, Moulton on Thames. *Platinum print. Collection of London School of Economics.*

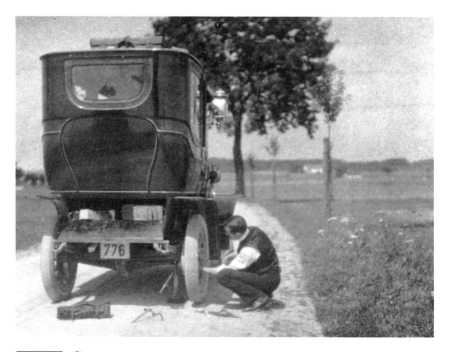

Car repair, 1909. Platinum print. Collection of London School of Economics.

*U*nidentified. *Platinum print. Collection of London School of Economics.*

Lusitania 1899. *P.O.P. Collection of London School of Economics.*

Self-portrait. Collection of London School of Economics.

Algeria 1909. The Ruisseau des Singes in the gorge of Rhda. Sissy and Charlotte watching the monkeys. *On the wallet containing this print, Shaw added: "The trees are full of monkeys; but you can't make them out." Platinum print. Collection of London School of Economics.*

Unidentified. Silver chloride print. Collection of London School of Economics.

Unidentified. P.O.P. Collection of London School of Economics.

Cliveden 1941. *Silver bromide print.*
Collection of London School of Economics.

From Irish country series. Collection of Harry Ransom Humanities Research Center, the University of Texas at Austin.

From Irish Country series. Collection of Harry Ransom Humanities Research Center, the University of Texas at Austin.

From Irish country series. Collection of Harry Ransom Humanities Research Center, the University of Texas at Austin.

Erskine hesitated a moment; recovered himself; and said: "Obviously enough — to me at least — it indicates the marking of the roadway."

"Not a bit of it," said Trefusis. "There never was such a mark as that on a road. It may be a very bad attempt at a briar, but briars don't straggle into the middle of roads frequented as that one seems to be — judging by those overdone ruts." He put the etching away, showing no disposition to look further into the portfolio, and remarked, "The only art that interests me is photography."

Erskine and Sir Charles again exchanged glances, and the former said:

"Photography is not an art in the sense in which I understand the term. It is a process."

"And a much less troublesome and more perfect process than that," said Trefusis, pointing to the etching. "The artists are sticking to the old barbarous, difficult, and imperfect processes of etching and portrait painting merely to keep up the value of their monopoly of the required skill. They have left the new, more complexly organized, and more perfect, yet simple and beautiful method of photography in the hands of tradesmen, sneering at it publicly and resorting to its aid surreptitiously. The result is that the tradesmen are becoming better artists than they, and naturally so; for where, as in photography, the drawing counts for nothing, the thought and judgment count for everything; whereas in the etching and daubing processes, where great manual skill is needed to produce anything that the eye can endure, the execution counts for more than the thought, and if a fellow only fit to carry bricks up a ladder or the like has ambition and perseverance enough to train his hand and push into the van, you cannot afford to put him back into his proper place, because thoroughly trained hands are so scarce. Consider the proof of this that you have in literature. Our books are manually the work of printers and papermakers; you may cut an author's hand off and he is as good an author as before. What is the result? There is more imagination in any number of a penny journal than in half-a-dozen of the Royal Academy rooms in the season. No author can live by his work and be as empty-headed as an average successful painter. Again, consider our implements of music — our pianofortes, for example. Nobody but an acrobat will voluntarily spend years at such a difficult mechanical puzzle as the keyboard, and so we have to take

our impressions of Beethoven's sonatas from acrobats who vie with each other in the rapidity of their *prestos,* or the staying power of their left wrists. Thoughtful men will not spend their lives acquiring sleight-of-hand. Invent a piano which will respond as delicately to the turning of a handle as our present ones do to the pressure of the fingers, and the acrobats will be driven back to their carpets and trapezes, because the sole faculty necessary to the executant musician will be the musical faculty, and no other will enable him to obtain a hearing."

The company were somewhat overcome by this unexpected lecture. Sir Charles, feeling that such views bore adversely on him, and were somehow iconoclastic and lowlived, was about to make a peevish retort, when Erskine forestalled him by asking Trefusis what idea he had formed of the future of the arts. He replied promptly:

"Photography perfected in its recently discovered power of reproducing color as well as form! Historical pictures replaced by photographs of *tableaux vivants* formed and arranged by trained actors and artists, and used chiefly for the instruction of children. Nine-tenths of painting as we understand it at present extinguished by the competition of these photographs, and the remaining tenth only holding its own against them by dint of extraordinary excellence! Our mistuned and unplayable organs and pianofortes replaced by harmonious instruments, as manageable as barrel organs! Works of fiction superseded by interesting company and conversation, and made obsolete by the human mind outgrowing the childishness that delights in the tales told by grown-up children such as novelists and their like! An end to the silly confusion, under the one name of Art, of the tomfoolery and make-believe of our playhours with the higher methods of teaching men to know themselves! Every artist an amateur, and a consequent return to the healthy old disposition to look on every man who makes art a means of money-getting as a vagabond not to be entertained as an equal by honest men!"

"In which case artists will starve, and there will be no more art."

"Sir," said Trefusis, excited by the word, "I, as a Socialist, can tell you that starvation is now impossible, except where, as in England, masterless men are forcibly prevented from producing the food they need. And you, as an artist, can tell me that at present great artists invariably do starve, except when they are kept alive by charity,

private fortune, or some drudgery which hinders them in the pursuit of their vocation."

"Oh!" said Erskine. "Then Socialists have some little sympathy with artists after all."

"I fear," said Trefusis, repressing himself and speaking quietly again, "that when a Socialist hears of a hundred pounds paid for a drawing which Andrea del Sarto was glad to sell for tenpence, his heart is not wrung with pity for the artist's imaginary loss as that of a modern capitalist is. Yet that is the only way nowadays of enlisting sympathy for the old masters. Frightful disability, to be out of the reach of the dearest market when you want to sell your drawings! But," he added, giving himself a shake, and turning round gaily, "I did not come here to talk shop. So—pending the deluge—let us enjoy ourselves after our manner."

"No," said Jane. "Please go on about Art. It's such a relief to hear anyone talking sensibly about it. I hate etching. It makes your eyes sore—at least the acid gets into Sir Charles's, and the difference between the first and second states is nothing but imagination, except that the last state is worse than the—here's luncheon!"

PHOTOGRAPHIC IMPOSTURES, WHAT THE WORLD SAYS, 1887

This unsigned criticism by Shaw was published under the head-ing "What the World Says" in the London newspaper The World *on 12 October 1887; it has never been reprinted.*

Shaw was employed on The World *staff as music and art critic in the late 1880s. This review, and one on the following year, are his only writings on photography at this time.*

In this first review devoted to photography, Shaw comments on the annual exhibition of the Photographic Society, which would become the Royal Photographic Society of Great Britain in 1894.

THE PHOTOGRAPHIC SOCIETY convivially opened their exhibi-tion, at the Old Water-Colour Society's rooms in Pall Mall, with a *soirée*. Now, it is hardly polite to object to the photographs of your host at a *soirée;* but some of the proceedings of the Society this year really cannot be suffered silently. The two cardinal defects of shop-window photography are vulgarity and imposture. Vulgarity is a primal curse; it is useless to protest against it; but imposture can be checkmated within the walls of an exhibition by determined and expert judges. What is to be said, then, to the deliberate award of a medal to the no less deliberate concoction of a landscape with sev-eral different planes of perspective in it, with the shadows falling in various directions, and with a couple of studio-lighted women twelve feet high or thereabouts in the foreground? It is just the picture to

catch the public, and just the trick for the Photographic Society to catch and defeat, if they had their duty at heart. As to the fashionable cooking and stippling of sitters' faces until the texture of the skin is like nothing but that of white kid gloves, the Society seems to regard it as a triumph of the art. Mr. F. E. Evans's "photomicrographs" are pretty but they should not have taken the medal on that ground from Mr. Andrew Pringle's more difficult and more valuable photographs of micro-organisms. There is not a single composite photograph in the exhibition. A medal has been given to Mr. John F. Robert's gaslight photographs of scenes from David Garrick, which were exhibited for months outside the Criterion Theatre, and are therefore within the recollection of all London as distinct — or rather indistinct — failures. At this rate of judging, a New Photographic Society will be needed unless the present one promptly mends its ways. There are some honest and beautiful photographs exhibited by Captain Abney and other first-rate workers; Mr. Payne's criminals are gruesomely interesting; and the orthochromatic photographs are remarkably successful, though they are not really orthochromatic. But none of these are in sufficient force to redeem the overcrowding of the walls with mere tradesman's work that make gratitude for the *soirée* impossible.

ABRACADABRA PHOTOGRAPHY, WHAT THE WORLD SAYS, 1888

―――

This review of the 1888 exhibition of the Photographic Society was Shaw's second and last column on photography while employed on the staff of The World. *Like the preceding year's review, it was unsigned and headed "What the World Says." It appeared in the 17 October 1888 issue of* The World *and has never been reprinted.*

THE PHOTOGRAPHIC EXHIBITION at the Old Water-Colour Society's room in Pall Mall is better than last year's, although there is still far too much of the sort of work that can be seen for nothing in the shop-window, not to mention one or two examples of "retouching" which can only be compared to the pipes and moustaches with which portraits of the sovereigns of England get decorated in school histories. Retouching claims to be an art within an art; and doubtless it is so in much the same way that conjuring as applied to table-turning is an art within an art. All the more reason for it to be artistically done. It ought, however, to be excluded from a photographic exhibition, on the simple grounds that it is not photography.

LETTERS TO THE EDITOR: MR. G. BERNARD SHAW ON THE ART CLAIMS OF PHOTOGRAPHY, 1900

This letter from Shaw to the editor of The Amateur Photographer *was published on 7 September 1900, and marks his first appearance as a writer in that publication. The letter was written in response to remarks made about Shaw in the previous week's column by "Lux," the pseudonym of a regular columnist.*

In the 31 August 1900 issue, Lux had referred to Shaw's having recently taken up the hobby of photography, and he expressed hope that through personal interest, Shaw would change his attitude about the artistic nature of photography which Lux assumed was negative: "Unless I am mistaken Mr. G. Bernard Shaw has ere now shown severity in his remarks on the artistic aspirations of photography, and now as soon as he has mastered the elements and discovered that metol or pyro will develop a plate, and coffee or ginger-beer will not, he may find himself drifting into higher levels, and learn for the first time that the pictorial aims of at least some photographers are better founded than they seemed."

Shaw indignantly responds to these remarks in the following letter:

IN SOME PERSONAL paragraphs on page 162 of our issue of last week "Lux" made reference to Mr. G. Bernard Shaw as having

recently taken to the practice of photography with all the enthusiasm of a novitiate. From this well-known and able writer we have received the following letter: —

Sir, — Your contributor, "Lux," is either the most ungrateful of photographers, or else he might more fitly sign himself "Tenebras." He calls me "a well-known art critic who has hitherto notably distinguished himself by his aversion to photography." Now, will it be believed that I have been from the first alone among art critics in asserting the claim of photography to be as much a fine art as painting or sculpture, and in treating photographic exhibitions as respectfully as the shows at the Royal Academy? I have still in my possession a letter from my late Fabian colleague, W. K. Burton, written to me in 1886, when, on receiving my first ticket for the press view at an exhibition of photographs, I consulted him with reference to the statement, then commonly made by critics, that the camera could not draw correctly. Fortified with Burton's demonstration that the camera, with the right lens and at the right distance, could draw with absolute correctness, and set on my guard by his observation that people always preferred a falsified picture as more "artistic," I went to the gallery, and soon found that a little criticism was badly wanted. I found that the photographers were up to all the tricks of the artists. Just as Bouguereau would paint a girl's head in his studio in an indoor north light, and then coolly paint in a background of sunny cornfield, so the photographer would pose three women in a room and print in behind them a sky and landscape with reference to which they were about thirty feet high, not even taking the trouble always to make the shadows of the different negatives used fall in the same direction. For that the judges would give him a medal. And when an exhibitor had, with great ease to himself, taken a photograph, and then with infinite labour retouched it and faked it until it was like nothing in the world but a stipple drawing on a piece of visiting card, with no quality in the execution, he was sure of a prize. Whereas genuine photographic execution went for nothing. It is my solemn belief that "Lux" must have been one of these medallists whom I denounced, and that he still confuses an aversion to his own crimes with an aversion to photography.

Before these criticisms were written, I had publicly defended the artistic claims of photography in discussions with authorities no less conspicuous than William Morris and Mr. Walter Crane; and an

old novel of mine,* out of print here, but still raging in America, introduces the subject in the same friendly vein. My last public utterance on photography was a speech in support of Mr. Horsley Hinton's claim for the recognition of photography as a fine art. He based his claim, by the way, on the fact that the photographer can re-arrange nature to an extent that would have scandalized Turner himself.

I observe that "Lux" hazards the statement that silver salts, acted on by light, cannot be reduced by coffee or ginger beer. Has he ever tried? If he has not — and I don't for a moment believe that he has — his sense of scientific responsibility is as perverted as his moral sense, which has permitted him to wantonly misrepresent a man who never injured him. — Yours faithfully,

G. Bernard Shaw.

*An Unsocial Socialist.

THE EXHIBITIONS, 1901

"The Exhibitions," Part I and II, represent Shaw's first official criticism. Written in two installments for the 11 and 18 October 1901 issues of The Amateur Photographer, *the articles review the 1901 annual exhibitions of the Linked Ring and the London Photographic Society.*

Shaw states his purpose in the reviews: "Let me here disclaim any intention of writing a complete account of the exhibitions. There is plenty of admirable work in them which I should point out with pleasure if that were my present business; as it is, I have mentioned, and shall mention, those works only which seem to me to best illustrate certain typical faults or qualities of the movement."

In these articles, Shaw sets the tone and the basic underlying themes for his later writings. With the formulation of his argument for photography as art and its superiority over the other arts, Shaw establishes his notoriety as a photography critic.

This review was reprinted as "George Bernard Shaw on the London Exhibitions" in Camera Work, *no. 14, April 1906. Excerpts were also included in "Aphorisms on Photography," a preface to a 1907 photography exhibition catalogue of the New English Art Club, and more recently under the title "On the London Exhibitions" in* Photography in Print — Writings from 1816 to the Present, *edited by Vicki Goldberg.*

Shaw was notoriously eccentric in his spelling and grammar; editors often "corrected" his manuscripts, which has led to various discrepancies in subsequent publications. As far as possible, the following essays have followed Shaw's originals.

I.

The fable of Pilpay, in which the three rogues persuaded the Brahman that an unclean beast was a lamb fit for sacrifice, has been used by Macaulay to illustrate the methods and efficacy of modern puffery and log-rolling. But if Pilpay had been a photographer he would have turned his fable inside out, and described three Brahmans persuading some poor rogue, who had brought a lamb to the altar, that it was only a mangy goat.

I know nothing funnier in criticism than the assurance of the painter and his press parasite, the art critic, that all high art is brush work; except, perhaps, the humility of the photographer, who is not yet allowed a parasite of his own, and must timidly beg for a contemptuous bite or two from that of the brusher. For surely nobody can take three steps into a modern photographic exhibition without asking himself, amazedly, how he could ever allow himself to be duped into admiring, and even cultivating an insane connoisseurship in, the old barbarous smudging and soaking, the knifing and graving, rocking and scratching, faking and forging, all on a basis of false and coarse drawing, the artist either outfacing his difficulties by making a merit of them, or else falling back on convention and symbolism to express himself when his lame powers of representation break down. In this year's exhibitions I find two portraits of myself—one in the Salon by Frederick Evans, the other in the New Gallery by Furley Lewis. Compare them with the best work with pencil, crayon, brush, or silver point you can find—with Holbein's finest Tudor drawings, with Rembrandt's Saskia, with Velasquez's Admiral, with anything you like. If you cannot see at a glance that the old game is up, that the camera has hopelessly beaten the pencil and paintbrush as an instrument of artistic representation, then you will never make a true critic; you are only, like most critics, a picture fancier. And please observe that these two portraits of me, far from being mechanically alike, are less so than any two drawings of me that have ever been made. The style of Mr. Evans contrasts as strongly with the style of Mr. Furley Lewis as the style of Velasquez with the style of Holbein. The portraits, too, though both like me, are not like one another. When I compare their subtle diversity with the monotonous inaccuracy and infirmity of drawings, I marvel at the gross absence of analytic power and of imagination which still

sets up the works of the great painters, defects and all, as the standard, instead of picking out the qualities they achieved and the possibilities they revealed, in spite of the barbarous crudity of their methods. But that is what always happens; for to those whose fancy for pictures is "an acquired taste," the faults of the brush are as dear as its qualities. It was once considered that the tone given to an Italian picture (late sixteenth century preferred) by a filthy coat of tallow-soot, acquired by a century of exposure to the smoke of a host of altar candles, was a chief element in its value; and "old masters," which had accidentally remained clean, were actually washed with porter to bring them down to the picture fanciers' standard. May I venture to add that I am not quite sure that I have not seen a few photographs this year that have been deliberately faked to make them resemble pictures?

It is now more than twenty years since I first said in print that nine-tenths (or ninety-nine-hundredths, I forget which) of what was then done by brush and pencil would presently be done, and far better done, by the camera.* But it needed some imagination, as well as some hardihood, to say this at that time, not because the photographic exhibitions were less convincing then, in spite of their delight in representing nature as eternally reflected in silver dish-covers, but because the photographers of that day were not artists (except when they photographed by stealth and exhibited the results in Bond Street and Burlington House as drawing), but craftsmen, more interested in their process than in its results, and often having no artistic purpose whatever: that is, no feeling to convey. Still, they photographed just as well, and plenty of them a good deal better than some of the modern artist-photographers; and they never played the old painters' game of making a merit of their failures — for instance, calling under-exposure Impressionism and fog Tone. If they are out of fashion now, let us not forget that when Tintoretto, the artist-painter, was in fashion, Orcagna, the craftsman-painter, was out of fashion, and that National Galleries are nevertheless just as keen on Orcagnas as on Tintorettos. Let us admit handsomely that some of the older men had the root of the matter in them as much as the younger men of to-day; but the process did not then attract artists. It may be asked why, if photography be so exquisite an artistic pro-

*An Unsocial Socialist, p. 230

cess, it did not attract them. Well, there were many reasons. The first and principal one is never mentioned. It was, that artists were terrified by the difficulty and mystery of the process, which, as compared with the common run of their daubing, in which any fool can acquire a certain proficiency, certainly did require some intelligence, some practical science, and some dexterity. However, many artists were quite handy and clever enough for it; and a good many of them, as I have hinted, used it secretly, with lucrative results. But on the whole, the process was not quite ready for the ordinary artist, because (1) it could not touch colour or even give colours their proper light values; (2) the Impressionist movement had not then rediscovered and popularised the great range of art that lies outside colour; (3) the eyes of artists had been so long educated to accept the most grossly fictitious conventions as truths of representation that many of the truths of the focussing screen were at first repudiated as grotesque falsehoods; (4) the wide-angled lens did in effect lie almost as outrageously as a Royal Academician, whilst the anastigmat was revoltingly prosaic, and the silver print, though so exquisite that the best will, if they last, be one day prized by collectors, was cloying, and only suitable to a narrow range of subjects; (5) above all, the vestries would cheerfully pay £50 for a villainous oil-painting of a hospitable chairman, whilst they considered a guinea a first-rate price for a dozen cabinets, and two pound ten a noble bid for an enlargement, even when the said enlargement had been manipulated so as to be as nearly as possible as bad as the £50 painting. But all that is changed nowadays. Mr. Whistler, in the teeth of a storm of ignorant and silly ridicule, has forced us to acquire a sense of tone, and has produced portraits of almost photographic excellence; the camera has taught us what we really saw as against what the draughtsman used to shew us; and the telephoto lens and its adaptations, with the isochromatic plate and screen, and the variety and manageableness of modern printing processes, have converted the intelligent artists, smashed the picture- fancying critics, and produced exhibitions such as those now open at the Dudley and New Galleries, which may be visited with pleasure by people who, like myself, have long since given up as unendurable the follies and falsehoods, the tricks, fakes, happy accidents, and desolating conventions of the picture galleries. The artists have still left to them invention, didactics, and (for a little while longer) colour. But selection and representation, covering

ninety-nine-hundredths of our annual output of art, belong henceforth to photography. Some day the camera will do the work of Velasquez and Peter de Hooghe, colour and all; and then the draughtsmen and painters will be left to cultivate the pious edifications of Raphael, Kaulbach, Delaroche, and the designers of the S.P.C.K. And even then they will photograph their models instead of drawing them.

So much for the general situation and its prospects. As to the exhibitions, which are the immediate pretexts of this article, the Salon impresses me, as it has done before, with a sense of the extent to which the most sensitive photographers have allowed themselves to be bulldosed into treating painting, not as an obsolete makeshift which they have surpassed and superseded, but as a glorious ideal to which they have to live up. I remember once accidentally spilling some boiling water over a photograph of myself, which immediately converted it into so capital an imitation of the damaged parts of Mantegna's frescoes in Mantua that the print delighted me more in its ruin than it had in its original sanity. On another occasion I photographed an elderly labourer with a scythe, and incautiously left the negative near a hot air flue, with the result that the film crinkled and produced a powerful and extraordinary caricature of Death, which had all the imaginative force of a lithograph by Delacroix, and very nearly all the unattainable infamy of his drawing. I have also a remarkable turn for forgetting something in taking a photograph: for instance, by inadvertently focussing with one lens and exposing the plate with another, I have produced fantastic images which would have qualified me for the extreme left of the New English Art Club in its early days. Now so thoroughly has my own experience as a critic and picture fancier sophisticated me, that these accidental imitations of the products of the old butterfingered methods of picture-making often fascinate me so that I have to put forth all my strength of mind to resist the temptation to become a systematic forger of damaged frescoes and Gothic caricatures. That this temptation is not always vanquished is proved by several works in both the exhibitions. Deliberate imitations of the priming of canvas and of the strokes of the crayon are to be found there; and one gentleman, exasperated at the revolting over-sharpness of the real Lucerne, has put it out of focus to an extent that would do injustice to Lincoln's Inn Fields on a November afternoon. Another gentleman, by impart-

ing a high-art mildew to some otherwise presentable photographs, and clapping them into frames of a colour that suggests nothing but the feebly baleful green of a sick slow-worm, has made the judges so afraid of being called Philistines if they confess their natural dislike of the effect, that they have awarded him a medal. But the giving of medals is at best an undignified and incurably invidious practice, involving a "judgment" which no really capable critic could honestly pretend to deliver. The Royal Photographic Society ought to dis-criminate between a lens (which may legitimately be Kew-certificated or medalled for passing a certain measurable test) and an artist, to whose nature and function anything like competition is abhorrent as a matter of feeling and irrelevant as a matter of fact.

On the whole, I greatly prefer the photographers who value themselves on being photographers, and aim at a characteristically photographic technique instead of a sham brush-and-pencil one. Look at the enormous humour and vividness of Mr. Craig Annan's George Frampton (only to be appreciated fully by those who know G. F.), and the fine sympathy of Mr. Holland Day's "Maeterlinck"! Would either of them have been possible if the artists had studied, not their sitters, but the possibilities of making the negative come up like a portrait by Mr. Sargent? It would be easy, I should think, for Mr. Furley Lewis to take his negative of Mr. Malcolm Lawson, and, by making a cleverly doctored enlargement, produce the effect of a portrait by Franz Hals, just as other exhibitors have aimed at some-thing as unlike a photograph, and as like a smart impressionist pic-ture, as possible; but Mr. Lewis has not thought of trying any such trick, knowing, I take it, that this sort of dissembling is not the strength of the forward movement, but its besetting weakness.

Mr. Steichen and Mr. Emmerich are justly distinguished by their work; but they dissemble sometimes: for instance, Mr. Emmerich's "Mill on the Elbe" is meant to look, not like a mill on the Elbe, but like a certain sort of picture of a mill on the Elbe. And then comes Mr. Frederick Graves, and says, "Steichen and Emmerich show me the way to fame; I will also dissimulate," his Birches being the result. And I certainly should not like a gallery full of such birches, though I could hardly have too much of such tones as Mr. Emmerich has produced in his quite undissembled photograph of a Church Interior. All the good church interiors, by the way, show the influence of Mr. Evans, who was, as far as I know, alone in that

field some years ago; and Mr. Evans made himself the most artistic of photographers by being the most simply photographic of artists. Yet I have a crow to pluck with Mr. Evans, too, for what I take to be a stroke of technical satire at the New Gallery. In photographing Mr. Dallmeyer with the Dallmeyer-Bergheim lens, he has, by the slimmest of hairs' breadths, overdone the soft definition which is the quality of that lens, and thus burlesqued the sort of portrait repre- sented most favourably by Mr. Auld's medalled "Study of a Head," in which the softness is carried to the point of suggesting incipient decomposition. Mr. Evans has used the lens with consummate judg- ment in his other portraits; and it seems hard that because Mr. Dallmeyer's invention has been abused to decompose other people, Mr. Evans should revenge them by disintegrating Mr. Dallmeyer himself with it. But the sarcasm need not be lost because it has fallen on the innocent; for it certainly strikes at a growing folly. When it was discovered by photographers that their cherished sharp focussing was detestable to artists, a convention arose that sharp focussing was wrong and soft focussing right. Hence we are getting focussing that is as much too soft as the old focussing was too sharp; and the "judges" are hastening to medal it, to show how advanced they are. Side by side with the satirist I detect also the propagan- dist. Just as, fifteen years ago, Mr. Whistler, in order to force the public to look at and for certain qualities in his work, would draw a pretty girl and then obliterate her face by slashing his pencil back- wards and forwards across it, in order to checkmate the "Who is she?" and "Ain't she pretty!" people, so does Mr. Horsley Hinton somewhat sacrifice one of his contributions to the Salon to teaching how the photographer can select a certain plane in his landscape for emphasis, and thus get effects of composition and perspective which are spoiled by the old plan of producing "depth of focus" by the use of a small stop, and flattening all the world into one well-defined plane. But there is reason in everything; and in this cunning but too instructive picture the transition from clear definition to downright blur is too sudden for my eye (which has perhaps too small a stop), and is underlined, besides, by the skill with which the artist plants his thistles and bushes, so as to catch fascinating flecks of light. On the whole, work like Miss Mathilde Weil's, in which difficult focus- sing problems are not purposely set up for solution, and what focussing there is is quite simply done, with a view to the picture

looking right, pleases my simple taste best. But do not conclude that I cannot appreciate the Barbizonian charm of Mr. Cochrane's lanes and draught horses, or that I would have their atmosphere marred by sharper focussing. His medal is one of the happy accidents of the "judging."

I hope to say something next week about the instances in which the very photographers who have copied from the painters the things they ought not to have copied have also left uncopied the things they ought to have copied, notably in matters of mounting, framing, and dimension. The remarkable display of colour photography needs a word likewise. Meanwhile, let me here disclaim any intention of writing a complete account of the exhibitions. There is plenty of admirable work in them which I should point out with pleasure if that were my present business; as it is, I have mentioned, and shall mention, those works only which seem to me to best illustrate certain typical faults or qualities of the movement.

II.

There is a good deal of blundering at the New Gallery by artists who have learnt that the old-fashioned white mount and gilt frame is tabooed nowadays by those who are "in the movement." The insufficiency of this merely negative knowledge is shown by several attempts to get into the movement by ignorantly following the latest fashion, with results quite as bad as the worst American attempts to imitate the masterpieces of the Kelmscott Press. One gentleman, vaguely associating high art with damaged panels of oak chests from Surrey cottages, gets an unsightly piece of brown timber, cuts it to the shape, and nearly to the size, of a fanlight, and sticks his photograph, cut to the shape of a protractor, in the middle of the fanlight. And he invites the connoisseur to buy this lumpish thing and stick it up in his wife's drawingroom. She will let him, perhaps, when he has burnt the frame and replaced it with one of reasonable size and handsome appearance, like that of Mr. Fitzgibbon-Forde's "Puritan Maiden." Then there is Mr. Crooke, who last year exhibited some portraits which owed their special charm to the intelligence with which he had learnt from the eighteenth century mezzotinters how to put his block of black tones on paper, how to proportion its sides, how to letter it, and how to frame it. But this year, instead of letting

well alone, he exhibits a portrait as to which, in spite of the sitter's good looks, the critic can say nothing except simply that it is too big. Strange, that a photographer whose work in the merely "professional" section last year positively tempted collectors, should, in the "pictorial" section this year, exhibit a warning to others not to neglect his own former example! Mr. Warneuke has made the same mistake: his "Ready for Market" is an overgrown thing.

In the works which are presented as prints, and not as family pictures, the confusion about margins is so obvious that I may as well lay down a little law about it. The aspirants to a place "in the movement" are right in supposing that the ordinary commercial slip-in mount, with the photograph in the mathematical centre of it, is a fashion of Gath. Fortunately, there is first-rate authority to correct it, and to give novices a safe starting-point for experiments of their own. The medieval scribe, who for centuries had nothing to do but to find out how to make a margined page look handsome, found out all that was to be found out about it; and modern pages have become ugly in proportion to the straying of the modern printer from the medieval practice. Any photographer who can get hold of a good medieval MS., or a Kelmscott Press book, can get his mount right by simply putting the photograph on it, where the medieval monk, or, following him, William Morris, put the block of letterpress on the page, always bearing in mind that the right-hand page of the opened book is the one to be copied, as the photograph is held by the right hand, and the margin should leave room for the thumb. M. Pierre Dubreuil, missing this point, has, by the mounting of his "Profil Perdu," irresistibly suggested that he is a left-handed man. Mr. Page Croft knows better: his "Meditation" is as obviously in its right place on the mount as M. Dubreuil's is out of it. Mr. French's mounting of his study is elaborately ingenious, and, centred as it is, would make a capital design for a letter-box in a hall-door. If he would shift his strip of platinum and its border well to the left of the mount and nearer the top, the letter-box suggestion would vanish, and the picture be *tout ce qu'il y a de plus dans le mouvement.* * The old white mount, representing simply the symbolic starched collar and cuff of the respectable man, hopeless from the artistic point of view, has very nearly vanished; but in the South Room at the New Gal-

*French phrase translated as "all that there is and more in the movement."

lery I noticed some stupendous examples exhibited by Messrs. Speaight, whose portrait of the Misses Gardner nevertheless seems to prove that they know how to frame a photograph without spoiling it, when their sitters will let them. M. Jean Lacroix has had the unhappy idea of trying to make his photographs resemble small etchings on monstrous pieces of "outside" paper. Why on earth should photography, the most beautiful of all the artistic processes, ape etching, which is quite the vilest? I could forgive M. Lacroix for imitating lithography or mezzotint, just as I forgive our American pioneers for photographing with a French accent, so to speak. I could even forgive him for etching, if he did it as well as Rembrandt or Whistler; but to *imitate* etching!!! All the same, his portrait of Desboutin is one of the good things in the exhibition.

If a calculation were made of the subjects represented by the total superficial area of silver, platinum, gum, and tissue in the galleries, the result would probably be ten per cent. of humanity, thirty per cent. of background, and sixty per cent. of clothes. In the New Gallery there is, amid acres of millinery and tailoring, just one small study of a whole woman, by Professor Ludwig von Jan, of a rich tawny-downy quality which would be called superb, masterly, and so forth, had it been drawn by Henner. I invite our friends the picture-fanciers to look at it a moment, and then think of the works of, say, Etty; or, if that is too dreadful, Ingres. Or say Correggio, and, at the opposite extreme of taste, the President of the Royal Academy.* True, the camera will not build up the human figure into a monumental fiction as Michael Angelo did, or coil it cunningly into a decorative one, as Burne-Jones did. But it will draw it as it is, in the clearest purity or the softest mystery, as no draughtsman can or ever could. And by the seriousness of its veracity it will make the slightest lubricity intolerable. "Nudes from the Paris Salon" pass the moral octroi because they justify their rank as "high art" by the acute boredom into which they plunge the spectator. Their cheap and vulgar appeal is nullified by the vapid unreality of their representation. Photography is so truthful — its subjects are so obviously realities, and not idle fancies — that dignity is imposed on it as effectually as it is on a church congregation. Unfortunately, so is that

*At the time of this article, the President was Sir Edward John Poynter (1896–1918). However, Shaw used the title to refer to the epitomy of academicism.

false decency, rightly detested by artists, which teaches people to be ashamed of their bodies; and I am sorry to see that the photographic life school still shirks the faces of its sitters, and thus gives them a disagreeable air of doing something they are ashamed of.

Photography in colours is either advancing with extraordinary strides or becoming very skilful in avoiding the subjects which baffle it. I remember seeing last year a colour photograph of a cauliflower, which will haunt me to my grave, so very nearly right, and, consequently, so very exquisitely wrong was it. I was accustomed to cheerfully and flagrantly impossible groups of a strawberry, a bunch of grapes, a champagne bottle, and a butterfly, remote alike from nature and from art. But this confounded cauliflower was like Don Quixote's wits: it was just the millionth of a millimetre off the mark, and hence acquired a subtle impressiveness, the effect in the cauliflower's case being disquietingly baleful, as if the all-but-healthy green of the vegetable had been touched by the poison of the Borgias. I find no such horror in the fascinating peep-show arranged by Messrs. Lumiere this year. It is true that they shun the cauliflower, and revel only in garden blooms, crockery, richly-coloured stuffs, French yellowblacks, and elaborately-tooled bookbindings. But the illusion is perfect: if the process is generally practicable, the "still life" painter may pawn his poor box of squirts of gaudy clay and linseed, and apply for a place as bill-poster. In colour printing much ingenuity has been spent in forging old engravings of various kinds. Some of the attempts are quite successful; but why not forge banknotes instead? I no more doubt the capacity of photography for imitating the lower methods than I doubt Vasari's story of Michael Angelo successfully imitating the caricatures scrawled on the walls by the Roman rabble. What really did interest and stagger me were Mr. Roxby's three-colour photographs from nature by Dr. Gustav Selle's process. If that blue jar is not an accidental success out of a mass of failures — if Mr. Roxby can do it as often and as surely as Messrs. Window and Grove can photograph Miss Ellen Terry, then the advance represented by these prints is a very notable one indeed; for they are complete as pictures; it is no longer a question of getting a blue photograph of a blue jar: Mr. Roxby has got a complete picture of the jar, and a picture of fine quality at that. What other successes the exhibition may contain I cannot say, as I arrived at the New Gallery before many of the items in the catalogue, and soon got

tempted away from the colour work by Dr. Vaughan Cornish's wave studies, and other scientific matters.

On the whole, the contrast of this R.P.S. exhibition with the last one shows that the American exhibitions at Russell Square* have precipitated matters a good deal, and that the bold energy of the German photographers, all the more effective in modifying our tastes because it overdoes everything, will not let us relapse easily. Last year the big "professional" gallery was as full of dish-cover silver prints as ever; this year a nice, shining, aluminium-complexioned officer, with his hair newly cut and brushed for the occasion, would attract a crowd as a curiosity. This sudden and thorough intimidation of the burnishers can hardly be taken as a change of artistic conviction; for the silver print has its charm and its use as much as gum and platinum. But it is, perhaps, as well that a Reign of Terror has been set up with regard to it, as it will not now be used by exhibitors, except for good reasons.

The conquest by photography of the whole field of monochromatic representative art may be regarded as completed by the work of this year. The conquest of colour no longer seems far off or improbable; and the day may come when work like that of Hals and Velasquez may be done by men who have never painted anything except their own nails with pyro. The worst painters — those whose colours never were on sea or land — are the safest from supersession. As to the creative, dramatic, story-telling painters — Carpaccio, and Mantegna, and the miraculous Hogarth, for example — it is clear that photography can do their work only through a co-operation of sitter and camerist which would assimilate the relations of artist and model to those at present existing between playwright and actor. Indeed, just as the playwright is sometimes only a very humble employee of the actor or actress manager, it is conceivable that in dramatic and didactic photography the predominant partner will not be necessarily either the photographer or the model, but simply whichever of the twain contributes the rarest art to the co-operation.

*An exhibition of the New School of American Pictorial Photography was held at the center of the RPS in Russell Square in October and November of 1900. Organized by F. Holland Day, the show included work by Day, Edward Steichen, Alvin Langdon Coburn, and Gertrude Käsebier. The diversity of the Americans' work influenced the British photographers, who until then had dealt mostly with portraits or landscapes.

Already that instinctive animal, the public, goes into a shop and says, "Have you any photographs of Mrs. Patrick Campbell?" and not "Have you any photographs by Elliott and Fry, Downey, etc., etc.?" The Salon is altering this, and photographs are becoming known as Demachys, Holland Days, Horsley Hintons, and so forth, as who should say Greuzes, Hoppners, and Linnells. But then the Salon has not yet touched the art of Hogarth. When it does, "The Rake's Progress" will evidently depend as much on the genius of the rake as of the moralist who squeezes the bulb, and then we shall see what we shall see.

In conclusion, let me recommend these hasty notes of mine to an intelligently liberal construction by photographers. As to the painters and their fanciers, I snort defiance at them; their day of daubs is over.

George Bernard Shaw on the Use of Orthochromatic Films and Screens, 1902

This letter from Shaw to The Amateur Photographer, *printed on 14 August 1902, begins in the style of an advertisement, and was intended for publication. It is singular in that in it Shaw addresses a specific technical inadequacy of photography, revealing his concerns as a practical photographer.*

Wanted: Colour-Sensitive Roller Films

SIR, – COMPETITION IN rollable films seems to be acute just now; and, so far, an English firm* has got to the front. For a guinea I can get nine quarter-plate twelve-exposure daylight cartridges, light in the tourist's pocket, unexplosive and uninflammable in his trunk, odourless, rolled on reels of hard wood that do not crumble when the winder drives them, and marked for speed at 300 Watkins. For the same sum the Kodak company gives me only seven cartridges, comparatively heavy to carry, mounted on a sort of gun cotton, assaulting the nose with a scent of ether and camphor which some people like, and others (including my wife, unfortunately) detest, and estimated for speed by Watkins at 130 to 180. It is true that the development of the Kodak film is simpler, but it does not cost more when

*Ilford Limited

the job is handed over to the manufacturers, and as people who are willing to pay three shillings a dozen for quarter-plate films in cartridges when they can get a dozen glass plates for a shilling are just the people who send their films in a heap after the summer holiday to be developed at three shillings a roll, all developing processes are the same to them provided the price is the same. As matters stand, then, the American firm, and the French and English competitors who merely copy the American firm, are beaten on every point that affects the "I press the button, and you do the rest" customer; that is, in price, weight, safety, and nasal neutrality.

Yet I would desert the English firm at once if any of its competitors would put a colour-sensitive roller film on the market. Like most people who have any feeling for landscape, I do not waste films on the noonday sun. It is when the shadows are long and the light begins to colour a little that my shutter begins to click. Even the most prosaic bank holiday Philistine gets tempted by the sunset that looks so pretty in his viewfinder. He snaps at it with a lens working at F/11 at best, and forms high hopes of the result, especially when his daughter poses in the foreground in a blue dress with her fair face shining in the declining rays. Result: a faint suggestion of a negress in a white frock sitting in a coal cellar. As to golden cornfields and contrasts of dark foliage and bright sward, they are unattainable at any hour. Naturally, the holiday snapshotters complain that their camera is no good, or the film insensitive, or else conclude that there is some mystery in photography which makes it useless for them to persevere with it. Any maker would supply them with a colour-sensitive film would at once improve their successes and decrease their percentage of failures. They would not know why, just as many people tell you that the Ilford chromatic plate is "better" than the Ilford ordinary do not know why; but they would buy the film that made the most of their exposures. In the evening, especially, when Nature not only offers the most tempting pictures, but provides her own orange screen to cut off the blue rays, a colour-sensitive film would score heavily.

A great deal of the disrepute of photography is due to the failures of colour-blind films used in cheap hand cameras with slow lenses. I well remember the disgust with which, during my tours in Italy, I used to reject photographs of paintings in the days before the orthomatic plate and screen came into use. Imagine the orange glow

of Carpaccio's colour turned into soot by an "ordinary" plate! Well, exactly the same disgust is felt to- day by the people who find Nature outraged in the same way.

Old photographers, who have used the same ordinary plate and developed it with the same pyro-ammonia finger-stainer ever since dry plates were invented, and who regard the boy who can develop a Brownie film with secret awe, tell the disappointed Kodaker that he will soon learn what light will photograph and what won't. But in photography as in everything else, progress is only possible by developing the means, not by contracting the end. It seems to me that a plate maker has no more right to sell me an "ordinary" plate nowadays than an optician has to sell me an uncorrected lens. If you buy a set of periscopic glasses, or a Dallmeyer-Bergheim lens, you are warned, as a matter of course, that they are not achromatic; but if you buy plates, it is assumed that you want them with obsolete imperfections.

Still, you can obtain colour-sensitive plates easily enough now, if you know about them. But there is not, as far as I know, a single colour-sensitive rollable film in the market, although the prices charged for rollable film are monstrous compared to the prices of the "orthochromatic" films on glass. — Yours, etc.,

G. BERNARD SHAW.

THE UNMECHANICALNESS OF PHOTOGRAPHY AN INTRODUCTION TO THE LONDON PHOTOGRAPHIC EXHIBITIONS, 1902

Initially published in The Amateur Photographer *on 9 October 1902, this article was the first of a two part series, written on the occasion of that year's photographic exhibitions held simultaneously by the Linked Ring and the Royal Photographic Society. However, "The Unmechanicalness of Photography" is an introductory essay and does not deal specifically with the exhibitions. Instead Shaw elaborates on his argument supporting photography under the pretext of defending statements that he had made in his review of the 1901 exhibitions.*

This article was reprinted in Camera Work, *no. 14, April 1906, and excerpts were included in "Aphorisms on Photography," a preface to a photography exhibition catalogue for the New English Art Club in 1907. It was also reprinted in* Camera Work: A Critical Anthology, *edited by Jonathan Green and published in 1973.*

BEFORE I RESUME the subject of the annual exhibitions of pictorial photography, let me, in mere humanity, beg my fellow journalists of every degree not to continue the really desolating display of clever ignorance — the most trying sort of ignorance — which has raged

ever since certain platitudes* of mine last year were extensively quoted, requoted, and quoted yet again, as startling and outrageous paradoxes.

It happens that, for the moment, we have our minds sufficiently open and active on the subject of photography to be rather aggressively conscious of its limitations, whilst we are at the same time so reconciled by long usage to the very same limitations in painting that we have become unconscious of them. That is why we think nothing of citing a dozen of the most obvious drawbacks to easel work, and throwing them in the teeth of photography as if we had never met with them in any other pictorial method. But this is not the worst. Critics who have never taken a photograph, elaborately explain why the camera cannot do what every painter can do, the instance chosen being generally of something that the camera can do to perfection, and the painter not at all. For example, one writer has taken quite pathetic pains to demonstrate the inferiority of the camera to the hand as an instrument of portraiture. The camera, he explains, can give you only one version of a sitter: the painter can give you a hundred. Here the gentleman hits on the strongest point in photography, and the weakest point in draughtsmanship, under the impression that he is doing just the reverse. It is the draughtsman that can give you only one version of a sitter. Velasquez, with all his skill, had only one Philip; Vandyke had only one Charles; Tenniel has only one Gladstone; Furniss only one Sir William Harcourt; and none of these are quite the real ones. The camera, with one sitter, will give you authentic portraits of at least six apparently different persons and characters. Even when the photographer aims at reproducing a favourite aspect of a favourite sitter, as all artist-photographers are apt to do, each photograph differs more subtly from the other than Velasquez's Philip in his prime differs from his Philip in his age. The painter sees nothing in the sitter but his opinion of him: the camera has no opinions: it has only a lens and a retina. One reply to this is obvious. It is, that if I only knew how stupid a painter can be, I would admit that many painters have no opinions, no mind, nothing but an eye and a hand. Granted; but the camera has an eye without a hand; and that is how it beats even

*"The Exhibitions, I & II," *The Amateur Photographer* (11 and 18 October, 1901) 282–284, 303–304.

the stupidest painter. The hand of the painter is incurably mechanical: his technique is incurably artificial. Just as the historian has a handwriting which remains the same whether he is chronicling Elizabeth or Mary, so the painter has a handdrawing which remains the same, no matter how widely his subjects vary. And it is because the camera is independent of this handdrawing and this technique that a photograph is so much less hampered by mechanical considerations, so much more responsive to the artist's feeling, than a design. It gives you a direct picture where the pencil gives you primarily a drawing. It evades the clumsy tyranny of the hand, and so eliminates that curious element of monstrosity which we call the style or mannerism of the painter, a monstrosity which, in some very eminent cases, amounts to quite revolting deformity. It also evades the connoisseurship in these deformities which is the stock-in-trade of many critics. The effect is just as if the brains of a goose had been removed. They lose their bearings completely, and flounder into the countersense that the camera is more mechanical than the painter's hand.

The true relation of the two can be seen by adding a third term to the comparison. There are things still more mechanical than the draughtsman's hand: to wit, the rule and compass. The medieval masons found out that if they drew their decorative patterns with rule and compass, they got regularity without life, interest, or beauty. So they made their patterns freehand; and the result was enchanting. But when a modern builder gets his brother-in-law the Mayor to humbug the Dean into a panic about "the dangerous condition of the west front," and so puts up a lucrative "restoration" job for himself, and a knighthood for the brother-in-law, at the expense of subscribers whose knowledge of art is represented by the delusion that photographs are mechanical, he tries to imitate the old work by rule and compass, and produces work which is no more enchanting than the figures in Euclid. Now if it could be proved against the camera that its lines were ruled and its curves struck with a compass, there would be some sense in the parrot cries of mechanicalness. The truth is that it is as much less mechanical than the hand, as the hand is less mechanical than the compass. The hand, striking a curve with its fingers from the pivot of the wrist or shoulder, is still a compass, differing from the brass one only in the number of movements of which it is capable. Not even when it is the hand of a

Memling can it strike a curve quite such as flesh or flower reaches by its growth; and the student of pictures who has never felt this incompatibility between the inevitable laws of the motion of a set of levers and the perfectly truthful representation of the forms produced by growth, will never be a critic of photography; his eye may be good enough to compare one picture with another, but not good enough to make a lens for a five shilling camera.

Easily accessible illustrations of this incompatibility may be found in the *Punch* drawings of Linley Sambourne. Whoever compares Sambourne's drawing of mechanical objects, such as jack-planes, yachts, saddles, guns, and the like, with his drawing of flesh contours, will see instantly that the mechanism of a hand that can follow the stroke of a tool almost to perfection cannot follow the swell of a muscle or the dip of a dimple at all, however cleverly it may suggest them. The same thing may be seen in the drawings of Durer, who, ingeniously as he could suggest a head, could not draw it as he drew a helmet; but I prefer to cite Linley Sambourne, because, thanks to photography, we now have his drawings virtually at first hand, without the intervention of the wood cutter. It is the sense of this difficulty that has given rise among artists to the saying "There is no outline in nature"; and you find Michael Angelo, in his finished drawings (as distinguished from his sketches and memoranda), discarding outline and presenting us with a mess of blacklead, out of which the figure rises as if modelled. Raphael, who, for so bad a painter, drew in black and white with masterly feeling, liked to coax his forms out of a very soft outline, just as John Leech did on a very different plane. All the delicate draughtsmen — Correggio, Greuze, Velasquez, Rembrandt (one can pick up instances at random) — felt and shrank from the mechanical stroke of the hand. Dürer and Walter Crane, on the other hand, have turned the fault into a quality by making their lines delightfully decorative, and taking advantage of the rich effects of colour and surface which great printers as well as great decorative draughtsmen can produce with simple ink and paper. Thus Crane can snap his fingers at photography, because the camera cannot design or decorate. It is so utterly unmechanical that it cannot arrange its lines, being indeed unable to draw a line at all. In representation, however, this unmechanicalness becomes a power instead of a disability. It is the secret of the mysterious something that every photograph has, and every design lacks. The equally

mysterious something that every design has and every photograph lacks is simply the mechanical mannerism of the lever and the stroke. That lack is a supreme charm in the representation of life and growth. What, then, are we to say to the wiseacres who tell us that all photographs are necessarily mechanical, and all designs purely "artistic"? There is as much difference between such criticism and that which always keeps the real world in one eye, and the studio world in the other, as there is between, say, the drawing of Flaxman, with his factitious sense of "the antique," and the drawing of Segantini.

It will be seen that the penalty of talking conventional nonsense about the camera is that its disparagers not only muff the case they bring forward, but miss the case they might bring forward if they had sufficient judgment to measure the enormous artistic importance of the new process. Their attempt to pass off their ignorance as superiority by a display of inconsiderate insolence was not necessary: it was only easy and lazy. There is plenty to be said against any pretension of the camera to supersede the designer altogether. The camera cannot decorate; it cannot dramatize; it cannot allegorize. Just as it cannot do the work of Dürer or Crane, any more than it can design wallpapers, so it cannot do the work of Raphael, or Kaulbach, or Hogarth. Of course you can twist boughs or festoon ribbons and arrange flowers decoratively, and then photograph them. You can pose actors in costume and photograph them. But a born decorative draughtsman like Crane will make you a good design in a fiftieth part of the time a bad photographic makeshift will cost; and as to anecdotic, dramatic, didactic, and historical tableaux vivants, you have only to glance at the attempts in the exhibitions at giving dramatic titles to sentimental looking portraits, to see that the camera's power of representation is so intense that the photographer who attempts little fictions of this kind is at once found out and scorned for playing the fool. This is why I selected Velasquez instead of Dürer or Raphael last year as an instance of a painter whose drawing the camera could beat. The passage in which I did so has been reproduced again and again in almost every paper in the country, and in many out of it, with every conceivable stupidity of comment. *
Most of the commentators, instead of honestly buying THE

*In the later outbursts a "sic" appears after the technical term "rocking," showing that the quoter is ignorant not only of photography but of mezzotint.

AMATEUR PHOTOGRAPHER, and reading the article they were criticizing, took the newspaper quotation as their text, and went to the greatest pains to show what an efficient booby trap I had unintentionally constructed. Velasquez was a terrible stumbling block. If I had said Raphael, they would not have minded so much; for they all know now (having been carefully told so) that Velasquez was beyond comparison a greater painter than Raphael. But if I had said Raphael I should have been quite wrong. Velasquez could have drawn Philip better with a telephoto lens than with his brush (he would have thrown a portrait lens at the head of the optician); but Raphael could not have produced the School of Athens or the Hampton Court cartoons with a camera, nor would he have dared to draw the halo of the Blessed Virgin round a head photographed from a real woman*. Compared with Velasquez, Raphael was a mere storyteller, whose draughtsmanship and colouring must have filled the Spaniard with contemptuous amazement. One can conceive Velasquez saying, "What this man expressed in these daubs of his must have some universal popularity, or he could not have gained his reputation; but an artist, in my sense, he certainly was not." And it is just as an artist in that sense, meaning a man with the power of representing life with subtle truth, that Velasquez with a camera could, except in colour, or in historical Breda Surrenders and so forth, have gone further than Velasquez with a brush. I chose my painter and my words warily; yet I grieve to say that only one writer (it was in a northern paper) knew his business well enough to begin his remonstrance with the words, "Of course all this is true; but etc., etc." The others appeared to have no idea that there is any distinction between what Hogarth did and what Monticelli did. Probably they have no idea that there is any distinction between the man who photographs a sewing-machine for a half-tone advertisement block, and Mr. Cochrane, or Mr. Evans. To them pictures are pictures, and photographs are photographs; and a picture is Art, and a photograph isn't, and there's an end. The truth is that neither a photograph nor a painting is necessarily "artistic"; nor does anybody

*By the way, Mrs. Barton has done this at both the Dudley and New Galleries; but Mrs. Barton has the advantage of Raphael by not being subject to the first fury of that outburst of demand for transcendant unrealities called the Renaissance. [Both footnotes by Shaw.]

who knows the A B C of criticism suppose that Fine Art refers to the processes by which works of Fine Art are produced, instead of to certain qualities of the product.

The attitude of the photographers themselves is not encouraging to their supporters. Far from claiming their rights, they are shy of accepting them when they are conceded. One or two have explained that my article last year was a joke! They believe that my object in the twenty years work I have done as a critic has been to have a reputation to fool away for their amusement. Happy egotists! As to the leading photographic journal, which insists so irritably that "every intelligent photographer has long since satisfied himself that it is absurd to claim for any kind of photography whatsoever the distinction of being a fine art," I can imagine an honest whitewasher, hearing rumours of the Arts and Crafts revival, and terrified at the prospect of being dragged out of his depth by demands for "tone" in areas and passages, proclaiming that "every painter in the trade knows that it is absurd to claim for any kind of brush work whatever the distinction of being a fine art." Still, without pretending to take such petulances seriously, I cannot look round the exhibitions without sympathizing with the veterans who indulge in them. For there is something more in them than the protest of the chemist and optician against the intrusion of the follies of the studio into his laboratory. The fact is, that photography is being taken up by painters and draughtsmen; and they are importing into the dark room the imperfections and corruptions of the methods which have come down to us from the stone age. These old methods are such arrant makeshifts that artists have always been forced to make a merit of each makeshift by cultivating the utmost virtuosity in its employment. This virtuosity in the artist calls for its corresponding connoisseurship in the critic; and the result is that fine art becomes a game of skill in which the original object of the skill is constantly being lost sight of; so that the genuinely original men who recall this object by periodical "returns to nature" are vehemently abused and ridiculed, not because their works are not like nature, but because they are not like pictures.

Hence, if you take an artist out of the Parisian ateliers, and give him a camera to work with, what happens? He immediately sets to work to produce, not photographs, but the sophisticated works of art which formerly attracted him to the painter's profession. His very

From Irish country series. Collection of Harry Ransom Humanities Research Center, the University of Texas at Austin.

Coole 1916. *Platinum print. Collection of London School of Economics.*

Unidentified, 1909. Platinum print. Collection of London School of Economics.

Unidentified. Platinum print. Collection of London School of Economics.

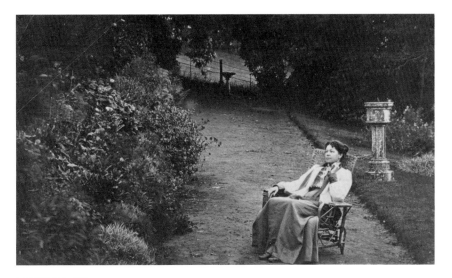

*U*nidentified. *Platinum print, brown-toned. Collection of London School of Economics.*

M<small>RS</small>. John Galsworth, Devon, 1914. *Platinum print.*
Collection of London School of Economics.

Genoa. 1933. *Silver bromide print. Collection of London School of Economics.*

Louise Broadwood, 1904. *Possibly taken on a visit to Rome, Italy. P.O.P. Collection of London School of Economics.*

first blunder in exposure, especially under-exposure, may result in a negative which a skilled tradesman would instantly scrub off the glass. The artist-novice makes a print from it, and finds that he has got something like what he calls an impression. Trained as he is to make merits of makeshifts in the atelier, he is not slow to make a merit of a mistake in the dark room. He very soon finds out that though his proceedings involve a great deal of what a London shopkeeper described to me the other day as the backbone of his photographic trade: namely, waste of materials by amateurs, yet an encouraging proportion of his plates, especially those which, if turned out by a skilled member of the trade, would lead to instant and precipitous loss of employment, give prints which have many of the qualities of those early makeshifts of Impressionism in which tone is achieved by a frank sacrifice of local colour and local drawing. If he is really an artist, the blunders he selects for exhibition will be more interesting than the unselected technical successes of the photographer who is not an artist. He soon learns how to produce these happy blunders intentionally, at which point, of course, they cease to be blunders and become crimes.

Finally, he discovers that the camera can imitate the most flagrant makeshifts of the draughtsman, and in so doing get all the advantage of that curiosity which mere processes rouse: the same curiosity that makes people with no ear for music crowd eagerly round a pianoforte to *see* Paderewski play. When a photographer prints from his negative through a hatching, and so makes the resultant picture look like an engraving or etching of some kind, his work immediately becomes what bric-a-brac dealers call a curio; and as a photograph had better be curious than merely null, the trick is not so unmeaning as it seems. Then there are the pigment processes, in which the most amusing games can be played with a kettle of hot water. The photographer gains control of his process, and can, if he likes, become a forger of painter's work.

When the photographer takes to forgery, the Press encourages him. The critics, being professional connoisseurs of the shiftiest of the old makeshifts, come to the galleries where the forgeries are exhibited. They find, to their relief, that here, instead of a new business for them to learn, is a row of monochromes which their old jargon fits like a glove. Forthwith they proclaim that photography has become an art; and all the old phrases that were composed

when Mr. Whistler was President of the British Artists and the New English Art Club was perceptibly newer than the New River Water Company, are scissored out of the old articles and pasted into the new ones, with substituted names, as Steichen for Whistler, Käsebier for Wilson Steer, Demachy for Degas or Sickert, and any lucky under-exposer for Peppercorn or Muhrman.

Now this is all very well; but who would not rather produce a silver print which could be fitted to an old description of a picture by Van Eyck or Memling, or a platinotype portrait that would rival a good impression of a mezzotint by Raphael Smith, than imitate with gum or pigment plasters the object lessons of the anti-academic propaganda of twenty years ago? I grant that some propaganda is still needed; that the old guard of photography used to tolerate, and even reward by medals, such monstrous faking as no gummist has yet been guilty of; that the plucky negative with microscopic definition, plenty of detail in the shadows (and everywhere else), and a range from complete opacity to clear glass, was made just as much an end in itself as the simulation of the makeshifts of painting and draughtsmanship now threatens to become; and that Philistinism was as rampant in the Royal Photographic Society as in the Royal Academy. But none of the Impressionists was so wanting in respect for his art as to pretend that the pictures in which he preached tone and atmosphere, or open-air light, were not paintings but photographs. Besides, he aimed at representing these things as he saw them, sometimes with very defective sight, it is true, but still honestly at first hand. Now some of our photographers who have been corrupted by beginning as draughtsmen and painters *are* wanting in self-respect; for they openly try to make their photographs simulate drawings, and even engravings; and they aim, not at representing nature to the utmost of the camera's power, but at reproducing the Impressionists' version of nature, with all the characteristic shortcomings and drawbacks of the makeshift methods of Impressionism. This modelling of new works of art on old ones, instead of on nature and the artist's own feeling, is no novelty: it is an Academicism pure and simple. Mr. Whistler was not academic; but the photographer who aims at producing a Whistleresque print is as academic as Nicolas Poussin. Every original artist draws into his wake a shoal of academics of his "school," who imitate his infirmities, and observe the limitations and conventions imposed on him against his will by the

imperfections of his methods and materials, just as bigotedly as they strive after as much as they understand of his excellencies. Thus in orchestral music we have the barks and stutterings of the defective trumpets written for by Beethoven, still imitated by learned professors, although modern instruments have a complete scale which makes the stuttering as unnecessary as it is absurd. Haydon, who wanted above all things to be an "old master," painted flesh a dirty yellow, because candle soot had reduced the altarpieces of his idols to that complexion. Let nobody suppose, therefore, that the critics who stood for Sargent against Bouguereau, for Monet against Vicat Cole, nearly twenty years ago, are now going to stand for the photographers who imitate Sargent and Monet against the original photographers. Much of the most daring and sincere work of the Impressionists and Naturalists dealt with most elusive and difficult subjects, and had to be painted with grotesquely inadequate colours; so that the desired effect was often suggested only by letting everything else go by the board, and demanding allowances from the spectator which the ordinary hooligan of the shilling turnstile refused, with loud horse-laughter, to make. Even spectators who were by no means hooligan, including John Ruskin himself, lost their tempers under the strain at first. But they soon saw the point of the movement, and made the allowances cheerfully, and even enthusiastically.

And now, may I ask, what right has photography to these allowances? None whatever, it seems to me. The difficulties which justified the Impressionist in asking for them do not exist for the camera. The photographer has his own difficulties, and receives his own allowances for them; and the minimization of these is quite enough to keep him busy. If he deliberately sets to work to make his photograph imitate the shortcomings, and forge the technique of the Impressionists, he must not be surprised if he finds that those who were most tolerant of both when they were the inevitable price of originality will be the most resolute not to stand them for a moment when they are a gratuitous academic affectation.

I prefer not to connect these painful observations with the names of any of the exhibitors of the Dudley and New Galleries. In their fullest force they do not fairly apply to any individual artist; but they are seasonable for all that. Nobody can look round the Salon without seeing that the remarkable and sometimes exquisite technique for which the French and American exhibitors are specially

honoured, is not always an original photographic technique; and nobody who remembers the first Grosvenor Gallery exhibitions and their offshoots (to go no further afield than St. James's parish) can possibly mistake these enthusiasts for anything but Academicians. The Academic enthusiasm is a wonderful and beautiful thing when it is young; but it leads to a dull and decrepit age. When Benjamin West first saw the Apollo Belvedere, he felt unutterable things; but if he had foreseen the curse that now superseded statue was to bring on later generations of Academy students he would have smashed it then and there. And a Whistler nocturne may in course of time become a greater academic nuisance than ten Apollo Belvederes.

And now enough of sermonizing. Let us have a look at the actual photographs.

SOME CRITICISMS OF THE EXHIBITIONS. THE 'LIFE STUDY,' 'THE FUZZYGRAPH,' AND 'THE UNDER-EXPOSED,' 1902

In this sequel to "The Unmechanicalness of Photography," Shaw finally addresses his criticism to the 1902 photographic exhibitions of the Linked Ring and the Royal Photographic Society. It was first published in the 16 October 1902 issue of The Amateur Photographer. *Excerpts were included in "Aphorisms on Photography," a preface to a catalogue for an exhibition of photography at the New English Art Club in 1907.*

IT IS IMPOSSIBLE to contemplate the Salon walls without condoling with Mr. Steichen on the conflict between Art and popular prudery. The camera can represent flesh so superbly that, if I dared, I would never photograph a figure without asking that figure to take its clothes off. I delight in mankind as nature makes it, and take such a moderate interest in mere garments that my tailor, though an irreproachable artist, has positively had to change his name to avoid the public discredit of my callous abuse of his masterpieces. It is monstrous that custom should force us to display our faces ostentatiously, however worn and wrinkled and mean they may be, whilst carefully concealing all our other points, however shapely and well-preserved. But the avenger has come in the person of the photographer. The

photographer's model, knowing that her face is the only part of her person by which she can be identified, hides that, and displays the rest recklessly. The method of concealment adopted by one of Mr. Steichen's sitters is to bury her face in a cat coiled up on the floor, thereby, of course, throwing into the most extravagant prominence those contours the very existence of which is conventionally regarded as a deplorable indiscretion of Providence, to be kept a guilty secret at all hazards. The poor lady's dilemma recurs in nearly all the figure studies. In desperation at seeing so many blushing backs turned to me, I venture to submit a plain proposition on this subject. If sitting for a complete life-study is a misdemeanour, it should not be committed, nor should the photographer make himself accessory to it. If it is not a misdemeanour, the sitter should not be ashamed of it. Our fashionable books of African and Australian travel are full of photographs of dark ladies, undraped and unembarrassed, whose natural propriety passes unchallenged because their self-possession makes us forget our unnatural prudery. But Mr. Steichen's ladies, though dark enough in all conscience (being apparently modelled in a paste of bread crumb and plumbago moistened with beer), hide their heads like ostriches. Half the pictures in the world, from Raphael's "Psyche" to Ingres' "Source," would be intolerable on such conditions. To make matters worse, Mr. Steichen actually labels the lady with the cat in the American language. He calls her a "nude." This may be American modesty; but in English the adjective is only used substantively by old-fashioned dealers to denote a naughty French picture. This use of the word is also exemplified on the books entitled Nudes from the Paris Salon. Consequently English artists use the term Life Study, which is more accurate descriptively, and better grammar to boot.

Mr. Steichen's life studies have all been made, apparently, in coal cellars; why, I do not know. What I do know is that those impressionists who were not "open airists" resorted to the coal cellar because it abolished local colour, the truth being that they could not at first get the "values" they aimed at except in monochrome. But local colour is not expected from a photographer. Monochrome is conceded to him as completely as to a copperplate engraver. Then why the coal cellar? Perhaps Mr. Steichen is in love with Mr. Whistler's portrait of Sarasate; but then Mr. Whistler gave us exquisite little jewellings of decorative colour and even some genuine and

subtle local colour in a very low key. Moreover, Mr. Whistler built up his tones and his colour from a cold black foundation against which a bit of brown fur — say, a muff on the sitter's hand — came up with a lurking richness that was very seductive, whilst the little jewels of decorative colour were always delicate and distinguished. Mr. Steichen starts with brown, and gets no further than brown. And the parts of his figures which are obscure do not produce the effect of being obscured by darkness; they suddenly become indistinct and insubstantial in a quite unconvincing and unreasonable way. This is emphasised by the success with which he has carried his main point: the modelling of the backs of the figures. Nothing could be more dainty than the surface and the lighting of these, or more convincing than the illusion of solidity. But the illusion stops at the nape of the neck. The invincible Puritan view of Woman as a creature who exists primarily to have her blushes spared seems to have checked the hand of Mr. Steichen at the point where a wicked foreigner would have gone on to conquer the gloss of the hair and the modelling of the chin and cheek just as he had conquered the modelling of the shoulders. It was probably the revolt of his artistic instinct against these disappointments and austerities that led to the compromise of the "Nude with cat." The cat I take to be a descendant of the animal whose skin supplied the fur for Mr. Whistler's muffs; but fur without local colour is at best a dismal makeshift. I remember when the critics had wrought themselves to such an infatuation of connoisseurship that they used to discuss the "colour" in etchings. And, mark my words, we shall presently hear about the colour of that cat.

I am myself far too sophisticated by long contact with pictures, and by the natural insanity which has withheld me from reasonable industrial pursuits and driven me into the practice of fine art, to be able to say honestly that I do not like these aberrations of photography into pseudo-Impressionism. They are so ingenious, so difficult, so finely perceived, above all, so direct in their conveyance of the artist's feeling (and the communication of feeling is the true diagnostic of fine art), that it is impossible for anyone who is not an utter Philistine, nay, an entire and perfect Chump, not to be interested by them. But my business as a critic is not to indulge my infirmities, but to warn others against them. I may find Mrs. Käsebier's work fascinating, and may envy her astonishing control of a process which is able to control me quite absolutely when I try my hand at it; but

I nevertheless insist that it is academic work; that what Mrs. Käsebier has aimed at is the imitation by the camera of the technique of the most spirited exploits of the French crayon draughtsmen; and that it is for the qualities which this academic pursuit has called forth incidentally, and not for the verisimilitude of the sham charcoal strokes, that she deserves the applause which nobody has been stern enough to withhold.

Besides, there are bigger techniques to imitate than those of the French charcoal men. Professor Watsek, of Vienna, has a magnificent Titian on the end wall of the Salon; and his blue seaport piece would almost stand comparison with the work of the great James Maris himself. The Americans are too devoted to Paris: the Germans and Austrians breathe a larger air. Yet even here Mrs. Käsebier saves her credit, for one of her portraits is a perfect Giorgone.

I do not think it can be denied that some of the Salon pictures are "fuzzygraphs." They raise the question, insoluble by the critic, whether the fuzz is the result of affectation or defective sight. Do the artists need a little more common sense; or do they simply need spectacles? Take Mr. Davison's work for example! It is extraordinarily agreeable in all sorts of ways: its light is in the natural key instead of in the grey scale of the classical chemical photograph; the white house-walls shine as in an African coast sun; the artist's power of getting what he wants by the photographic process is unquestionable. But if I saw the edges of a house blur as they blur in Mr. Davison's pictures, I should conclude that I was going to faint, and probably do it too. Yet there is a long range within which focussing, or closeness of contact in printing, can be modified without outraging my eyesight. Take Mr. Craigie: his prints vary from silken sharpness to misty softness; but no question arises, for the subjects always look right. So all I can say is that as Mr. Davison's focussing does not look right to me, I conclude that my eyes give better definition than his. Mr. Moss and Mr. Keighley must have eyes like mine, because some of their work seems to me irreproachable. Yet Mr. Moss, except in his "Forest Road," gives what is to me coarse focussing; and one of Mr. Keighley's pictures is an arrant fuzzygraph. If I had to choose between sharp focus for its own sake and soft focus for its own sake, instead of being simply convincingly right, I should certainly be smart like M. Puyo rather than slovenly and woolly like

the anti-definitionist doctrinaires. But that is a matter of temperament.

Some of these days the Linked Ring will have to discuss the degree of allowance that may fairly be claimed by exhibitors for under-exposed foregrounds. Here, for instance, is Viscount Maitland's "Incoming Tide," so good a sea piece that it would have been very hard to reject it. But the rock, or wreck, or whatever it is, in the foreground is quite impossible: it is a black hiatus in the picture, like the landscape in an ordinary sky negative. Now the under-exposed foreground is one of the most objectionable conventions of the classical school of landscape painting. We do not want the old question, "Where do you put your brown tree?" revived in the form, "Where do you put your under-exposed foreground object?" In marine pieces it is specially unnatural, because at sea, where the surface reflects the light instead of absorbing it as clay does, there are none of the obscurities that lurk on land. Whilst there is light there is recognition: rock granularity, limpet shell, and seaweed can be identified as long as there is a gleam of daylight. I know that it is this very prodigality of reflected light that makes the exposure for the distant sea as incompatible with the exposure for the foreground rock as an ordinary sky exposure is incompatible with an ordinary landscape exposure. I know also that as the sea, unlike the land, will not keep quiet, the device of a coloured screen and a relatively prolonged exposure is not available except in high summer light. Still, if the Linked Ring denies to the landscape photographer the indulgence of a baldheaded sky, and expects him to use two negatives, why should it not expect the marine photographer to use three? I ask this because sacrificed foregrounds are very hard to bear, especially when they are surrounded by works such as Mr. Keighley's, in which the same difficulty in sylvan scenery has been completely mastered. However, as I have said, the sea piece is very good, much better than the sandhills by the same artist, which quite miss the wonderful bright cleanness which is the sandhill's charm. Photography can catch that charm, though Mr. Llewellyn Morgan, at the New Gallery, has been as effectually baffled by it as Viscount Maitland. Mr. Evans has proved it; and one of the two exquisite little marine pieces by Mr. Rudolf Eickemeyer in the Salon proves it again. Mr. Evans, by the way, exhibits a dainty little landscape, entitled "Clear Shining After Rain," in which, by the use of mercury toning, he has pro-

duced a foreground of violet and a distance of cinnamon, the effect
being completed with great subtlety by the colour of the mount. To
me the three tones produce a subtle discord that is quite diabolical;
and though I perceive that I might acquire a taste for it as I might
for absinthe, I prefer to steel myself against it, and to enjoy the
novel sensation of having caught Mr. Evans for once doing some-
thing that one can grumble at. There is but one Evans portrait,
worse luck; but there are cathedral pieces, especially some from York,
that cannot be bettered. Mr. Evans is this year like Sir Christopher
Wren; if you would see his monument in the Salon, look around.
The decoration and lighting and hanging are his; and he has cer-
tainly made the room a work of art in itself. But the Dudley Gallery
is hardly light enough. It is impossible to have too much light for
photographs; yet what light there is has to be diffused by veils, which
diminish it. The hanging is homicidal in only one instance: that of
Dr. Grindrod, whose "Woodcutters" are slaughtered in a manner
that makes one hope they are not so good as his "Boys Bathing," or
his work at the New Gallery.

One cannot help wishing that Mr. Hugo Henneberg would not
halt between the charms of block printing and photography. A finely-
photographed vista through a row of apparently block-printed pop-
lars is a distressing anomaly. I fully appreciate the command of pho-
tographic processes which enables Mr. Henneberg to turn out the
finest photographs or the boldest posters at will. An exhibition of
posters by him would be as interesting as an exhibition of his pho-
tographs; but to exhibit pictures which are half-poster, half-
photograph, seems to me mere waywardness. Another artist with an
insubordinate fancy for a particular effect is Mr. Grimperl, who is
so fond of streaks of white light (white horses) that he lavishes them
on his landscapes almost as freely as Nature does on the sea in a
gale. Then there are the photographs of places which look as if they
had stolen another country's climate: for instance, Mr. Stieglitz's
Venice, which looks like Paris, and Miss Devens' Capri, which looks
like Whitby. Miss Devens may be forgiven for the sake of the very
attractive work she has so liberally contributed; but Mr. Stieglitz,
for so eminent a hand, has taken things easily this year, hardly
going beyond snapshots. Mr. Horsley Hinton, on the other hand,
has broken away from himself most refreshingly. His old manner,
which was showing signs of that safe precept of the old dealer "When

you strike a good line, stick to it," has shed its mannerism and chased the clouds from its heavy skies. Indeed, he has two pictures which are not conventional Horsley Hintons at all, one being an impression of Ireland, which I recognised as native to me across the Gallery, and the other a landscape in the most polished eighteenth century taste. Mr. Holland Day's portrait of Madame Georgette le Blanc (Monna Vanna) is a triumph of characterisation: it gives precisely that typical aspect of the sitter which the victims of photographobia are so fond of proving that the camera cannot seize.

The New Gallery is not so fruitful in morals as the Dudley. The Royal Photographic Society mixes up optics and fine art, trade and science, in a way that occasionally upsets the critical digestion. It is divided between two quite incompatible interpretations of the word exhibition, which means sometimes a huge international display of industrial products, with gold medals for future use as advertisements, and sometimes a collection of works of fine art. To complete the muddle, the R.P.S. has been so effectually laughed out of its old notion that photographs are to be esteemed according to certain technical conditions in the negative, that it has now arrived at the conclusion that a pictorial photograph is one in which the focussing and the exposure are put wrong on purpose. Consequently, whilst it solemnly medals some of its exhibits as if they were sewing machines, it is afraid to give a medal to any picture that does not look more or less mildewed, lest it should be ridiculed for Philistinism. And whenever it gets a photograph which in its secret soul it thinks very good, it is ashamed to say so, and puts it in the "professional" section. As it happens, the object of this guilty admiration sometimes *is* very good. And sometimes the fuzzygraph which the Society puts in the pictorial section because it privately thinks it very bad *is* very bad. Thus, whenever the poor Society happens to be right, it makes the judicious laugh — exactly what it outrages its conscience to avoid. Fortunately, in the judgment of photographs, as in so many other judgments, the cases which present any difficulty are few and far between; and so the Society keeps up appearances in spite of its lapses from common sense. Its best point, perhaps, is that it has no snobbish objection to a manufacturer's sample as such. It has been abused this year for putting a sample photograph of some fish, frankly described as "by the Mattos Chemical Company," into its pictorial section; but it has been perfectly right in doing so, as the picture

happens to be a remarkably good one. The Society's mistake was in not insisting on the replacement of the Company's name by that of the artist who did the work. The Royal Academy, with all its faults, has never described the pictures in its exhibitions as by Messrs. Winsor and Newton or George Rowney; and the Royal Photographic Society need not sink lower than the Academy by describing a picture in its exhibition as the work of a joint stock company.

Many of the Salon exhibitors are in force at the New Gallery also. The well-understood antipathy of the old Society to forged pictorial techniques acts wholesomely in restraint of such games; but, of course, the front rank photographers have to be welcomed on their own terms, and do as they please. M. Dubreuil indulges his whim for imitating portraits in oil with unfinished backgrounds to his heart's content, the portraits being so good that the folly must be indulged. The most thoroughgoing example of the old school, Lieutenant-Colonel Gale's "Chairs to Mend: Umbrellas to Mend," staggers humanity at the Salon, not at the New Gallery. Robust and barbarous, it is not at all put out of countenance by the Steichens and Demachys, being as successful in its way as they in theirs. Mr. John Hodges is the last man I should have expected to find among the fuzzographers; but his "Sea, Sky, and Smoke" suffers from the softness of the great steamer wake which leads up to the sky and smoke. Sea foam is the whitest, sharpest, glitteringest thing in nature: enlargement or soft focussing seems always fatal to photographs of it. Mr. Eickemeyer has found this out; but Mr. Hodges has not; his picture, though very effective and pictorial, underrates the brilliancy and fascination of that great track of foam in the foreground. The greatest success in this direction is Mr. Thomas Wright's "Winter," a satisfactory snow piece. Mr. John Bushby's catching picture of sails reflected in the distorting mirror of the calmly-heaving Ionian sea illustrates a certain marked difference between the ways of the Salon and of the R.P.S. The Linked Ring, when it is really free to choose (which is, of course, not always the case), gives much higher marks to skill than to luck. The old society gives equal honours to luck; and I by no means blame it therefore, because a man must be an artist to know when he is in luck, and because the bits of luck are very attractive.

In colour photography there seems to be no advance since last year, rather a set-back, if anything, perhaps through success leading

to carelessness. The professional photography is distinctly worse than last year except in the case of artists like Mr. Furley Lewis, whose work is not shop routine, and ought not to be classed with it. Mr. Bacon's balloon photographs are, as Mr. Bolas has pointed out, much more interesting as pictures than a good many of the works which aim at picturesqueness and nothing else. This is not at all an uncommon feature of scientific work, from which let me hasten to draw the moral that a man who is determined to be nothing but an artist often ends by not being even that, whilst the man of wider interests and more varied activities makes all the deeper mark.

On the whole, the movement of the year seems to be in the direction of more straightforward and specifically photographic work. The best of the newer men, like Mr. Beresford, are on the side of Mr. Evans, Mr. Horsley Hinton, and those who produce pure photography by great skill in negative making and printing, rather than on the side of the clever draughtsmen who manipulate the pigment processes so as to dissemble photography as much as possible. I cannot say that I regret this tendency. Not that I would suggest any such academic moral as that platinotype is a more artistic process than pigment. My fancy is all the other way. But it happens that the gum process is much more controllable in the wrong direction than the platinotype process, and that the fascination of the masterpieces of the great painters and draughtsmen is so great that it is very hard to refrain from imitating them down to their very handwritings if it is at all possible to do it. And that is no doubt the reason why, in this year's output, so much of the originality is in platinotype and so much of the imitative cleverness and *chic* in gum.

EVANS—AN APPRECIATION, 1903

Shaw wrote this essay for Camera Work, *no. 4, of October 1903, which spotlighted Evans's work. Frederick H. Evans was a close friend of Shaw's, and to Shaw's mind, "one of the two greatest photographers in the world," the other one being Alvin Langdon Coburn. It is significant that the only two articles Shaw wrote about individuals were devoted to these two men.*

Y ES: NO DOUBT Evans is a photographer. But then Evans is such a lot of things that it seems invidious to dwell on this particular facet of him. When a man has keen artistic susceptibility, exceptional manipulative dexterity, and plenty of prosaic business capacity, the world offers him a wide range of activities; and Evans, who is thus triply gifted and has a consuming supply of nervous energy to boot, has exploited the range very variously.

I cannot say exactly where I first met Evans. He broke in upon me from several directions simultaneously; and some time passed before I coordinated all the avatars into one and the same man. He was in many respects an oddity. He imposed on me as a man of fragile health, to whom an exciting performance of a Beethoven Symphony was as disastrous as a railway collision to an ordinary Philistine, until I discovered that his condition never prevented him from doing anything he really wanted to do, and that the things he wanted to do and did would have worn out a navvy in three weeks. Again, he imposed on me as a poor man, struggling in a modest lodging to make a scanty income in a brutal commercial civilization

for which his organization was far too delicate. But a personal exam-
ination of the modest lodging revealed the fact that this Franciscan
devotee of poverty never seemed to deny himself anything he really
cared for. It is true that he had neither a yacht, nor a couple of
Panhard cars, nor a liveried domestic staff, nor even, as far as I
could ascertain, a Sunday hat. But you could spend a couple of
hours easily in the modest lodging looking at treasures, and then
stop only from exhaustion.

Among the books were Kelmscott Press books and some of them
presentation copies from their maker; and everything else was on
the same plane. Not that there was anything of the museum about
the place. He did not collect anything except, as one guessed, cur-
rent coin of the realm to buy what he liked with. Being, as afore-
said, a highly susceptible person artistically, he liked nothing but
works of art: besides, he accreted lots of those unpurchasable little
things which artists give to sympathetic people who appreciate them.
After all, in the republic of art, the best way to pick up pearls is not
to be a pig.

But where did the anchorite's money come from? Well, the fact
is, Evans, like Richardson, kept a shop; and the shop kept him. It
was a book-shop. Not a place where you could buy slate-pencils,
and reporter's note-books, and string and sealing-wax and paper-
knives, with a garnish of ready-reckoners, prayer-books, birthday
Shakespeare, and sixpenny editions of the Waverley novels; but a
genuine book-shop and nothing else, in the heart of the ancient city
of London, half-way between the Mansion House and St. Paul's. It
was jam full of books. The window was completely blocked up with
them, so that the interior was dark; you could see nothing for the
first second or so after you went in, though you could feel the stands
of books you were tumbling over. Evans, lurking in the darkest cor-
ner at the back, acquired the habits and aspect of an aziola; the
enlargement of his eyes is clearly visible in Mrs. Käsebier's fine por-
trait of him. Everybody who knows Evans sees in those eyes the
outward and visible sign of his restless imagination, and says "You
have that in the portraits of William Blake, too"; but I am convinced
that he got them by watching for his prey in the darkness of that
busy shop.

The shop was an important factor in Evans's artistic career; and
I believe it was the artist's instinct of self-preservation that made him

keep it. The fact that he gave it up as soon as it had made him independent of it shows that he did not like business for its own sake. But to live by business was only irksome, whilst to live by art would have been to him simply self-murder. The shop was the rampart behind which the artist could do what he liked, and the man (who is as proud as Lucifer) maintain his independence. This must have been what nerved him to succeed in business, just as it has nerved him to do more amazing things still. He has been known to go up to the Dean of an English Cathedral — a dignitary compared to whom the President of the United States is the merest worm, and who is not approached by ordinary men save in their Sunday-clothes — Evans, I say, in an outlandish silk collar, blue tie, and crushed soft hat, with a tripod under his arm, has accosted a Dean in his own cathedral and said, pointing to the multitude of chairs that hid the venerable flagged floor of the fane, "I should like all those cleared away." And the Dean has had it done, only to be told then that he must have a certain door kept open during a two hours' exposure for the sake of completing his scale of light.

I took a great interest in the shop, because there was a book of mine which apparently no Englishman wanted, or could ever possibly come to want without being hypnotized; and yet it used to keep selling in an unaccountable manner. The explanation was that Evans liked it. And he stood no nonsense from his customers. He sold them what was good for them, not what they asked for. You would see something in the window that tempted you; and you would go in to buy it, and stand blinking and peering about until you found a shop-assistant. "I want," you would perhaps say, "the Manners and Tone of Good Society, by a member of the Aristocracy." Suddenly the aziola would pounce, and the shop-assistant vanish. "Ibsen, sir?" Evans would say. "Certainly; here are Ibsen's works, and, by the way, have you read that amazingly clever and thought-making work by Bernard Shaw, The Quintessence of Ibsenism?" and before you are aware of it you had bought it and were proceeding out of the shop reading a specially remarkable passage pointed out by this ideal bookseller. But observe, if after a keen observation of you in a short preliminary talk he found you were the wrong sort of man, and asked for the Quintessence of Ibsenism without being up to the Shawian level, he would tell you that the title of the book had been changed, and that it was now called "For Love and My Lady," by

Guy de Marmion. In which form you would like it so much that you would come back to Evans and buy all the rest of de Marmion's works.

This method of shopkeeping was so successful that Evans retired from business some years ago in the prime of his vigor; and the sale of the Quintessence of Ibsenism instantly stopped forever. It is now out of print. Evans said, as usual, that he had given up the struggle; that his health was ruined and his resources exhausted. He then got married; took a small country cottage on the borders of Epping Forest, and is now doing just what he likes on a larger scale than ever. Altogether an amazing chap, is Evans! Who am I that I should "appreciate" him?

I first found out about his photography in one of the modest lodgings of the pre-Epping days (he was always changing them because of the coarse design of the fireplace, or some other crumple in the rose leaf). He had a heap of very interesting drawings, especially by Beardsley, whom he had discovered long before the rest of the world did; and when I went to look at them I was struck by the beauty of several photographic portraits he had. I asked who did them; and he said he did them himself — another facet suddenly turned on me. At that time the impression produced was much greater than it could be at present; for the question whether photography was a fine art had then hardly been seriously posed; and when Evans suddenly settled it at one blow for me by simply handing me one of his prints in platinotype, he achieved a *coup de théâtre* which would be impossible now that the position of the artist-photographer has been conquered by the victorious rush of the last few years. But nothing that has been done since has put his work in the least out of countenance. In studying it from reproductions a very large allowance must be made for even the very best photogravures. Compared to the originals they are harsh and dry: the tone he produces on rough platinotype paper by skilful printing and carefully aged mercury baths and by delicately chosen mounts, can not be reproduced by any mechanical process. You occasionally hear people say of him that he is "simply" an extraordinarily skilful printer in platinotype. This, considering that printing is the most difficult process in photography, is a high compliment; but the implication that he excels in printing only will not hold water for a moment. He can not get good prints from bad negatives, nor good negatives from ill-judged exposures, and he does

not try to. His decisive gift is, of course, the gift of seeing: his picture-making is done on the screen; and if the negative does not reproduce that picture, it is a failure, because the delicacies he delights in can not be faked: he relies on pure photography, not as a doctrinaire, but as an artist working on that extreme margin of photographic subtlety at which attempts to doctor the negative are worse than useless. He does not reduce, and only occasionally and slightly intensifies; and platinotype leaves him but little of his "control" which enables the gummist so often to make a virtue of a blemish and a merit of a failure. If the negative does not give him what he saw when he set up his camera, he smashes it. Indeed, a moment's examination of the way his finest portraits are modeled by light alone and not by such contour markings or impressionist touches as a retoucher can imitate, or of his cathedral interiors, in which the obscurest detail in the corners seems as delicately penciled by the darkness as the flood of sunshine through window or open door is penciled by the light, without a trace of halation or over-exposure, will convince any expert that he is consummate at all points, as artist and negative-maker no less than as printer. And he has the "luck" which attends the born photographer. He is also an enthusiastic user of the Dallmeyer-Bergheim lens; but you have only to turn over a few of the portraits he has taken with a landscape-lens to see that if he were limited to an eighteenpenny spectacle-glass and a camera improvised from a soap-box, he would get better results than less apt photographers could achieve with a whole optical laboratory at their disposal.

Evans is, or pretends to be, utterly ignorant of architecture, of optics, of chemistry, of everything except the right thing to photograph and the right moment at which to photograph it. These professions are probably more for edification than for information; but they are excellent doctrine. His latest feat concerns another facet of him: the musical one. He used to play the piano with his fingers. Then came the photographic boom. The English critics, scandalized by the pretensions of the American photographers, and terrified by their performances, began to expatiate on the mechanicalness of camera-work, etc. Even the ablest of the English critics, Mr. D. S. McCall, driven into a corner as much by his own superiority to the follies of his colleagues as by the onslaught of the champions of photography, desperately declared that all artistic drawing was sym-

bolic, a proposition which either exalts the prison tailor who daubs a broad arrow on a convict's jacket above Rembrandt and Velasquez, or else, if steered clear of that crudity, will be found to include ninety-nine-hundredths of the painting and sculpture of all the ages in the clean sweep it makes of photography. Evans abstained from controversy, but promptly gave up using his fingers on the piano and bought a Pianola, with which he presently acquired an extraordinary virtuosity in playing Bach and Beethoven, to the confusion of those who had transferred to that device all the arguments they had hurled in vain at the camera. And that was Evans all over. Heaven knows what he will take to next!

GEORGE BERNARD SHAW

PREFACE, PHOTOGRAPHS BY MR. ALVIN LANGDON COBURN, 1906

The following article was originally written as an introduction to the catalogue for Alvin Langdon Coburn's first one-man exhibition at the Royal Photographic Society in 1906. Coburn and Shaw had become friends several years before when Coburn had approached Shaw to make his portrait. Coburn was just beginning his photographic series "Men of Mark." From their first meeting, Shaw helped Coburn with this project, introducing him to many of his famous friends and colleagues.

Shaw actually volunteered to write the introduction to Coburn's catalogue, saying, "You will need someone to beat the big drum for you." Shaw recognized that his growing reputation would attract special attention to Coburn's exhibition. Indeed Shaw's support made an invaluable contribution to the rise of Coburn's international fame as a photographer — this preface became Shaw's single most-reprinted article on photography, and, in 1906, was published (with slight differences in editing) under varying titles in numerous photographic periodicals: The British Journal of Photography *and* The Amateur Photographer *in England, and* Photo-Era, Metropolitan Magazine, *and* Camera Work *in America. The following is the most complete of the different versions.*

Shaw's famous quotation, "The photographer is like the cod which produces a million eggs in order that one may reach maturity," originated in this essay, and was repeated countless times in print.

The exhibition of sixty-four photographs included a variety of Coburn's work: landscapes, cityscapes of London, Rome, and Venice among others, and a number of portraits of literary and art figures including one of Shaw. The show opened at the R.P.S on 5 February 1906, and ran through 31 March. The exhibition then traveled to the Liverpool Amateur Photographic Association's headquarters, where it was exhibited from 30 April to 14 May of the same year. Shaw's preface was reprinted for their exhibition catalogue.

M R. ALVIN LANGDON Coburn is one of the most accomplished and sensitive artist-photographers now living. This seems impossible at his age — twenty-three; but as he began at eight, he has fifteen years technical experience behind him. Hence, no doubt, his command of the one really difficult technical process in photography — I mean printing. Technically good negatives are more often the result of the survival of the fittest than of special creation: the photographer is like the cod, which produces a million eggs in order that one may reach maturity. The ingenuities of development which are so firmly believed in by old hands who still use slow "ordinary" plates, and develop them in light enough to fog a modern fast colour-sensitive plate in half a second, do not seem to produce any better results than the newer timing system which is becoming compulsory now that plates are panchromatic and dark rooms must be really dark. The latitude of modern plates and films, especially those with fast emulsions super-imposed on slow ones, may account partly for the way in which workers like Mr. Evans get bright windows and dark corners on the same plate without over-exposure in the one or under-exposure in the other. And as to choosing the picture, that is not a manipulative accomplishment at all: it can be done by a person with the right gift at the first snapshot as well as at the last contribution to the Salon by a veteran. But printing remains the test of the genuine expert.

Very few photographers excel in more than one printing process. Among our best men, the elder use platinotype almost exclusively for exhibition work. People who cannot see the artistic qualities of Mr. Evans's work say that he is "simply" an extraordinarily skilful

platinotype printer, and that anybody's negatives would make artistic pictures if he printed them. The people who say this have never tried (I have); but there is no doubt about the excellence of the printing. Mr. Horsley Hinton not only excels in straightforward platinotype printing, but practises dark dexterities of combination printing, putting the Jungfrau into your back garden without effort, and being able, in fact, to do anything with his methods except explain them intelligibly to his envious disciples. The younger men are gummists, and are reviled as "splodgers" by the generation which cannot work the gum process. But Mr. Coburn uses and adapts both processes with an instinctive skill and range of effect which makes even expert photographers, after a few wrong guesses, prefer to ascertain how his prints are made by the humble and obvious method of asking him. The device of imposing a gum print on a platinotype — a device which has puzzled many critics, and which was originally proposed as a means of subduing contrast (for which, I am told, it is no use) — was seized on by Mr. Coburn as a means of getting a golden brown tone quite foreign to pure or chemically-toned platinotype, whilst preserving the feathery delicacy of the platinotype image. Lately, having condescended to oil painting as a subsidiary study, he has produced some photographic portraits of remarkable force, solidity, and richness of colour by multiple printing in gum. Yet it is not safe to count on his processes being complicated. Some of his fittest prints are simple bromide enlargements, though they do not look in the least like anybody else's enlargements. In short, Mr. Coburn gets what he wants one way or another. If he sees a certain quality in a photogravure which conveys what he wants, he naively sets to work to make a photogravure exactly as a schoolboy with a Kodak might set to work with a shilling packet of P.O.P. He improvises variations on the three-color process with casual pigments and a single negative taken on an ordinary plate. If he were examined by the City and Guilds Institute, and based his answers on his own practice, he would probably be removed from the classroom to a lunatic asylum. It is his results that place him *hors concours.*

But, after all, the decisive quality in a photographer is the faculty of seeing certain things and being tempted by them. Any man who makes photography the business of his life can acquire technique enough to do anything he really wants to do: where there's a will there's a way. It is Mr. Coburn's vision and a susceptibility that

make him interesting and make his fingers clever. Look at his portrait of Mr. Gilbert Chesterton, for example! "Call that a technique! Why, the head is not even on the plate; the delineation is so blunt that the lens must have been the bottom knocked out of a tumbler; and the exposure was too long for a vigorous image." All this is quite true; but just look at Mr. Chesterton himself! He is our Quinbus Flestrin, the young Man Mountain, a large, abounding, gigantically cherubic person, who is not only large in body and mind beyond all decency, but seems to be growing larger as we look at him — "swellin' wisibly," as Tony Weller puts it. Mr. Coburn has represented him as swelling off the plate in the very act of being photographed, and blurring his own outlines in the process. Also he has caught the Chestertonian resemblance to Balzac, and unconsciously handled his subject as Rodin handled Balzac. You may call the placing of the head on the plate wrong, the focussing wrong, the exposure wrong, if you like; but Chesterton is right; and a right impression of Chesterton is what Mr. Coburn was driving at. If you consider that result merely a lucky blunder, look at the portrait of Mr. Bernard Partridge! There is no lack of vigour in that image: it is deliberately weighted by comparative under- exposure (or its equivalent in under-development); and the result is a powerfully characteristic likeness. Look again at the profile portrait of myself *en penseur** — a mere strip of my head. Here the exposure is precisely right, and the definition exquisite without the least hardness. These three portraits were all taken with the same lens in the same camera, under similar circumstances. But there is no reduction of three different subjects to a common technical denominator, as there would have been if Franz Hals had painted them. It is the technique that has been adapted to the subject. With the same batch of films, the same lens, the same camera, the same developer, Mr. Coburn can handle you as Bellini handled everybody, as Hals handled everybody, as Gainsborough handled everybody, or as Holbein handled everybody, according to his vision of you. He is free of that clumsy tool, the human hand, which will always go its own single way and no other. And he takes full advantage of his freedom, instead of contenting himself, like most photographers, with a formula that becomes almost as tiresome and mechanical as manual work with a brush or crayon.

*French: "as thinker"

In landscape he shows the same power. He is not seduced by the picturesque, which is pretty cheap in photography, and very tempting: he drives at the poetic, and invariably seizes something that plunges you into a mood, whether it is a mass of cloud brooding over a river or a great clump of a warehouse in a dirty street. There is nothing morbid in his choices: the mood chosen is often quite a holiday one; only not exactly a Bank Holiday: rather the mood that comes in the day's work of a man who is really a free worker and not a commercial slave. But, anyhow, his impulse is always to convey a mood, and not to impart local information or to supply pretty views and striking sunsets. This is done without any impoverishment or artification: you are never worried with that infuriating academicism which already barnacles photography so thickly — selection of planes of sharpness, conventions of composition, suppression of detail, and so on. Mr. Coburn goes straight over all that to his mark, and does not make difficulties until he meets them, being, like most joyous souls, in no hurry to bid the devil good-morning.

MR. GEORGE BERNARD SHAW
ON THE FOREGOING ARTICLE,
1907

The "foregoing article," on "Monsieur Demachy and English Photographic Art," was written by Robert Demachy, a renowned French photographer of the late-nineteenth and early-twentieth centuries. First contributed to the Revue de Photographie, *the monthly periodical of the Photo Club of Paris, Demachy's article was reprinted in the 29 January 1907 issue of* The Amateur Photographer *and followed by responses from three Englishmen, including Bernard Shaw.*

To understand Shaw's response, one must be aware that at the turn of the century, the general attitude of photographic societies was that for photography to achieve the status of high art, the photographic character of the medium had to be subordinated to painterliness. A popular technique used to achieve this aesthetic was the gum-bichromate process, of which Demachy was the acknowledged king. This process allowed a great deal of manipulation in the darkroom. The resultant images had a marked painterly quality; the photographic character of the image was obscured through hand and brushwork.

However, around 1905, English and American photographers began to celebrate the intrinsic characteristics of photography. Demachy's article attacks the "backward tendency" of the English, and condemns the critics who espouse the emphasis on photographic qualities. He sums up: "Let us entertain no illusions with the movement now being organized in England. It is bringing us straight back to the mechanical system against which

we have so persistently fought. The photographic character is, and has always been an antiartistic character."
Shaw's response to this article follows:

THIS OUTBURST OF our friend Demachy is pure *lèse*-photography.* What is all this about "the photographic character being an anti-artistic character"? About "methods of art which are incontestably superior to photography"? Name those methods. What are they? I deny their existence. I affirm the enormous superiority of photography to every other known method of graphic art that aims at depicting the aspects and moods of Nature in monochrome. I say that a photographer imitating the work of a draughtsman is like a man imitating the noises of a barnyard: he may do it very cleverly, but it is an unpardonable condescension all the same. Also, he is substituting an easy, limited, and exhausted process for a difficult one which has never yet been pushed to the limit of its possibilities. He fails in respect for his art. He is a traitor in the photographic camp. If he really prefers the old methods, let him practise them in the old way, and leave the genuine old-fashioned mark of the human finger and thumb on his copies of Nature; for the camera will never catch the true flavor of that quaint bungling; and even if it could, humanity would rightly refuse to concede to it that allowance which we make so willingly for the infirmity of the painter's hand, and the clumsiness of his medium. We can stand things from Corot that we would not stand for a moment from Demachy.

The old photography was never half so mechanical as the best painting necessarily is. What Demachy really means is that it was — as it still is — largely practised as a commercial process by men who were not artists. Also that a certain set of them admired one another, exhibited one another's pictures, awarded one another medals, and sometimes wore velveteen jackets, and stopped getting their hair cut. They did not know that Ruskin and Rossetti were keenly interested in photography, and practised it. They probably never heard of Ruskin and Rossetti. They provoked a reaction in which, as usual, the baby was emptied out with the bath, and the qualities of silver prints and

*Shaw's pun on "lèse majeste" which means an offense against a sovereign power.

the merit of clean workmanship were called inartistic because the school with which they were associated was inartistic. There are still people who think that platinotype is artistic, and albumenized paper inartistic; that under-exposed metol-developed plates are artistic, and "plucky" negatives inartistic; worst of all, that a print which shows that the photographer is a connoisseur of the Barbizon school is artistic, and a print which might have been made by a man who never saw a picture in his life, inartistic. The counter-reaction is just as foolish; and Demachy is right to warn us against the danger of a brainless inversion of these propositions. But such oscillations are inevitable. Demachy's own work, showing as it did the enormous value to a photographer of a complete and sensitive connoisseurship in modern art, led several French and American photographers to make their photographs almost as bad in some respects as weak drawings or charcoal sketches. Demachy himself did not make this mistake: his taste was too severe, and his commonsense too strong. And Puyo is clearly one of the old Robinsonian school: he would have got medals twenty-five years ago. But as to—

I regret that an urgent appointment at the Court Theatre compels me to break off at this thrilling point.

GEORGE BERNARD SHAW IMPROVISES AT THE SALON. PHOTOGRAPHY IN ITS RELATION TO MODERN ART, 1909

On 26 October 1909, The Amateur Photographer *printed this abridgement of a lecture given by Shaw at the Photographic Salon of 1909. Although the article was not written by Shaw, the authors have chosen to include it because the lecture is reported in its entirety, and the lecture acts as a neat summation of Shaw's views on photography and art. Moreover this lecture was Shaw's final public word — his swan song — on photography; it marks the end of his intimate involvement with the societies. Shaw continued his own photography, but he faded from the Salon scene and ceased writing on photography.*

Mr. GEORGE BERNARD Shaw delivered a long and characteristically brilliant address at the Photographic Salon on Monday evening of last week. Mr. Reginald Craigie occupied the chair, and many well-known workers in photography and other graphic arts were among the large audience. The following is an abridgment of Mr. Shaw's remarks: —

I really do know something about photography. There is an impression abroad that the sparkle of my utterances on art is due to the fact that I don't know anything about it.

Some time after I had given up my position as musical critic for *The World*,* I met the editor, and said to him, "Well, you have got an excellent man in my place, I hear." "Yes," was the reply, "we have got a man who really understands music, you know."

But, really, all that there is to be said about photography I have said long ago—it makes about two pages—and I greatly dislike to repeat myself, except in politics, where you get hardened.

When the suggestion is made that women should be given the vote, a number of men say at once, "What does Aunt Maria know about foreign politics?" Now, such an interrogation does not really show the absurdity of giving women the vote, but it shows the absurdity of the whole democratic principle.

These men, in casting a stone at Aunt Maria, take for granted the complete political education of Uncle John, and as Uncle John knows as little about foreign politics as Aunt Maria, the logical issue of such an argument would be to take the vote away from Uncle John.

It is exactly the same with the comparisons between photography and painting. All the objections made to photography really apply to the graphic arts as a whole, and generally with much greater force to painting and drawing than to photography.

Photography is very much more difficult and tedious than drawing or painting. There is only one exception to this rule, and that is the case of oil-painting, with which, so far, photography has not come into serious competition.

One of the reasons why the skilled artist does not take to photography is because it is so much more troublesome, and occupies him for so much longer. I don't think people realise how quickly the really able artist works. Take, for instance, that very accomplished draughtsman, Mr. Strang. I have been photographed by Mr. Coburn and Mr. Evans. My portrait has also been made by Mr. Strang in the most difficult sort of draughtsmanship that a man can undertake. He placed a copper plate on an easel, and made a dry point etching direct, finishing it in a shorter time than either of the two photographers I have named has ever finished a print. Yet there is a sort of notion that Mr. Strang spends hours over a portrait, and Mr. Coburn merely minutes. If you have a faculty for drawing you

*Shaw worked as music critic for *The World* from 1890 to 1894.

will never take up photography, save for its special qualities and superiorities — never for its saving of time or labour.

Now I come to the limitations of photography. There are certain departments of art which remain outside its scope. Many years ago, when I was a younger and probably a better-looking man, I was walking down the hall of a house in Ashley Gardens, when I saw a man who made an extremely disagreeable impression upon me. He appeared so sinister that I instinctively turned aside; as I did so, he did the same, and then I realised that the image was myself in a mirror.

I suppose such things are due to the absolute irrelevance of the body to the soul. I do not raise the question as to whether my exterior is worthy of my genius — personally, I do not think it is — but it is not this mortality, this corruptible, that is the real me at all. It will be thrown aside and scrapped. The thing we shall hand on is the most vital part of ourselves, and it is this we want to see in our portraits.

The portrait photograph has only come into popularity by the destruction of its essentially truthful qualities. Photography comes up against a real antipathy in human nature to the truth. One may attribute the hatred of photography which is felt by many artists to the fact that photography is a little too uncompromising.

I think nothing is more extraordinary than to look round at any photographic exhibition, and find to how very small an extent photographers are influenced by the general march of art outside. Of late years, however, they have begun to influence one another in an artistic direction. Many of the less original photographers are now producing artistic work rather on the lines of those photographers who are artists.

But the only modern photographer who does show the influence of outside art is Demachy. Here you see a man who has thoroughly imbibed the tradition of the Barbizon school — who is, indeed, saturated with it even at the cost of sacrificing the integrity of his photography.

Those who have studied the subject of evolution must have been impressed by the fact that the evolutionary processes which recur, recur at shorter intervals of time, and that processes which must originally have taken millions of years for their accomplishment are now accomplishing themselves in comparatively brief periods.

The evolution of Nature from the lowest to the highest forms of life was a tremendously long process, but that process has been duplicated in each one of us at and before his birth, and there it has been packed into a very small compass of days. Something of the same kind has occurred in the history of art.

The laboured processes of the art of painting took centuries to accomplish, but a similar evolution of processes has been run through in the case of photography within our own memory.

At the present time, one of our great difficulties about painting is that none of our painters know how to paint.

At the Royal Academy of any year one will find a certain amount of clever work, but in the courtyard below, on looking at a carriage and a pair of horses, and noticing the perfect manner in which the varnish has been put upon the carriage, we shall say, "Now, the man who did that was not like those duffers upstairs; he knew how to produce the perfect trade finish — the only real finish the artist should aim at."

If, however, we go to the National Gallery, and keep well behind the sixteenth century, we shall see how the men who painted in those days knew their craft. They knew it in the sense that the carriage-painter knew it — they had fine technique.

In English art, up to the time of Hogarth, this technique was admirable. The men may have been what we call artists, but they began as apprenticed tradesmen. Later on we have Sir Joshua Reynolds, and although there may be much to admire in him, we shall at least understand why he was called an "incompetent dauber." Later still, we have Turner, and here we come to faking of the most stupendous kind. The great aim of Turner was to get his effects, no matter by what medium or in what way. And the ordinary painting of to-day has lost all the old, genuine technical finish — the trade finish — which I regard as being the very first thing a man should master before he sets himself up to make a living out of his art.

Now, photography really began with men who were tradesmen. They sometimes, indeed, carried the thing to ridiculous extremes, but they were able to get all their tones perfectly upon the silver surface, and people were delighted with it. Then they began to practise combination printing, which had faults of scale, and so on, easy to be excused in a Du Maurier drawing, but rather to be jumped on

in the case of photography. The pictures by Robinson, however, were really very charming, and there was no nonsense about them.

But this kind of thing, like extreme virtue, began to produce a reaction, and in process of time somebody discovered lampblack at an oil shop, and produced the first gum drawing. The actual photograph was taken a little out of focus, and the lampblack piled on. It looked artistic, and the more it was reminiscent of the oil shop the better.

I think, however, that the time has come to go back to some of the qualities of the older men. We have had enough toleration for a certain sort of impressionism. Under-exposure is found out. Personally, I do not enjoy this sort of thing as I used to do.

The really professional photographer will in the future work in photogravure. And if you are going to have photogravure blocks, it will not do to have sketchy, under-exposed negatives.

I hope the Linked Ring will try to get up a sort of historical exhibition, beginning with the photographs of Hill — which are a little over-praised, perhaps — and Mrs. Cameron, together with a number of daguerreotypes, and then the silver prints of the good old school that Robinson belonged to; afterwards the first gum prints — a chamber of horrors — and the products of the first American invasion; Mr. Evans' platinotypes, and, finally, Mr. Coburn's photogravures.

I suppose it would be too much to suggest a series of photographs of old paintings, beginning with Van Eyck, carrying the thing up to the fifteenth century, and afterwards bringing in such an "incompetent dauber" as Reynolds. Anyhow, I throw out this suggestion for an exhibition that might possibly rally public interest in photography. But do not let the catalogue of such an exhibition be prefaced by remarks by Dr. Johnson.

At the conclusion of Mr. Shaw's remarks, a discussion took place, in which Mr. J. C. Warburg, Miss A. B. Warburg, Mr. F. H. Evans, Mr. Malcolm Arbuthnot, Mr. F. C. Tilney, Mr. Holbrook Jackson, and others took part. Replying, Mr. Shaw said:

"Mr. Tilney speaks of Salonistic art. When the Linked Ring was first started there was, of course, a great difference between their work and the work of those from whom they had separated. But to-day, going from this exhibition to the New Gallery, a perfectly young man would not understand what was meant by Salonistic

art. The two are very like Tweedledum and Tweedledee. Indeed, I believe that the R.P.S. is even more violently impressionistic.

"A friend of mine was asking to which exhibition he should send his work. 'Send whichever is darkest,' was the answer, 'to the R.P.S.; they like dark things.' At the R.P.S. they are very much in the phase that the Linked Ring was years ago.

"I do implore Mr. Tilney and others to study my lectures more carefully in order to find out when I am joking and when I am not. I was not joking about the carriage-painting. Mr. Tilney thinks I was, simply because in his opinion a carriage is a funny thing.

"After a great deal of trouble the other day I persuaded a coach-builder to paint a motor-car in the way I wanted it. If I had asked Sargent to paint it so, he could not have done it.

"The modern painter-artist is really an amateur — he is a gentleman. He has picked up painting from somebody else who really did not know how to paint. If a friend of mine wishes to be a sculptor I impress it upon him that he should learn to be a mason.

"I want painters to get back their old technique. Whenever I meet an artist I always try to get out of his head the idea that he is a gentleman.

"Mr. Arbuthnot speaks of current dislike of any evidence of originality. That is because people very seldom refer pictures to Nature at all. They want something like other people's pictures.

"The nineteenth century — the most abominable century that ever existed — was the century in which people lost their love of colour. The nineteenth century got more and more afraid of colour. Colour came to be looked upon as disreputable, and respectable men had to wear deep black and spotless white.

"In the same way people have mounts for their pictures — collars and cuffs round their paintings — and the more respectable people are, the wider and wider are the mounts.

"On this wall, again, we have that most abused Chodzko portrait. It is not like the ordinary portrait of the Lord Mayor, and therefore it is abused; not, mind you, because it is a bad likeness, but because it is placed in the picture in an unaccustomed way. Speaking for myself, I do not care for too much unconventionality. I like a man to restrain himself to one per cent. of unconventionality; if it is more than that it upsets my calculations.

"I think differently from two speakers, in setting great store upon the time spent on a work of art, regarding this in some sense as a standard of its merit.

"Ford Madox Brown carried out some decorating work for the Manchester Corporation at so much a square foot. I think that is the right thing. That is how the artist ought to be paid — not for his artistic gifts, but for the time and labour that he puts into a given piece of work.

"Finally, Mr. Holbrook Jackson complains that I call photography art, and suggests that I should call it simply 'photography.' But why not call painting 'painting,' and etching 'etching'? I don't know whether Mr. Holbrook Jackson denies that photography is an art in the same sense as painting is an art. I don't know how he possibly can. The only difference is that the photographer works with machinery that is more perfect than the machinery in the artist's studio, which is the clumsiest in the world. That is to say, therefore, that painting is more, not less, mechanical than photography."

The meeting closed with an enthusiastically accorded vote of thanks to Mr. Shaw.

EXTRACT, EDUCATION AND THE CINEMATOGRAPH, 1914

The following is an extract from a symposium on "Education and the Cinematograph," first printed in The Bioscope, *Educational Supplement no. 2, on 18 June 1914. It was later reprinted under the title "Bernard Shaw's Unqualified Approval of the Cinematograph" in* Current Opinion, *a New York publication, in August 1914.*

The article reveals Shaw's early interest and enthusiasm for cinema, and one can speculate on Shaw's potential as a film critic if he had not already become so involved with his plays.

AN OBVIOUS APPLICATION of the cinema to education is the reform of the Art School, with its "life class" studying an absurdly unlifelike naked human being in a condition of painful and hideous simulated petrifaction and paralysis. Our art students slave for years at this abomination, and finally deprive themselves of all power of drawing or even seeing a figure in action. The cinematograph can not only shew the figure in action, but can arrest the action at any instant, and thereby not only surprise here and there a moment at which the figure is graceful and expressive, but—what is more important— prove that ninetynine times out of a hundred the arrested action is artistically impossible, and that when the really successful draftsman or sculptor presents a figure in action he combines several suc-

cessive moments in his representation, and thus arrives at an outline no model can possibly give him.

In all athletic exercises, and in dancing, what is called "shewing form" can be done by the cinema. Much of the clumsiness and ugliness of our habits is simple ignorance; we have never seen anything better, and are even ashamed of pleasing our natural taste for something better, because it would make us look peculiar. The cinematograph, by familiarizing us with elegance, grace, beauty, and the rest of those immoral virtues which are so much more important than the moral ones, could easily make our ugliness look ridiculous. The moral virtues can take care of themselves only too well; it is our deficiency in the immoral ones that is keeping us back in the march of civilization.

APPENDICES

SELECTED CHRONOLOGY

With photographic events in **bold** type

1856 Born 26 July in Dublin, Ireland.

1871 On leaving school becomes a clerk in a Dublin firm of land agents.

1872 Mother and sisters move to London; Shaw lives with father in lodgings.

1876 Leaves his job and joins his mother in London.

1879 Makes his first speech at the Zetetical Society; writes his first novel, *Immaturity* (not published until 1930).

1880–83 Writes four more novels: all five unanimously rejected by London and New York publishers. **The fifth novel,** *An Unsocial Socialist,* **1883, includes first writings about photography.**

1884 Foundation of the Fabian Society, which he joins. *An Unsocial Socialist* first printed in serial form in *To-Day,* in installments throughout the year.

1885 Member of Executive Committee of Fabian Society. Active as social reformer.

1886 Hired as Art Critic for *The World.*

1887 **First review of a photographic exhibition for** *The World,* 12 October.

1888 **Second review of a photographic exhibition for** *The World,* 7 October; becomes Music Critic for *The Star* under the pseudonym *Corno di Bassetto.*

1889 Edits *Fabian Essays* (writing two of them).

1890 Music critic for *The World* under his own name.

1892 His first play, *Widowers' Houses,* is staged in London by a private theatre club for two performances.

1894 Leaves *The World.* Writes *Arms and the Man,* which is performed for eleven weeks but records a severe loss.

1895 Drama critic for *The Saturday Review.* Writes *The Sanity of Art.*

1898 Leaves *The Saturday Review.* Marries Charlotte Payne-Townshend at a London registry office and moves to her flat in Adelphi Terrace, London. Seven plays published, *Plays Pleasant and Unpleasant,* and *The Perfect Wagnerite.* **Buys his first camera, a Kodak, and becomes an enthusiastic amateur photographer. First published photograph,** *The Dying Vegetarian,* **published in** *The Academy,* **15 October.** (1898–1904 has growing success as a playwright: first performances of *You Never Can Tell, John Bull's Other Island, The Philanderer, Man and Superman,* and *Major Barbara.*) **Meets Frederick Evans, bookseller and later Shaw's mentor in photography.**

1900–1909 **Period of Shaw's major activities in photography, during which he wrote all his essays for the photographic press, primarily for** *The Amateur Photographer.* Meets Alvin Langdon Coburn (1904), whom he befriends, champions and photographs on many occasions during this period.

1911 Resigns from The Executive committee of the Fabian Society. Plays now regularly performed with great success. **With Frederick Evans, provides an evening of "Wit and Music" at the Camera Club.**

1914 **Writes "Education and the Cinematograph," published in** *The Bioscope* 18 June. First World War begins; *Commonsense About the War* makes him unpopular. *Pygmalion* is a sensational success in London.

1917 **Takes part in discussion at the Camera Club, on vortographs by A. L. Coburn, February.**

1918 End of First World War.

1923 Writes *Saint Joan,* performed in New York with great success.

1926 Receives Nobel Prize for Literature. Seventieth birthday dinner.

1928 Publishes *The Intelligent Woman's Guide to Socialism and Capitalism.*

1930 **Opens exhibition of photographs of Russia at the Camera Club 5 December.**

1931 Visits Russia and received by Stalin.

1932–34 Visits South Africa, America, New Zealand, South Africa, and takes Pacific Cruise.

1937 **"Nine Pages of Photographs by Bernard Shaw" published in** *The Countryman,* April.

1939 Second World War begins.

1943 Mrs. Shaw dies on 12 September. Shaw's Corner bequeathed to The National Trust the following year.

1945 End of Second World War.

1948 **Many of Shaw's snapshots used in** *Bernard Shaw Through the Camera,* by F. E. Lowenstein.

1950 **Publication of** *Bernard Shaw's Rhyming Picture Guide to Ayot St. Lawrence.* Dies at Shaw's Corner 2 November. His ashes, with those of his wife, scattered in the garden.

COLLECTIONS WHICH INCLUDE
PHOTOGRAPHS BY BERNARD SHAW

Art Institute of Chicago
Michigan Avenue at Adams Street
Chicago, Illinois 60603
(312) 443-3600
(Includes one photograph by Shaw)

British Library of Political and Economic Science
London School of Economics and Political Science
10 Portugal Street
London WC2 AHD, England
01-405-7686
(Uncounted, uncatalogued Shaw collection that includes thousands
of photographs, primarily platinum prints on permanent loan from
the National Trust)

International Museum of Photography at the George Eastman House
900 East Avenue
Rochester, New York 14607
(716) 271-3361
(Collection includes three photographs by Shaw)

Metropolitan Museum of Art
Department of Prints and Photographs
5th Avenue at 82nd Street
New York, New York 10028
(212) 879-5500
(Collection includes four photographs by Shaw)

National Museum of History and Technology
Smithsonian Institute
Washington, D.C. 20560
(202) 357-1300
(Collection includes four photographs by Shaw)

Princeton University
Art Museum
McCormick Hall
Princeton, New Jersey 08540

(609) 452-3794, 452-3788
(Collection includes one photograph by Shaw)

Royal Photographic Society of Great Britain
The Octagon
Milsom Street
Bath, BAI.IDN
England
(Collection includes two autochromes by Shaw)

Colin Smythe
Cornerways
Mill Lane
Gerrards Cross, Buckinghamshire, England
028-13-86000
(Private collection of about 250 photographs by Shaw, including portraits of figures from the Irish Literary Revival)

University of Texas at Austin
Photography Collection
Harry Ransom Humanities Research Center
P.O. Drawer 7219
Austin, Texas 78713-7219
(512) 471-9124
(Collection of Shaw photographs, numbering about 25, Irish country scenes and self-portraits)

GLOSSARY

Many of the individuals, places, processes and techniques mentioned by Shaw in his photographic criticisms may be unfamiliar to the general reader. This glossary has been compiled in order to clarify those names and terms which had relevance to photographers during Shaw's time.

Abney, Captain William de Wiveleslie (1843–1920): English photochemist whose work included experiments with the use of fogged film, photographing the ultra-red spectrum, alkaline development and density in dry-plates. He wrote many papers and books on his experiments, which he often read for the Photographic Society (London), of which he was president for five years.

Achromatic: A lens made of several different focal length elements which eliminates the "spread" of colors and produces a cleaner image.

Amateur Photographer, The: A British photographic periodical which was first published in 1884. This journal was not connected with any society or club and addressed itself to the amateur public at large.

Anastigmat: A lens which produces accurate points in the image corresponding to points in the subject, without distortion.

Annan, Craig (1864–1946): Scottish photographer who worked professionally in portraiture. He was a founding member of the Linked Ring and an early contributor to the salons of the former and the Royal Photographic Society (RPS). He was an internationally renowned leader of British pictorial photography.

Arbuthnot, Malcolm (1874–1967): English photographer, working first as an amateur, and later professionally. He contributed articles to *The Amateur Photographer,* including one on the gum-bichromate process which he favored in his own work. He was a member of the Linked Ring for ten years, but he quit photography and took up painting when a fire destroyed all his negatives.

Autochrome: Color photographic process patented in 1904 in France by the brothers Auguste and Louis Lumiere. It appeared on the market in 1907.

Bacon, Reverend John MacKenzie (1846–1904): English cleric, scientist, author and amateur photographer specializing in aerial photographs from balloons, which he exhibited at the Photographic Society. He authored two books: *The Dominion of the Air* and *By Land and Sea.*

Barbizon School: A group of French landscape and genre painters of a naturalist style, led by Pierre-Etienne-Theodore Rousseau (1812–1867). These artists got their name from the fact that some of them painted the area around Barbizon, a village south of Paris and near the forest of Fontainebleau.

Barton, Mrs. George Aaron (nee Caroline Brewer Danforth) (d. 1930): Prominent English pictorial photographer who mainly photographed children, often using religious themes and titles. Her photographs won many awards.

Beardsley, Aubrey Vincent (1872–1898): English draftsman and illustrator of the art nouveau movement. He is renowned for his black-and-white drawings of fantastic and often erotic subjects, which were chiefly used as illustrations for books and periodicals. He was also a poet and a friend of Frederick Evans, who championed his works.

Beresford, G. C. (no dates): Known to be an active portrait photographer, at least in the first twenty years of this century. He was a favorite photographer of Shaw's, and one of his portraits of Shaw hangs in Shaw's Corner. The National Portrait Gallery in London includes his work.

Bolas, Thomas (1848–1932): English chemist, photographic writer and inventor of one of the earliest cameras. He edited *The Photographic News* from 1884 to 1889, and for a number of years wrote a weekly column, "Acta Eruditorum," in *The Amateur Photographer,* which reviewed current progress and experiments in photography.

Bond Street: A London street renowned for its number of art galleries.

Bouguereau, Adolphe William (1825–1905): French painter who exhibited at the Royal Academy in the 1870s and 1880s. He painted mythological and religious subjects with an almost photographic realism.

Brown, Ford Madox (1821–1893): English painter and designer, working in a realist style, and later in a more decorative manner. Shaw cited his work for the Manchester Corporation, which refers to a commission for the Manchester Town Hall. Brown worked from 1878 to 1892 on this series of twelve large paintings which depicted the history of the city.

Brownie film: The Kodak No. 1 Brownie camera was introduced in 1900 and used roll film, with each negative measuring 2¼ by 2¼ inches.

Bulb: A pneumatic bulb which, when squeezed, forced air through a rubber tube and triggered the shutter. Commonly used by studio photographers of the period.

Burlington House: Home of the Royal Academy after 1854. It is located on the north side of Piccadilly in London.

Burne-Jones, Sir Edward (1833–1898): English painter of the Royal Academy, whose work was in a romantic medievalist style.

Burton, W. K. (no dates): English amateur photographer and writer. He invented a photographic exposure table which set an example for later variant exposure guides.

Cabinet: An albumen print with the image size 5½ by 4 inches, and mounted on a card which was 6½ by 4½ inches. This popular mode of presentation was introduced by F. R. Window in 1866 and was mainly used for theatrical photographs. It was an offshoot of the smaller carte-de-visite.

Cameron, Julia Margaret (Mrs. Hay Cameron) (1815–1879): British pictorial photographer, highly renowned for her portraits of famous men of Victorian England and for her allegorical works.

Campbell, Mrs. Patrick (nee Beatrice Stella Tanner) (1865–1940): Celebrated English actress and a close friend of Shaw's. She played the role of Eliza Doolittle in Shaw's play *Pygmalion.*

Chesterton, Gilbert Keith (1874–1936): English author and poet.

Cinematograph: This name can refer to the movie camera, the movie projector, or the movie itself. The Cinématographe was the first successful film projector, having been introduced by August and Louis Lumiere in 1895.

City and Guilds Institute: An organization founded around 1880, developed in order to maintain technical colleges and schools in London and assist in the provision of technical instruction in other institutions in London, in the provinces, and sometimes in the colonies. Another function was the registration and examination of classes throughout the country for technical arts, engineering, leather goods, etc.

Coburn, Alvin Langdon (1882–1966): Leading American photographer, who was a founding member of the Photo-Secession in America and a member of the Linked Ring in England. Coburn photographed many famous men of the time, including Shaw, with whom he was great friends. Coburn was one of the first photographers to explore abstract form with the camera. He invented the vortoscope, a device made of three mirrors which, when held in front of the lens, would fragment the resultant image. He made a series of these vortographs in 1917. Coburn was also one of the first to use the photogravure as an artistic process and not simply as a means of reproduction.

Cochrane, Archibald (no dates): English photographer and member of both the RPS and the Linked Ring.

Cole, Vicat (1833–1893): English painter and member of the Royal Academy.

Colour-sensitive roller film: Photographic emulsion on a flexible support (as opposed to glass) which is sensitive to all colors of the spectrum — except red at Shaw's time of writing.

Combination printing: The printing of two or more negatives onto the same sheet of paper in order to create a more artistic effect.

Cornish, Dr. Vaughan (no dates): English photographer who did a series of photographs of waves breaking, and later photographed the building of the Panama Canal.

Craigie, Reginald (d. 1930): English pictorial photographer, interested mostly in portraiture and figure studies. He was a leading member of the Linked Ring, of which he served as secretary for a number of years. In 1908 he was instrumental in the reestablishment of the Camera Club.

Crane, Walter (1845–1915): English illustrator and book designer. He was also a Fabian, and made a series of woodcuts entitled "Cartoons for the Cause."

Croft, J. Page (no dates): English photographer who developed an improved pigment paper which he demonstrated at a meeting of the RPS in 1906.

Crooke, William (d. 1928): English professional portrait photographer who worked in Scotland and was a member of the Linked Ring. He patented an improved portable headrest for photography in 1888. He was an early champion of the artistic nature of platinotypes.

Dallmeyer-Bergheim lens: A soft-focus lens designed in 1896 by Thomas Ross Dallmeyer at the suggestion of J. S. Bergheim, a painter.

Dallmeyer, Thomas Rudolphus (1859–1906): English optician and inventor who headed an optical firm which specialized in photographic lenses. In 1891 he developed the first telephoto lens, and later, the popular Dallmeyer-Bergheim portrait lens. He authored five books on photographic lenses, and was president of the RPS in 1900.

Davison, George (1856–1930): English amateur photographer, specializing in the gum-bichromate process. He was a founding member of the Linked Ring and was managing director of Kodak Ltd. from 1898 until 1912, when he was asked to resign because of his connection with anarchist organizations.

Day, Frederick Holland (1864–1933): Leading American pictorial photographer and an early champion of photography as art. He became infamous for his "The Seven Last Words of Christ," a series of photographs for which Day himself posed. He was one of the few select American members of the Linked Ring.

Degas, Hilaire Germain Edgar (1834–1917): French impressionistic painter of portraits and genre scenes. The theme of dancers was a prominent one in his work. Degas was also an enthusiastic photographer.

Delacroix, Eugéne (1798–1863): French painter of the neobaroque style. He was also a protagonist for photography as art.

Delaroche, Paul (1797–1856): French academic painter who, at the request of the government, made a favorable report on the effects of daguerreotypes on painting. Roger Fenton studied painting under his tutelege.

Demachy, Robert (1859–1936): Renowned French photographer and champion of the gum-bichromate process and author of numerous articles and five books on photography. A leader of the art photography movement in France, he helped to found

the Photo Club de Paris. He was also a member of the Linked Ring, and exhibited his work internationally.

Devens, Mary (no dates, but active around 1900): American* photographer, interested primarily in landscapes and figure studies. She was a member of the Photo-Secessionists in America and became a member of the Linked Ring in 1902. (*There is some conflicting information about her being English or American.)

Downey, William, and Downey, Daniel (dates unknown): A professional photographic firm (W. and D. Downey) renowned for its court portraits. They were active in Newcastle and London during the latter part of the nineteenth century.

Dubreuil, Pierre (b. 1872): French photographer whose early pictorial work included landscapes and allegories. Later he became a leader in the realist photography movement in France. He was a member of the Photo Club de Paris and the Linked Ring.

Dudley Gallery: A gallery in Piccadilly, London, where the Linked Ring Brotherhood held their annual salons from 1893 until 1905, when the gallery was demolished. From 1905-1909 the salons were held at the galleries of the Royal Society of Painters in Water Colours in Pall Mall St., London.

Du Maurier, George (christened Louis Palmella Busson) (1834– 1896): French draughtsman who worked for *Punch*. He also wrote a novel in 1894, *Trilby*, which was a best-seller.

Eickemeyer, Rudolf (1862-1932): American pictorial photographer and professional portraitist. A member of the Linked Ring, he exhibited his work internationally in the 1890s and early twentieth century. In 1900 he published a book of photographs of Negroes entitled *Down South*. He was also known for his snow scenes.

Elliot, Joseph John (1835-1903) and **Fry, Clarence Edmund** (no dates): Partners in one of the most successful English photographic firms, Elliot and Fry, which specialized in portraiture.

Etty, William (1787-1849): English painter of the royal Academy. He did heroic historical paintings and nude studies.

Evans, F. E.: This is actually F. H. Evans; the initial *E* was an error in the original article. When Evans first started photographing in the 1800s, he took pictures of shells and sea creatures through a microscope. See Frederick H. Evans for more information.

Evans, Frederick H. (1853-1943): Leading British photographer and bookseller. He is renowned for his photographs of English and French cathedrals. He was a prominent member of the Linked Ring, and contributed many articles to photography magazines.

Flaxman, John (1755-1826): English sculptor and illustrator. He was a member of the Royal Academy and was appointed professor of sculpture there in 1810.

Frampton, George (1860-1928): English sculptor.

French, Mr.: Possibly J. T. French of the South London Photographic Society, or the name could refer to J. T.'s son, Bertie, who was beginning to photograph in 1899.

Furniss, Harry (1854–1925): Irish illustrator and caricaturist who worked for *Punch* in the 1880s and 1890s. He illustrated the column "Essence of Parliament" with his caricatures of political figures.

Gale, John or Joseph (1835–1906): English amateur photographer who made naturalistic photographs of figures in the landscape. There is some conflicting information about his first name and army title, which is alternately listed as colonel or lieutenant colonel, but identical dates indicate that it was the same Gale who was active first in the Linked Ring and then in the RPS at that time.

Graves, Frederick (no dates): English photographer and author, contributing to *The Amateur Photographer*. He also wrote a novel, *Ombra — The Mystery*.

Grimperl, Mr.: This name was misspelled in the original article, and Shaw was actually referring to George Grimprel, a French photographer and member of the Linked Ring.

Grindrod, Dr. Charles F. (d. 1910): English pictorial photographer of landscapes and a member of the RPS. He was also a poet.

Gum-bichromate process: A controlled printing process, introduced in 1894, which uses paper coated with gum arabic and treated with potassium bichromate. The gum layer, which contains a pigment is exposed to light under a negative and then washed with water. The insoluble parts are left behind, but the result is variable through the length of washing and hand and brushwork.

Gummists: Workers in the gum-bichromate process, which allowed a considerable amount of manipulation during the printing process.

Gum or pigment plasters: Derogatory term used by Shaw for manipulative photographic processes using gum-bichromate printing.

Hatching: In art, a set of parallel lines drawn to produce the effect of shading. Some photographers used this technique on their negatives or on overlays to make their photographs more artistic.

Haydon, Benjamin Robert (1786–1846): English painter of religious themes and an opponent of the Royal Academy.

Henneberg, Dr. Hugh (1863–1918): Austrian landscape photographer working in the gum-bichromate process. He was a member of the Camera Club and the Linked Ring, exhibiting at the London salon from 1892 on.

Henner, Jean-Jacques (1829–1905): French painter known for his portraits of women and his nudes in Venetian landscapes.

Hill, David Octavius (1802–1870): Scottish painter and photographer. He initially took up photography as an aid to painting. In partnership with Robert Adamson (1821–1848), he worked as a professional portraitist using the calotype process.

Hinton, Alfred Horsley (1863–1908): English photographer and one of the leaders of the Linked Ring. He also wrote many articles on photography and edited *The Amateur Photographer* from 1893 until his death.

Hodges, John Alfred (1861–1907): English photographer and author of technical photographic articles. He was an honorable secretary of the RPS and a frequent exhibitor. His most notable work was a photographic study of Wales.

Ilford chromatic plate: Ilford plates began production in 1879 and within ten years commanded the largest sale of any dry-plates in the world. Their chromatic plates made use of new advances in photographic emulsions to extend their spectral response. Such orthochromatic plates were advocated by Shaw.

Isochromatic: Synonym of orthochromatic. (*See* orthochromatic.)

Jackson, Holbrook (1874–1948): Author of *Bernard Shaw,* a biography. He was a founding member of the Leeds Art Club.

Käsebier, Gertrude (1852–1934): American photographer who worked professionally in portraiture. She was a member of the Photo-Secessionists and the Linked Ring. The first issue of *Camera Work,* 1903, highlighted her work.

Kaulbach, Wilhelm von (1805–1874): German painter, highly celebrated in his day. He specialized in historical paintings which depicted Germany's victory over Eastern invaders.

Keighley, Alexander (1861–1947): English landscape photographer and one of the leading figures of British pictorial photography. He was a founding member of the Linked Ring and later joined the RPS.

Kelmscott Press: A cooperative publishing and printing enterprise noted for the beauty of its paper, and the design and binding of its productions. It was founded in 1891 by William Morris.

Kodaker: Photographer who used any model of the Kodak camera. It was often used generically to denote any amateur using a detective or hand camera.

Lacroix, Jean (no dates): French amateur photographer, active between 1895 and 1914. He was a member of the Photo Club de Paris.

Leech, John (1817–1864): English caricaturist and illustrator for *Punch* from its beginning in 1841.

Lewis, Furley (1868–1940): English professional photographer who made portraits of many eminent figures of that period. He was president of the RPS from 1914 to 1916. Also an experimenter in photographic technology, he developed the bromoil transfer process and did pioneer work in trichromatic halftone.

Linked Ring, The: A secession group of photographers, formed in England in 1892 and continuing until 1910. The founding members included H. P. Robinson and Alfred Maskell, who rebelled against the Photographic Society because of their emphasis on technical and professional work. The secessionists also wanted to separate themselves from the amateur snapshooters. The Linked Ring exalted art photogra-

phy and held annual exhibitions which they called "salons," a name taken from the Royal Academy exhibitions.

Linnell, John (1792–1882): English landscape painter and patron of the arts. He commissioned William Blake to illustrate the *Book of Job,* in 1825, with twenty-one engravings.

Lumiere, Auguste (1862–1954) **and Louis** (1864–1948): French brothers who invented the autochrome process, one of the first successful color photographic processes, patented in 1904. They were also early experimenters in cinematography.

MacColl, Dugold Sutherland (1854–1948): English writer and art critic, contributing to *Spectator, Saturday Review,* and *Weekend Review.* He was also the editor of *Artworks* and a lecturer at the University College of London. He later became keeper and Trustee for the Tate Gallery, and continued to write about art until his death. (Shaw spells the name *McCall.*)

Maeterlinck, Count Maurice (1862–1949): Belgian poet, dramatist, and essayist.

Maitland, Viscount (no dates): English professional photographer and member of the Linked Ring. He shared a partnership with the Duke of Newcastle in a portrait studio, the Syndicate of Pictorial Portraiture, which appears to have been dissolved when Maitland joined the Rough Riders in Africa in 1900.

Mercury toning: Unknown process for altering image color. Mercury was generally used as a method of increasing the density of an underexposed or underdeveloped negative. The negative is first bleached with a salt of mercury and then redeveloped to full strength.

Mezzotint: A type of engraving on copper or steel, produced by burnishing the previously roughened surface to render various tones.

Monticelli, Adolphe (1824–1886): French painter best known for his park landscapes. His work influenced postimpressionists.

Morgan, Dr. Llewellyn (no dates): English pictorial photographer, exhibiting at the RPS at the turn of the century. He was president of the Liverpool Amateur Photographic Association in 1901, and served as chairman of the Exhibition Committee for the Northern Photographic Exhibition, 1904.

Morris, William (1834–1896): English artist, poet and socialist. He championed the revival of handicrafts, emphasizing flat surface decoration. He was very influential in Europe and America by the end of the nineteenth century.

Moss, Charles H. (no dates): British amateur photographer. He was one of the founding members in 1889 of the Rotherham Photographic Society and its president for eleven years. He later became a member of the Linked Ring. He worked in the gum-bichromate process, contributing an article on that subject to *The Amateur Photographer* in 1903.

National Gallery, London: A national collection of art that began in 1824 with Parliament's purchase of the late John Julius Angerstein's collection of pictures. It

did not have a permanent home until 1838, when the new building in Trafalgar Square was opened. It is now one of the world's great collections.

Naturalism: A trend in art towards realism.

New English Art Club: A secessionist society of artists, founded in 1886 in reaction against the restrictions of the Royal Academy. Sargent was one of the founding members. The club held exhibitions at the Dudley Gallery, showing avant-garde work.

New Gallery, The: An exhibition space located in Regent Street, London. The RPS held exhibitions there from 1900.

Ordinary plates: All nineteenth-century plates were only sensitive to blue light and could be safely handled and processed in yellow illumination. Because these emulsions had dominated photography until the early years of this century, they were termed *ordinary.*

Orthochromatic: Photographic emulsions sensitive to all colors except red, producing tonal values of light and shade in a photograph that correspond to the tones in nature.

Panchromatic: Photographic emulsions sensitive to all colors of the visible spectrum. The first truly panchromatic emulsion was marketed by Wratten and Wainwright Ltd., London, in 1906.

Partridge, Sir Bernard (1861–1945): English artist and cartoonist for *Punch.*

Payne: There were several Paynes active in photography at this time, but the specific "Mr. Payne" who photographed criminals is not presently known.

Peppercorn, Arthur Douglas (1847–1924): English landscape painter influenced by the Barbizon School. He exhibited at the Royal Academy from 1869.

Photogravure: A photo-mechanical method of reproducing photographs in printers' ink, which Coburn had mastered and brought to such a stage of perfection that the photogravure became the final product, not a mere reproduction.

Photo-micrographs: Photographs of images projected by a microscope.

Photo-Secessionist: The Photo-Secession, New York, was formed by Alfred Stieglitz in 1902. Its aim was to champion photography as a fine art, through its exhibitions (from November 1905 at 291 Fifth Avenue—"291"—The Little Galleries of the Photo-Secession) and its publication, *Camera Work,* a luxuriously printed quarterly journal which began in January 1905.

Pigment processes: Photographic printing processes, such as the carbon process and the gum-bichromate process, which use pigment in the emulsion.

Platinotype: A photographic print using platinum, as opposed to silver salts. Platinum prints were prized by art photographers because of their delicate silvery tones and for the permanence of the process.

P.O.P.: Printing-Out Paper, so named because the image appeared during exposure under the negative, and did not need to be developed in chemicals. The abbreviation was first used in 1891 for a gelatine-chloride paper marketed by Brittania Works (since 1900, Ilford Ltd.).

Pringle, Andrew (1850-1929): English photographer, author and inventor. He specialized in photomicrographs of bacteria.

Puyo, Charles (1857-1933): Renowned French photographer and author of a book on photography and numerous articles which dealt mostly with the gum-bichromate and oil transfer processes which he favored in his own work. He was a leading member of the Photo Club de Paris and the Linked Ring. (The name *Captaine E. J. Constant Puyo* was also discovered in research, but the birth and death dates are the same, indicating that this is the same person.)

Punch: A British humor periodical which began publication in 1841. One of its founders was Henry Mayhew, an early photographer. Throughout the nineteenth century, *Punch* published many caricatures lampooning the new art of photography.

Pyro: Abbreviation of pyrogallic acid, which is a weak acid used in photographic developing.

Pyro-ammonia finger-stainer: Pyrogallic acid and liquid ammonia were the major ingredients of thousands of nineteenth-century developers, all of which were notorious for producing stubborn black stains on hands after immersion. Potassium cyanide, a deadly poison, was often used as a stain remover.

Roberts, John F. (known to be active in the 1880s): English photographer who photographed scenes from the play *David Garrick* by the sole illumination of gaslight. These photographs were made for theatrical advertisements.

Robinson, Henry Peach (1830-1901): English photographer, and one of the foremost champions of art photography as early as the 1850s. He was very influential through his photographs and writings, especially his *Pictorial Effect in Photography,* first published in 1869 and which became one of the most widely read books on photography. He was an early member of the Photographic Society of Great Britain, later seceding to help found the Linked Ring.

Robinsonian School: A group of photographers who followed Henry Peach Robinson's tenets on pictorial photography.

Rossetti, Dante Gabriel (1828-1882): English painter of the Pre- Raphaelite movement.

Royal Academy of Arts in London: An institution founded in 1768 to provide annual exhibitions and schools of art training. In the late nineteenth century its reputation was greatly lowered because of its conservative nature and resistance to creative innovation.

Royal Photographic Society of Great Britain: A learned association of photographers formed in London in 1853 under the name of Photographic Society. Sir Charles Eastlake, president of the Royal Academy, became their first president. In 1874 its

name was expanded to The Photographic Society of Great Britain, and in 1894 it became the Royal Photographic Society of Great Britain. The society has continued to the present day, although its headquarters are now in Bath.

Ruskin, John (1819–1900): English writer and critic of art and architecture during the neoclassicist and Romantic periods. He championed the work of William Turner and denounced James Whistler.

Salon, The: The annual exhibition of the Linked Ring, first held in 1893. The term was taken from the Royal Academy exhibitions.

Sambourne, Edward Linley (1844–1910): English illustrator and cartoonist for *Punch*.

Sargent, John Singer (1856–1925): American portrait painter. He was a member of the Royal Academy, seceding in 1886 to form the New English Art Club, although his involvement with that group was brief.

Segantini, Giovanni (1858–1899): Italian impressionist painter who favored alpine landscapes in his work.

Sickert, Walter Richard (1860–1942): English impressionist painter and art critic. He was a member of the Royal Academy, and was later associated with the New English Art Club.

Society of British Artists: An association of artists formed in the early nineteenth century, partly in reaction to the monopoly of the Royal Academy. James Whistler was president from 1886 to 1888.

Speaight, F. W. (no dates) and **Richard** (d. 1938): English brothers and partners in a professional photographic firm which specialized in court portraiture and theatrical work. In 1926 Richard published *Memoirs of a Court Photographer*.

Steer, Philip Wilson (1860–1942): English impressionist painter. He was a member of the Royal Academy from 1883 to 1885, and then joined the New English Art Club in 1886, which he was affiliated with for the rest of his life.

Steichen, Edward (1879–1973): Prominent American photographer who was a Photo-Secessionist and a leading proponent of art photography at the turn of the century. He was also a member of the Linked Ring.

Stieglitz, Alfred (1864–1946): Internationally renowned American photographer active from the 1880s until his death. He was the leader of the Photo-Secessionists in America, directing their gallery, "291," and editing their publication, *Camera Work*. He was also a member of the Linked Ring.

Strang, William (1859–1921): Scottish painter and graphic artist, chiefly known for his etchings, illustrations and portraits. He was a member of the Royal Academy.

Tableaux vivants: French term literally translated as "living pictures." In art, the term refers to the depiction of a staged scene of costumed models.

Tenniel, Sir John (1820–1914): English painter, illustrator and cartoonist for *Punch*. He created the first illustrations for *Alice's Adventures in Wonderland* in 1865. He was a regular exhibitor at the Royal Academy. Shaw refers to his *Gladstone,* which portrayed the British prime minister William Ewart Gladstone (1809–1898), who was also an honorary member of the Royal Academy.

Terry, Dame Ellen Alice (1847–1928): Famous English actress who played many of Shaw's heroines. The first role which she played for Shaw was expressly written for her: Lady Cicely Waynflete in *Captain Brassbound's Conversion.*

Tinley, Frederick Colin (1865–1951): English artist, teacher and exhibitor at the Royal Academy. He was also involved in photography as a critic and lecturer, and served as a judge at some of the photography exhibitions. He was elected a Fellow of the RPS. He wrote many essays on art photography, and in the 1920s he compiled several photographic annuals which included his criticism and reproductions of pictorial work from the RPS.

Turner, Joseph Mallord William (1775–1851): English painter of historical subjects, landscapes and seascapes. His emphasis on light influenced the impressionists. He was a member of the Royal Academy.

Von Jan, Professor Ludwig (d. 1908): German pictorial photographer, best known for his nude studies, and a professor of art and history at Strassburg University. He exhibited frequently as a member of the RPS. His photographs were used as illustrations in the publication *Le Nu en Photographie* by Bruno Meyer.

Warburg, Agnes Beatrice (1872–1953): English amateur photographer and an early worker in the autochrome process. She was a member of the RPS and also exhibited regularly in the salons of the Linked Ring from 1900–1909. She founded the Halcyon Club for women artists. Her brother, J. C. Warburg, was also a noted photographer.

Warburg, John Cimon (1867–1931): English amateur photographer and writer on photography for many English and German publications. He was an active member of the RPS, exhibiting also in the Linked Ring salons. He was an early experimenter with the autochrome process, and he also favored the gum-bichromate process as well as the platinum printing process.

Warneuke, W. M. (d. 1924): Scottish professional photographer specializing in portraiture. He was a regular contributor to exhibitions in Scotland and at the RPS.

Watkins: An early measurement of light intensity for film exposure. The term was derived from Alfred Watkins, who patented a standard exposure meter in 1890. A test strip of silver chloride paper was exposed to light, and the time that the strip took to darken indicated the exposure.

Watzek, Hans (1848–1903): Influential Viennese photographer, painter and professor of drawing. He was a member of the Viennese Camera Club and the Linked Ring. He photographed a wide variety of subjects including landscapes, portraits and still lifes. A pictorialist, he worked in the gum-bichromate process and used a

spectacle lens in order to increase the softness of his photographs. (Shaw spelled the name *Watsek.*)

Weil, Mathilde (no dates): American professional photographer, specializing in portraiture. She first exhibited her work in the 1898 exhibition of the RPS.

West, Benjamin (1738–1820): American painter of the neoclassicist and romantic periods. He was a founding member of the Royal Academy and served as the second president, succeeding Sir Joshua Reynolds.

Whistler, James Abbott McNeill (1834–1903): American impressionist painter who became infamous for his increasingly nonrepresentational paintings, notably his nocturnes.

Window, F. R and **Grove** (no dates): Two Englishmen who ran a professional photography studio. Mr. Window created the cabinet portrait which the firm specialized in. They also made cameo and silhouette portraits. They produced hundreds of photographs of Ellen Terry during the career of this famous actress.

SELECTED BIBLIOGRAPHY

In chronological order

G. Bernard Shaw. *An Unsocial Socialist.* London: Swan Sonnenschein, Lowrey and Co., 1887. Excerpts pertaining to photography on pp. 226–231; 288–296 of 1906 edition. First printed in serial form in the periodical *To-Day* (unsigned but Shaw's name appears in the index to each bound volume) vol. 1 (March-June 1884), pp. 205–220, 284–306, 343–373, 445–472; vol. 2 (July-December 1884), pp. 30–55, 105–128, 199–229, 311–335, 431–455, 543–579.

Unsigned. "A Novelist on Photography and its Applications." *The Photographic News,* 3 July 1885, p. 431. Precis of passages relating to photography in *An Unsocial Socialist.*

Shaw, Bernard. "What the World Says." *The World* 693 (12 October 1887): p. 15. Unsigned review by Shaw on the Photographic Society Exhibition.

Shaw, Bernard. "What the World Says." *The World* 746 (17 October 1888): p. 15. Unsigned review by Shaw on the Photographic Society Exhibition.

Shaw, Bernard. *The Dying Vegetarian. The Academy,* 15 October 1898, p. 67. Reproduction of one of Shaw's earliest photographs.

The Amateur Photographer, 24 March 1899, p. 223. Notice of lecture at Hindhead Hall, Surrey, at which G.B.S. proclaimed himself "an ardent Kodaker."

Lux. "Personalities." *The Amateur Photographer,* 31 August 1900, p. 162. Columnist claims that G.B.S. disparages photography; Shaw protests in the next issue. G. Bernard Shaw. "Mr. G. Bernard Shaw on the Art Claims of Photography." *The Amateur Photographer,* 7 September 1900, p. 185.

Lux. "Personalities." *The Amateur Photographer,* 14 September 1900, p. 202. Lux responds to Shaw's criticism of the previous week.

Shaw, Bernard. "The Exhibitions." *The Amateur Photographer,* 11 and 18 October 1901, pp. 282–284, 303–304. Reprinted as "George Bernard Shaw on the London Exhibitions" in *Camera Work* 14, (April 1906): pp. 57–62. Excerpts reprinted in "Aphorisms on Photography," a preface to a catalogue for "An exhibition of modern

photography at the galleries of the New English Art Club, 67a New Bond Street. January 28–February 9," 1907. London: New English Art Club (wrappers). Excerpt reprinted as "On the London Exhibitions" in *Photography in Print — Writings from 1816 to the Present,* Vicki Goldberg, ed. New York: Simon and Schuster, 1981, pp. 223-231.

Watchman. "Words from the Watch-Tower." *The American Amateur Photographer,* 14 (1902): pp. 556-557; 557-558. An American response to Shaw's criticism of the London Exhibition; notice of Shaw's criticism of George Davison's "fuzzygraphs."

Shaw, Bernard. "George Bernard Shaw on the Use of Orthochromatic Films and Screens." *The Amateur Photographer* 14 (August 1902): pp. 123-24.

Shaw, Bernard. "The Unmechanicalness of Photography, An Introduction to the London Photographic Exhibitions." *The Amateur Photographer,* 9 October 1902, pp. 286-289. Reprinted in *Camera Work* 14 (April 1906); pp. 18-25. Excerpts reprinted in "Aphorisms on Photography," a preface to a catalogue for *An exhibition of modern photography at the galleries of the New English Art Club, 67a New Bond Street. January 28–February 9,* 1907. London: New English Art Club (wrappers). Also reprinted in *Camera Work: A Critical Anthology,* Jonathan Green, ed. Millerton, NY: Aperture, 1973, pp. 62-66, 99.

Shaw, Bernard. "Some Criticisms of the Exhibitions: 'The Life Study,' 'The Fuzzygraph,' and 'The Underexposed'." *The Amateur Photographer,* 16 October 1902, pp. 305-307. Excerpts reprinted in "Aphorisms on Photography," a preface to a catalogue for *An exhibition of modern photography at the galleries of the New English Art Club, 67a Bond Street, January 28–February 9,* 1907. London: New English Art Club (wrappers).

Shaw, Bernard. "Evans — An Appreciation," *Camera Work,* 2 (October 1903): pp. 13-16. Reprinted in "In Praise of Frederick H. Evans, Hon. Fellow: A Symposium" (postcard message in the Introductory, followed by a reprint of the article), *Photographic Journal,* February 1945, sec. A, pp. 31-32. Facsimile reprinted in *The Print* (Life Library of Photography) New York: Time-Life Books, 1970, pp. 33-36.

C. W. B. "The Cult of the Ugly." *The Amateur Photographer,* 9 January 1906, p. 37. Shaw quotation regarding criticism of the Royal Photographic Society, with following commentary.

Shaw, Bernard. "Preface" to *Catalogue of an Exhibition of the Work of Alvin Langdon Coburn, February 5–March 31, 1906.* London: Royal Photographic Society of Great Britain, pp. 1-4. Reset for the Liverpool Amateur Photographic Association exhibition from 30 April–14 May 1906. Reprinted as: "George Bernard Shaw on Coburn's Photography" in *British Journal of Photography,* 2 February 1906, pp. 86-87; "Photographs by Mr. Alvin Langdon Coburn" in *The Amateur Photographer,* 6 February 1906, pp. 111-112; "Coburn's Exhibit at the Royal" in *Photo-Era,* March 1906, pp. 173-176; "Coburn the Camerist" in *Metropolitan Magazine,* May 1906, pp. 236-241; and "Bernard Shaw's Appreciation of Coburn" in *Camera Work,* 15 (July 1906): pp. 33-35.

Unknown. "A Pen Portrait of George Bernard Shaw." *The Amateur Photographer,* 6 February 1906, p. 102. Interesting personality sketch of G.B.S. as photographic critic.

Shaw, Bernard. *Camera Work* 15 (July 1906): pl. 6. Portrait of Alvin Langdon Coburn.

Shaw, Bernard. " 'G.B.S.' on Art in Utopia." *The British Journal of Photography,* 30 November 1906, p. 953. Review of Fabian Society lecture by Shaw on the commercial ethics of art and photography, including portraiture.

Shaw, Bernard. "Mr. George Bernard Shaw on the Foregoing Article" (comment on "Monsieur [Robert] Demachy and English Photographic Art"). *The Amateur Photographer,* 29 January 1907, p. 94.

Unsigned. *The British Journal of Photography,* 1 March 1907, pp. 156–157. Comment on Shaw's remarks concerning portraiture, including Holland Day's depiction of Christ.

Dixon, Scott. "Colour Photography and Other Recent Developments of the Camera." *The Studio: Special Summer Number,* 1908. Includes "A Landscape," pl. 93 from an autochrome by G.B.S.

The Magpie. "G.B.S.-itis." *The Amateur Photographer,* 26 October 1909, p. 422. Review of a talk "of coruscating brilliance" by G.B.S. at the Salon.

Unsigned. "Topics of the Week." *The Amateur Photographer,* 26 October 1909, p. 403. Review of Shaw's talk at the Salon.

Shaw, Bernard. "George Bernard Shaw Improvises at the Salon: Photography in its Relation to Modern Art." *The Amateur Photographer,* 26 October 1909, pp. 416–417. Abridged version of address at Photographic Salon. Also variant text reprinted as "The High Crimes of the Camera," in the *New York American,* 21 November 1909, 7C: 2.

Unsigned. "Shaw-Evans. An Evening of Art and Music at the Camera Club." *The Amateur Photographer,* 6 March 1911, p. 220. Review of performance featuring a talk by Shaw on Frederick Evans, and Evans playing the pianola.

Vogue, vol. 46, 1 October 1915, p. 64. Reproductions of several Shaw photographs taken at Code.

Unsigned. "The Camera Club." *The British Journal of Photography,* 16 February 1917, p. 87. Review of discussion on the vortographs made by by A. L. Coburn.

Unsigned. "An Exhibition of Photographs." *Manchester Guardian,* 6 December 1930, pp. 7, 15. Photograph of G.B.S. at the Camera Club's exhibition of photographs of modern Russia, with review of Shaw's comments.

"Nine Pages of Photographs by Bernard Shaw." *The Countryman,* 15 (April 1937): pp. 96–105. Photographs: *Augustus John, Three Views of Derwentwater, Sir John Squire, Kitchen Garden* and *Orchard at Ayot St. Lawrence in the early morning, between Harlech and Portmador.*

Shaw, G. Bernard. *Shaw Gives Himself Away.* Newton, Wales: The Gregynog Press, 1939. Autobiographical miscellanea.

Busch, Arthur. "George Bernard Shaw — Photographer." *Popular Photography,* 16 (February 1945); pp. 19–21, 100–103. Excellent lengthy article on Shaw's photography, including the full "epistolary interview" with G.B.S. conducted by Kenneth Porter, *Popular Photography*'s European correspondent.

Porter, Kenneth R. "Bernard Shaw as Photographer." *Illustrated,* 31 March 1945, pp. 12–13. Interview with G.B.S. Reprinted in partial facsimile in Arthur Busch, "George Bernard Shaw — Photographer," *Popular Photography,* 16 (February 1945): pp. 19–21, 100–103.

Loewenstein, F. E. *Bernard Shaw Through the Camera.* London: B & H White Publications Ltd., 1948. Includes many portraits of family and acquaintances by G.B.S.

Shaw, G. Bernard. *Sixteen Self Sketches.* London: Constable and Company Ltd., 1949. Autobiographical miscellanea, includes Shaw's photograph of his mother.

Shaw, Bernard. *Bernard Shaw's Rhyming Picture Guide to Ayot Saint Lawrence.* Luton, England: Leagrave Press Ltd., 1950. Fifty-nine snapshots taken by G.B.S. with accompanying verses.

Chappelow, Allan. "An Ideal Model." *The Photographic Journal,* January 1951, pp. 36–39. Personal account of Chappelow's last portraits of G.B.S. taken shortly before his death.

Coburn, Alvin Langdon. "George Bernard Shaw, 26 July 1856 to 2 November 1950." *The Photographic Journal,* January 1951, p. 30. Obituary of G.B.S.

Gernsheim, Helmut. "G.B.S. and Photography." *The Photographic Journal,* 4 January 1951, pp. 31–36. Includes full text and facsimile of Gernsheim's interview with G.B.S.

Moholy, Lucia. "G.B.S. and Photography." *The Photographic Journal,* June 1951, p. 205. Letter from Lucia Moholy with Shaw correspondence repudiating views on photography in *An Unsocial Socialist.*

Ervine, St. John. *Bernard Shaw, His Life, Work, and Friends.* London: Constable and Company, Ltd., 1956. No mention of photography, but a readable biography.

Henderson, Archibald. *George Bernard Shaw: Man of the Century.* New York: Appleton-Century-Crofts, 1956. "No biography of me except Henderson's is authorized." — G.B.S. 18 September 1940.

Chappelow, Allan. *Shaw The Villager and Human Being,* London: Charles Skilton Ltd., 1961. Anecdotal contributions by Shaw's housekeeper, doctor, gardener, neighbors, and fifty others. Many reminiscences mention Shaw and his camera. Especially pp. 1–24.

Laurence, Dan, ed. *Platform and Pulpit.* London: Rupert Hart-Davis, 1962. The full texts of thirty-seven of Shaw's formal lectures, speeches and debates.

Karsh, Yousuf. *In Search of Greatness.* New York: Alfred A. Knopf, 1962, pp. 74, 94–95. Karsh's experiences when photographing G.B.S.

Shenfield, Margaret. *Bernard Shaw: A Pictorial Biography.* New York: The Viking Press, 1962. A light, illustrated introduction to Shaw's life—minus photography. Includes four portraits by Shaw.

Gernsheim, Helmut, and Gernsheim, Alison, eds. *Alvin Langdon Coburn: Photographer. An Autobiography,* London: Faber and Faber, 1966. Relationship between G.B.S. and A.L.C., 1904–1950.

Murray, Nickolas. *The Revealing Eye.* New York: Athenaeum, 1967, p. xvii. Paul Gallico's introduction includes Murray's verbatim notes of a visit with and sitting by Shaw, undated but probably between 1920 and 1926.

Gernsheim, Helmut in collaboration with Gernsheim, Alison. *The History of Photography: from the camera obscura to the beginning of the modern era.* New York: McGraw-Hill Book Co., 1969, pp. 423–424, 461, 464, 467, 469. Includes discussion of G.B.S. as amateur photographer and his association with A. L. Coburn and F. Evans.

Weintraub, Stanley. *Shaw, An Autobiography.* Two volumes: 1856–1898; 1898–1950. New York: Weybright and Talley, 1970. An assemblage of his confessions, taken from prefaces, reviews, speeches, etc.

Chappelow, Allan. *Shaw—"The Chucker-Out."* London: George Allen and Unwin Ltd., 1969. A biographical "symposium." Shaw the snapshooter is frequently mentioned, and Chappelow describes the taking of a famous Shaw portrait, *The Chucker Out.*

Freund, Gisele. *The World in My Camera.* New York: The Dial Press, 1974, pp. 100, 125–128. Freund's experiences when photographing G.B.S.

Laurence, Dan H. *Shaw: An Exhibit.* Austin: Humanities Research Center, 1977. A catalogue of an exhibition by Dan Laurence at Humanities Research Center, University of Texas, Austin, 11 September 1977–28 February 1978. Items 88–98 concern photography, including photographs by G.B.S. and pieces of correspondence. The HRC possesses thirty-three pieces of Shaw correspondence to Frederick Evans.

Pictorial Photography in Britain 1900–1920. Exhibition catalogue with essay by John Taylor, London: Arts Council of Great Britain in association with The Royal Photographic Society of Great Britain, 1978, pp. 14, 15, 26, 29, 31, 32, 77. Brief mentions of G.B.S. and photography.

Shaw's Corner, The National Trust, 1978. Reprinted 1984. Guide booklet to Shaw's house at Ayot St. Lawrence.

Harker, Margaret. *The Linked Ring: The Secession Movement in Photography in Britain, 1892–1910.* London: Heinemann, 1979, p. 114, pl. 87. Portrait of Frederick Evans by G.B.S.

Hopkinson, Tom. *Treasures of the Royal Photographic Society, 1839–1919.* London: Focal Press, 1980, pp. 17, 22, 34. Brief mentions of G.B.S. as photographer, with one Shaw portrait of Frederick Evans, p. 22.

Lassam, Robert. "George Bernard Shaw as Photographer." *National Trust,* Spring 1981, p. 12. Precis of Shaw's interest in photography, illustrated with two images by G.B.S. from the L.S.E. collection.

Laurence, Dan, ed. *Bernard Shaw: Collected Letters.* Four volumes: 1874–1897; 1898–1910; 1911–1925; 1926–1950. New York: Dodd, Mead and Co., 1972–1988. Includes a selection of Shaw's letters to Frederick Evans, A. L. Coburn and other photographers.

Flukinger, Roy. *The Formative Decades: Photography in Great Britain, 1839–1920.* Austin: University of Texas Press, 1985, p. 126. One photograph by G.B.S., *Irish Fisherman,* with descriptive caption by Flukinger.

INDEX